D1596396

Algerian national cinema

Manchester University Press

Algerian national cinema

Guy Austin

Manchester University Press
Manchester and New York
distributed in the United States exclusively by Palgrave Macmillan

Published by Manchester University Press
Oxford Road, Manchester M13 9NR, UK
and Room 400, 175 Fifth Avenue, New York, NY 10010, USA
www.manchesteruniversitypress.co.uk

Distributed in the United States exclusively by
Palgrave Macmillan, 175 Fifth Avenue, New York,
NY 10010, USA

Distributed in Canada exclusively by
UBC Press, University of British Columbia, 2029 West Mall,
Vancouver, BC, Canada V6T 1Z2

British Library Cataloguing-in-Publication Data
A catalogue record for this book is available from the British Library

Library of Congress Cataloging-in-Publication Data applied for

ISBN 978 0 7190 7993 1 hardback

First published 2012

The publisher has no responsibility for the persistence or accuracy of URLs for any
external or third-party internet websites referred to in this book, and does not guarantee
that any content on such websites is, or will remain, accurate or appropriate.

Typeset 10/12pt Photina
by Graphicraft Limited, Hong Kong
Printed in Great Britain
by TJ International Ltd, Padstow

Contents

List of illustrations

All illustrations are courtesy of the Iconothèque at the Bibliothèque du Film in Paris. Every effort has been made to contact copyright holders. If claiming copyright please contact the author.

Preface

Why conceive of Algerian film as a national cinema rather than a transnational, diasporic or regional one? Firstly, because I feel that, as regards Algeria, an understanding of national identity can illuminate issues and realms that Western readers in general are not fully aware of. In terms of the so-called 'clash of civilisations' after '9/11', Islamic states such as Algeria have too often been perceived in the West as 'other' and hence as threatening. One wish I have for this book is that is might help, via an analysis of cinema, to break down some misunderstandings and assumptions about Algeria, which remains to a large extent underrepresented or misrepresented in the UK media. But the book is also about Algerian national cinema because a focus on the national can allow a critique of nationalist ideology, and so can illuminate the ways in which the official mythologising of a national culture at the 'centre' of the postcolonial state has marginalised the diverse identities within the nation. Cinema is one of the ways that repressed identities (for example, women, or the Berber communities) have managed to find representation outside the dominant nationalist discourse. Moreover, in terms of postcolonialism, former colonies have at times tended to be construed as the 'margins' rather than the 'centre' of competing discourses and power relations. Addressing national culture in a postcolonial state is one way of recognising that the 'centre' is not only to be located in the West. Looking at Algerian cultural production through the optic of the relationship with France (or with its neighbours in North Africa) might risk neglecting a detailed engagement with the specificities of a vast country which has a variegated history and an array of plural identities. One of the potential pitfalls of a transnational approach, then, is that it might neglect 'historical and cultural specificity', failing 'to fully

acknowledge the (cultural) politics of difference' (Higbee 2007: 84). In short, the transnational can seem at times 'not specific enough or sufficiently politically engaged' (Higbee 2007: 85). Finally, as writers such as Ranjana Khanna have begun to argue recently, Algeria stands as a form of test case, where issues of representation and power (terror and counter-terror, the postcolonial and the neo-colonial, gender and symbolic violence) are being played out and articulated (see Khanna 2008). This books aims to contribute to the understanding of Algeria in similar terms, via a consideration of its cinema as one of the principal means whereby identities have been articulated in a national context.

I have given the titles of films in French rather than Arabic or Berber where a choice arises, because these are the titles under which Algerian films have usually been circulated most widely. Alternative titles are given in the filmography at the end of the book. Finally, a note on the availability of the films: this varies. Some I saw at the cinema, paricularly at film festivals, some at the Centre Culturel Algérien in Paris, others on DVD or even VHS. Increasingly, however, the internet is allowing global access to Algerian films. Entire versions of films as diverse as *Omar Gatalto*, *Machaho* and *Le Clandestin* are now available online and the number is increasing.

All translations from the French are my own unless otherwise indicated.

References

Higbee, Will, 'Beyond the (trans) national: towards a cinema of transvergence in postcolonial and diasporic francophone cinema(s)', *Studies in French Cinema*, 7:2 (2007), pp. 79–91.

Khanna, Ranjana, *Algeria Cuts: Women and Representation, 1830 to the Present* (Stanford, CA: Stanford University Press, 2008).

Acknowledgements

Thank you for your help and support: Fatiha Arab and Khirredine Midjoubi at the Centre Culturel Algérien in Paris, Joanne Austin, Thomas Austin, Hal Branson and Side Cinema, Jan Clarke, Amanda Crawley Jackson, Máire Cross, Hugh Dauncey, Habiba Djahnine, Julia Dobson, Verena Domberg, Matthew Frost at MUP, Amor Hakkar and Sarah Films, Yacine Helali, Jim House, Ranjana Khanna, Joe McGonagle, Nick Morgan, Martin O'Shaughnessy, Kamal Salhi, Mani Sharpe, Audrey Small, Neelam Srivastava, Nina Sutherland and Sabrina Yu. Also to all the students who took my 2010 modules on Algerian cinema at Newcastle University, especially Josie McDonough for her insights on *Viva Laldjérie* and Matt Dowe, Ben Ryder and Jamie Bensohn for their analysis of *Rome plutôt que vous*.

This book is dedicated to my family.

1

An introduction to modern Algerian history and politics

Being Algerian has been described as 'the most complicated history of citizenship in the world' (Khanna 2008: 70). Algeria combines an ancient Berber culture with the historical influence of diverse invasions and colonial occupations (Carthaginian, Roman, Vandal, Arab, Byzantine, Egyptian, Spanish, Ottoman and French). For Pierre Bourdieu, the French sociologist who worked on Algeria throughout his career, this complex history plus the often dysfunctional relation between the state and the people makes what he calls the Algerian problem 'la limite extrême de tous les problèmes sociaux et politiques' [the extreme example of all social and political problems] (Bourdieu 1997: 21). Bourdieu identifies key issues in the recent history of Algeria as originating in the after-effects of colonialism and the war of liberation against the French (1954–62) – he calls the state's position on both these matters an attempt to repress the repressions that resulted – as well as in the confusions and inconsistencies of a language policy which sought to expunge French from everyday use amongst the subordinate classes but kept it alive among the elites (Bourdieu 1997: 22). The complex inter relation of Arabic and French informs the very name of the territory, since the French term l'Algérie was itself derived from the Arabic El Djezaïr meaning 'the islands'. The language question is just one of the repercussions of Algerian history that reverberate to this day. But the French colonial occupation of Algeria from 1830 onwards was far from the first, nor did Algerian history begin with the arrival of the French as some colonial discourse suggested. Previous attempts to control North African territories had been made by the Carthaginians (largely unsuccessful) and more successfully by the Romans, the Arabs and the Turks. Resistance was led by the indigenous Berber population, the oldest

community in Algeria. As Kateb Yacine puts it in his novel *Nedjma*, the tree of the nation is rooted in an ancient tribal grave (Yacine 1996:.200). Berber figures such as Jugurtha, a Numidian king who fought the Romans, were subsequently venerated in the nationalist discourse of modern independent Algeria. Even in the Arab-dominated, officially Muslim independent Algeria, the Berber pagan Jugurtha was invoked in the 1976 National Charter as representing the origin of the nation (Evans and Phillips 2007: 15). A Berber presence has been a constant in Algerian history throughout the waves of invasion and occupation. Berbers now make up between 20 and 30 per cent of the current population of 35 million, with their most long-standing communities concentrated in particular regions including in the east Kabylia and the Aurès mountains, and to the south the Mzab and the nomadic Tuaregs of the Sahara Desert (see Change 2009: 19). Modern Algeria is however officially an Islamic state and its national language is Arabic: both legacies of the Arab invasion that began in 647.

Sunni Islam is the official religion of Algeria, and Muslims account for 99 per cent of the current population (see Change 2009: 35). Official nationalist discourse hence tends to portray the Arabisation and Islamisation of Algeria as central to the country's history. Seen through this optic, the seventh-century defeat of the Berber resistance – led by the Jewish queen Dihaya Kahina – and the subsequent conversion of the Berber tribes to Islam 'came to symbolize the inevitable triumph of Islam' and 'the formation of an Arabo-Islamic identity' central to state discourse on nation formation (see Evans and Phillips 2007: 17). The adoption of Islam by the Berbers did not however unproblematically synthesise Arab and Berber identities, nor did Arab culture become strongly established in Algeria until the eleventh century. The earlier Arabisation of the Machrek (eastern North Africa) by invasion from the Middle East meant that pre-Arabic languages in that region disappeared very early. By contrast, the Maghreb (Morocco, Algeria, Tunisia) was only fully Arabised after the invasion of the Banu Hillal tribe in 1051; this saw the loss of Roman dialect, but the major pre-Arabic language, Berber and its variants, remained and have survived to the present day (see Niehoff 1997: 50). A resultant sense of rupture has been identified between the Arab majority in Algeria and Arab nations in the Middle East, whereby Algerian Arabs can feel cut off from the perceived centre of Arab-Islamic culture. Meanwhile the marginalisation of Berber languages and culture by the modern Algerian state remains a crucial issue, one reflected

in the struggle to develop a Berber cinema within Algeria (see Chapter 5).

If Algeria during the medieval period was ruled by powerful religious dynasties, such as Islamic Berbers, the Almoravids and the Almohads, in the sixteenth century it was taken over by the Ottoman Empire, an occupation that saw the era of the so-called Barbary Pirates, operating out of Algiers. As Marnia Lazreg has noted, 'Europeans referred to Algerian ship activity [. . .] as "piracy", thereby obscuring the fact that it was initially a response to the Spanish *reconquista* with its attendant expulsion of Muslims to North Africa [. . .] and attempts at seizing Algerian ports' (Lazreg 1994: 22). The country was administered as a regency, not from Constantinople but from Algiers, by the Turkish military elite headed by the *dey* or head of state. As a result, when the city ultimately surrendered to the French in 1830, the declaration was made not in Arabic or Berber, nor indeed in French – the language of the the future occupation – but in Turkish (see Djebar 2000: 228). Prior to the French invasion, Algiers had begun to suffer from impoverishment and depopulation. In fact, the diplomatic incident used as a partial justification for military action by France – the *dey* of Algiers striking the French consul-general with a fan in April 1827 – was an expression of frustration at France's reluctance to pay debts owed to the Regency. A French blockade of three years followed, and ultimately the expedition of 14 June 1830 in which 37,000 French troops landed at Sidi-Ferruch. By 5 July Algiers had been captured. An ulterior motive for this action was provided by French domestic politics. Ahead of the elections due for July 1830, the Bourbon monarchists wished to shift attention from internal conflicts while bolstering their own popularity via a military success. Charles X mobilised the rhetoric of religious conflict along with nationalism in his address to parliament on 2 March 1830, when he contrasted the Barbary power of Algiers with a France aided by the Almighty and championing the triumph of Christianity (see Vigier 1991: 16). When the French colonial presence in Algeria was itself questioned in the twentieth century by Sheikh Ben Badis, then attacked and ultimately defeated in the 1954–62 war, religion was again to play a key part in the construction of a nationalist cause – in this case, a Muslim Algerian cause (see below and Chapter 3).

The fall of Algiers did not achieve all that the French had wished for. News reached Paris too late to prevent the defeat of the Bourbon faction in the elections and the turmoil of the July Revolution.

Meanwhile, Algerian resistance remained. The coastal towns of Oran and Annaba were quickly occupied, but it took thirty years and hundreds of thousands of men before the territory of Algeria was 'pacified' by the French. The most successful resistance leader was Abd el-Kader, who inflicted defeats on the French during the 1830s and surrendered only in 1847. During this time not only did the size of the French military presence in Algeria increase (from 72,000 troops in 1841 to over 100,000 in 1846) but so did the brutality of their campaign. Led by Thomas Bugeaud, the army began to disrupt and control indigenous activites such as farming, following his order to 'empêcher les Arabes de semer, de récolter, de pâturer sans notre permission' [prevent the Arabs from sowing, harvesting, or feeding their animals without our permission] (cited in Michel 1991: 24). More infamously the French under Bugeaud also committed atrocities and massacres, notably by means of 'enfumades', when villagers were suffocated by smoke after being shut up in caves. Thanks to such tactics, by 1857 the conquest of Algeria was complete, although rebellions were to recur periodically.

As early as 1847, the French historian Alexis de Tocqueville observed how France had plunged Algeria into darkness: 'nous avons rendu la société musulmane beaucoup plus misérable, plus désordonnée, plus ignorante et plus barbare qu'elle n'était avant de nous connaître' [we have made Muslim society much more wretched, wild, ignorant and barbarous than it was before it encountered us] (cited in Michel 1991: 25). The imposition of French colonialism on Algeria has been described by Bourdieu as a shock of such magnitude that it ruptured 'not only the economic order but also the social, psychological, moral and ideological' (cited in Silverstein and Goodman 2009: 15). The reduction of Algerians to second-class citizens in their own country, the removal of Algerian land (often tribally rather than individually owned) from Algerian hands, the placing of political, legal and economic power in the hands of European settlers and the brutal 'pacification' of Algerian rebellions were all part and parcel of the colonial system. But beyond these material depradations the Algerians also suffered, according to Bourdieu, the loss of 'something that they could never recover: their cultural unity' (cited in Silverstein and Goodman 2009: 16). Moreover, as Lazreg comments, 'From now on, Algerians will be figments of the French imagination' (Lazreg 1994: 36). As we shall see in the course of this book, an attempt to wrest Algerian identity away from colonial constructions, as well as a

mythologising of lost national unity (and a critique of this nostalgic idea), is central to much Algerian cinema.

The French in Algeria were conscious of previous imperial structures notably those imposed by the Roman Empire. Indeed the French colonial project sought to emulate Rome's 'civilising' discourse by establishing one European empire on the ruins of another, with which the French shared a Latin identity. This ideology found physical manifestation in the building of a new French bridge on the ruins of a collapsed Roman one at El-Kantara near Constantine, or in 1838 building from scratch – on the site of an ancient Roman port – the town of Philippeville, 'the first entirely French town in Algeria' (Zarobell 2010: 117). A certain amount of the French colonial system in Algeria was also calqued upon inherited Ottoman structures: hence the use of 'compliant local leaders' in the roles of *caïds* (tax collectors), *cadis* (judges) and *bachagas* (tribal leaders) (Evans and Phillips 2007: 30) – figures often represented as collaborators in Algerian cinema, as in *Les Hors la loi* or *La Montagne de Baya* (see Chapters 3 and 5). But whereas Constantinople had left Algeria to be administered at arm's length, the ultimate phase of the French colonial project was to declare Algeria part of France itself: 'With the advent of the Third Republic (1871), northern Algeria was divided into three French departments – Algiers, Oran and Constantine – that were in principle governed by the same laws as metropolitan France. The Algerian Sahara remained under military jurisdiction' (Colonna 2009: 90, n.10). This legal change did nothing to prevent the so-called 'underdevelopment' of Algeria. Political power and material resources (notably the best agricultural land) were in the hands of European settlers known as *pieds-noirs* – predominantly French, but also Spanish and Maltese. The result was to drive the indigenous Algerian tribes further into remote or infertile areas (the mountains or the desert), where the hardships associated with a struggle for subsistence only increased. The land-grab was accelerated by official policy in the aftermath of unsuccessful Algerian revolts, when the state confiscated land held by the rebels: hence 450,000 hectares were removed from Algerian tribal ownership after the suppression of a rebellion led by Moqrani in 1871. A combination of official annexations and shady private deals meant that during a century of colonialism, from the 1830s to the 1930s, an estimated 7.7 million hectares, or 40 per cent of Algerian-held territory, was transferred to European hands (Droz 1991: 43).

Not all Algerians were conceived as the same in French colonial eyes. The so-called 'Kabyle myth' of the late 1800s suggested that the Berber communities based in Kabylia were more assimilable to French values than their Arab counterparts (see Chapter 5). It has been noted that the Kabyle myth 'was preceded by a successful "Jewish mytho-logy" that initiated policies based on the "fact" that Jews were less "barbaric" than Muslims' (Schreier 2006: 116). The requirement for Muslims in Algeria to renounce their religion in order to gain French citizenship was not applied in the same way to Jews, since 'By the 1840s, Jews were submitted to a separate leglisation from Muslims, and in October 1870 the government naturalized Algerian Jews en masse' (Schreier 2006: 101). This was the famous *décret Crémieux* which, despite officially granting the thirty thousand or so Algerian Jews French citizenship, did not prevent them from being targeted by an anti-semitism described as one of the essential characteristics of the colonial mentality during the Third Republic (see Ageron 1991: 56). Particularly around the turn of the century, several anti-Jewish leagues were established in cities such as Algiers and Constantine, contesting the *décret Crémieux* – which was ultimately abolished by the Vichy government as soon as it came to power in 1940. It is not-able however that, despite incitement from the colonisers' anti-Jewish lobby, Muslim Algerians tended not to target their Jewish neighbours, who for all their religions differences shared the same language, neigh-bourhoods and even names (see Ageron 1991: 56). Racial tensions did however emerge briefly in 1943 in Constantine, and more regularly during the struggle for independence which, as we shall see, was formulated above all as a Muslim cause. Indicative of Algeria's long-standing ethnic, religious and cultural diversity, the Jewish community remained much less visible than Arabic or Berber communities in Algerian culture and cinema after independence.

The colonial division of Algerian territory – whether originally in Arab, Berber or Jewish hands – can be characterised as threefold: firstly, *quadrillage*, that is to say the military 'occupation and control of the entire geographical space'; secondly, the forced dispossession of fertile Algerian land, and the development of a certain modern infrastructure, both to the benefit of the *pieds-noirs*; and thirdly, the concomitant massive disparity between the northern cities and the *bled* or rural interior, between 'the advanced urban and European-dominated societies' established around Algiers, Oran and Constantine, and the 'underdeveloped interior in which 70 per cent of Algerians

lived in abject poverty as peasants and nomads' (MacMaster 2009: 9, 10). The resultant pauperisation of the Algerian population was exacerbated by famines, epidemics, a rural exodus, massive unemployment – all of which are referenced in the epic film *Chronique des années de braise* (see Chapter 2) – and at the same time by a surge in demographic growth in the twentieth century, which saw the non-European population almost double in two generations from 4.5 million in 1914 to 8.5 million in 1954 (Droz 1991: 43). This period of demographic growth in the 1920s, 1930s and 1940s also saw a crystallisation of Algerian nationalism around several factions and charismatic leaders, notably Sheikh Ben Badis and Messali Hadj. The former is renowned for his 1936 *déclaration nette* in which he asserted that Algeria would never assimilate into the French nation:

> cette nation algérienne musulmane n'est pas la France; il n'est pas possible qu'elle soit la France. [. . .] c'est une nation totalement éloignée de la France, par sa langue, par ses moeurs, par ses origines ethniques, par sa religion [this Muslim Algerian nation is not France; it is not possible that it ever be France. It is a nation entirely removed from France, by its language, its customs, its ethnic origins and its religion]. (cited in Ageron 1991: 89)

Islam was central to this vision of nationalism. Ben Badis had set up the AOMA (Association des oulémas musulmans algériens) in 1931, aimed at politicising Algerian opinion through a system of reformed Islamic schools, sports clubs and cultural activities. His anti-colonialist, Arabo-Islamic credo was succinctly expressed in the slogan 'L'Islam est ma religion. L'Arabe est ma langue. L'Algérie est mon pays' [Islam is my religion. Arabic is my language. Algeria is my country] (see Ageron 1991: 90). As incorporated into the post-1962 Algerian state, this credo was to be used to exclude non-Arab identities, principally Berbers, from official definitions of nationalism. Contemporaneous with the AOMA of Ben Badis were the two organisations established by Messali Hadj, first the communist-derived L'Etoile nord-africaine, then, after the latter was shut down by the French in 1929, the PPA (Parti du peuple algérien). Hadj too used powerful nationalist rhetoric, declaring that 'l'Algérie ne fut jamais française, elle n'est pas française, elle ne sera jamais française' [Algeria is not French, never was French, never will be French] (see Ageron 1991: 91). The green and white flag of L'Etoile nord-africaine was eventually adopted as the Algerian national flag. But Hadj was denied a place in the negotiation of a

post-independence Algerian state, principally because during the war against the French he rejected the dominant revolutionary force, the FLN (Front de libération nationale), and established a rival organisation, the MNA (Mouvement national algérien). From 1957 onwards it was the FLN rather than the MNA which gained supremacy in the Algerian revolution.

The Algerian war or Algerian revolution began with an insurrection in the Aurès mountains in the east of the country on 1 November 1954. The struggle was fuelled by versions of nationalism often derived from Hadj or Ben Badis, memories of the French massacres of civilians at Sétif in 1945 (described by the PPA as 'genocide') and also the increasingly brutal French reprisals against rebel activity – from the killing of over a thousand Algerians after the death of 71 Europeans in August 1955 to the infamous torture techniques such as *la gégène* (electric shocks). Despite the focus on urban conflict (and on the French use of torture) in the most well-known representation of the war, *La Bataille d'Alger* (see Chapter 3), the revolution was in fact 'predominantly a peasant-based phenomenon'; French control was strongest in the urban centres and weakest in the underdeveloped *bled* where over half of the country's 8.7 million Muslims lived (MacMaster 2009: 28–9). Europeans made up only 0.3 million of Algeria's 9 million population, and were heavily dependent on military, administrative and material investment from mainland France, combined with a political and legal system that denied representation and rights to the Muslim majority. This disparity extended to education, so that 'On the eve of the war in 1954, while virtually all European childen aged six to fourteen years received primary schooling, this was true for only one in five Algerian boys, and one in sixteen girls' (MacMaster 2009: 29). One of the major achievements of the post-independence regime, although not one translated into employment figures, was a massive increase in the education of Algeria's children, especially girls: between 1954 and 1987 the education of Algerian girls aged six to fourteen had risen from below 10 per cent to 71.5 per cent (MacMaster 2009: 370). The importance of the rural peasantry in supporting the revolution had certain negative consequences. According to Assia Djebar, the FLN purges led by Colonel Amirouche during 1958–59 targeted young, urban, French-speaking volunteers such as students, leaving up to three thousand activists dead: 'The hunt is on: death to the students who have joined up in massive numbers, to the intellectuals coming from the cities to fuse their revolutionary spirit with that of

the "peasant masses"' (Djebar 2001: 198). Other key internal schisms divided the FLN leadership from the MNA (which was even on occasion funded by the French) and to some degree from the ALN (the Armée de libération nationale), the military wing of the FLN itself. Internal purges and factional conflicts between the revolutionary groups, in which the FLN and its so-called 'army of the frontiers' based in Tunisia and Morocco ultimately came out on top, set a pattern of clandestine power stuggles, internal repression and civil war, which would resurface in Algeria in the aftermath of independence in 1962, in the ongoing secrecy and repression exercised by the politico-military elite and in the 'black decade' of the 1990s (see Chapter 7). As Djebar and others have noted, in the post-1962 one-party state, the FLN exploited the memory of the liberation struggle while denying to the masses the hoped-for liberation from anything other than French rule (for example, in the form of democratic representation, women's rights, or a share in the country's energy wealth):

> In their speeches they were to invoke the dead on every occasion – by dint of repeating 'a million dead,' they paid attention only to quantity, they, the survivors, in the pink of health, becoming more and more at ease year by year, gaining weight, complacency, space, nourishing their bank accounts. (Djebar 2001: 127)

For Bourdieu, the suffering in the war against the French simply reified or made visible the violence at the heart of the colonial system: 'La guerre fait éclater en pleine lumière le fondement réel de l'ordre colonial, à savoir le rapport de force par lequel la caste dominante tient en tutelle la caste dominée' [The war brings to light the real foundation of the colonial order, namely the balance of power according to which the dominant class hold dominion over the dominated class] (Bourdieu 1961: 22). Against a modern French army of over four hundred thousand, including two hundred thousand Algerian soldiers (*harkis* and others) fighting with the French, the ALN numbered only fifty thousand fighters. In addition to deaths, torture and atrocities such as rape, the indigenous Algerian population suffered from the French policies of *regroupement* and *déracinement* which during the war saw three million people leaving their home villages – as the protagonist leaves her family home in the 1967 film *Le Vent des Aurès* (see Chapter 3). Forced by the French into internment camps, or fleeing to slums on the edge of the northern cities, Algerians were systematically cut off from their family networks and their larger clan

or tribal connections. By the end of 1960, 24 per cent of the Algerian population were in French camps or 'new villages' (see MacMaster 2009: 242, n.80). Moreover, three hundred thousand refugees were to be found in camps on the Tunisian and Moroccan borders (see Fanon 2001: 224). None the less it should be remembered that thousands of Algerians suffered purges from within the revolutionary movement itself, while French soldiers and European civilians were the target of atrocities. Most notorious was the fate of the *harkis*, Algerian soldiers fighting for the French who were left behind when the latter withdrew in 1962. It is estimated that upwards of ten thousand *harkis* – and perhaps as many as 150,000 – were massacred in postwar purges (see Pervillé 1991: 123). For the war overall, and not counting the *harkis*, French losses are estimated at 25,000 troops plus nearly three thousand civilians. Algerian casualties are much harder to quantify, with the FLN citing the memorable, mythologised figure of a million dead, while official French figures suggest only a tenth of that; an investigation by a team of historians in the 1990s posited the true death toll of Algerians (again, excluding the *harkis*) as between three and four hundred thousand (see Anon. 1991).

The three-year tenure of Ahmed Ben Bella, independent Algeria's first president, has been characterised as 'Social crisis, political opposition, military defeat' – the latter at the hands of Morocco in a border dispute (see Evans and Phillips 2007: 79). In June 1965 a military coup saw Colonel Houari Boumediene (former leader of the army of the frontiers) topple Ben Bella. Under Boumediene, the influence of the military on the Algerian state only increased: 'A partner in 1962, the army was now the arbiter of Algerian politics' (Evans and Phillips 2007: 80). To independent Algeria's socialism was added a plethora of Arabisation policies, the growing influence of hardline Islamic opinion and, after Boumediene's death in 1978, an accommodation with free-market economics. Boumediene's Soviet-inspired socialism can be seen in the Agrarian Revolution of the early 1970s, which attempted to reverse some of the French colonial land-grab by means of 'a redistribution of cultivable lands confiscated from French landowners [. . .] followed by a series of measures designed to put in place a collectivist use of the land [. . .] in the form of state farms' (Colonna 2009: n.6, 90). It has been claimed that the theoretical foundation for these reforms was also derived in large part from Bourdieu's concepts of the 'de-peasanted peasant', that is to say of Algerian peasantry as dispossessed and alienated by colonialism (see Goodman and

Silverstein 2009: 20). Bourdieu's conceptualising of Algerians as 'forcibly removed from their "enchanted" universe, literally uprooted from their villages' by the shock of colonialism has been construed as unfortunately mirroring and possibly fuelling 'Algeria's post-independence agrarian development politics, which have been based on a related split between a precolonial idyll and a postcolonial peasantry imagined only in terms of loss – broken, backward, and marginal to the Algerian nation, with nothing to offer of its own' (Goodman 2009: 116, 117). Certainly colonial occupation by the French was a major factor in fragmenting Algerian identity, notably through the imposition of the French language as well as the witholding of civil rights and the redistribution of fertile land from Algerians to European settlers – thus in effect literalising this 'uprootedness' (*déracinement*) and forcing peasants to uproot and move to the *bidonvilles* or shanty-towns on the edge of the cities. With the Agrarian Revolution proving unsuccessful, the FLN also attempted to overcome these historical disjunctures by promulgating classical Arabic and by rejecting French – or appearing to reject it.

Outlined in the Tripoli Charter of 1962, Arabisation (*at-Taârib*) was required of Algerian schools from 1965, and led to Arabic signposting in 1976. However, the elites in post-1962 Algeria continued to use French, while condemning the mass of the population to Arabisation policies which often resulted in disenfranchisement, since the classical Arabic demanded was not the language of the Arab street (that was a vernacular Algerian Arabic), and still less the language of the Berber communities (see Chapter 5). Despite its symbolic capital in the newly independent nation, Arabic was largely sidestepped by the political and military elites, such that in the neo-colonial Algeria a schism rapidly opened between 'une culture francophone de bien être social et une culture de misère arabo-berbère' [a French-speaking culture of social well-being and an Arabo-Berber culture of poverty] (Moatassime 1997: 66). This impression was only increased when the law of July 1988 forbade Algerians to attend French-language schools; as a consequence, the moneyed Algerian elite began educating their children in France, Belgium and Switzerland, exacerbating the gulf between the Arab-speaking mass population and a French-speaking elite educated in Europe (see Mengedoht 1997: 86–7, n.49). From 1962 to 1988 – a watershed year in Algerian politics, as we shall see – the key means by which the state sought to paper over the gulf between the elite and the disenfranchised majority was to mobilise

memories of the war against the French. Even before Algerian inde-
pendence, Frantz Fanon had warned of the rewriting of history as
myth by the leaders of ex-colonies: 'The leader pacifies the people
[. . .]; we see him reassessing the history of independence and recalling
the sacred unity of the struggle for liberation' (Fanon 2001: 135).
Fanon continues: 'The leader, seen objectively, brings the people to a
halt and either persists in expelling them from history or preventing
them from taking root in it' (Fanon 2001: 136). Fanon's prescience
even extends to predicting the corruption and self-interest that will
accompany the success of the anti-colonial party (in Algeria's case,
the FLN regime): 'The party, which during the battle had drawn to
itself the whole nation, is falling to pieces. [. . .] The party is becoming
a means of private advancement' (Fanon 2001: 137–8). More recently,
an equally trenchant critique of postcolonial Algeria has been
launched by Ranjana Khanna: 'Algeria set itself up as the avant-garde
third world nation that had effectively rid itself of the imperialist
machine and was working on an Islamist socialist model', suggesting
that it would 'value the work done by men and women alike during
the war of independence' (Khanna 2008: xiii). In effect, argues
Khanna, Algeria betrayed these ideals and became a neo-colonial state.
Neo-colonialism is defined by Shohat and Stam as 'a regeneration
of colonialism through other means', a state where 'geo-economic
hegemony' repeats the power structures of colonial rule (Shohat and
Stam 1994: 40). In Algeria this meant a one-party state that concen-
trated power in the hands of a shadowy but massively influential
politico-military elite while – despite advances in education, as men-
tioned above – the rights of minoritarian groups (principally women
and Berbers) were repressed and the vast majority of the population
remained in poverty and unemployment.

The officially secular and socialist nature of the nation-state estab-
lished after 1962 should not obscure the significance of religion in
Algeria. One critique of Bourdieu's massively influential work on
Algerian society is his tendency to neglect the importance of Islam.
To give one example, his account of Berber culture in Kabylia as
predominantly oral rather than written is partly based on an elision
of the role of Qur'anic schools and texts in Berber communities (see
Goodman 2009). For the first century or so of French occupation,
Algerian religious authority had been largely held by the marabouts
(saints) who embodied ancient religious folk practices and by the pro-
ponents of mystical Sufism – glimpsed in the Berber folk narrative of

La Montagne de Baya (see Chapter 5). This form of popular Islam has even been described as enabling 'men and women to live their lives as if they were not colonized', since it allowed Algerians – of both genders – to 'give meaning to their daily existence and establish a sense of continuity with the precolonial past' (Lazreg 1994: 85). By the 1920s, 'both *marabouts* and official *imams* [had] declined in popular legitimacy' since in nationalist eyes they were insufficiently opposed to the French; the stage was set for Islamic reform, led by Sheikh Ben Badis (MacMaster 2009: 42). Ben Badis's famous declaration of 1936 welded together Islam, nationalism and the Arabic language in an anti-colonial vision of Algerian identity. By emphasising the importance of Arabic, this construction of national identity already tended to exclude Berber communities and thus foreshadowed their repression by the nation-state after independence. What is more, Ben Badis attacked popular Sufism in favour of a reformist Islam which restricted the participation of women (see Lazreg 1994: 82). After independence, official policy and discourse continued to equate Islam, Arabic and nationalism. During Boumediene's presidency (1965-78) there was a gradual shift from secular socialism to increasingly pro-Islamic policies: sales of alcohol to Muslims were forbidden, mosque building increased and in 1976 Friday was enshrined as the day of prayer. Under Boumediene the state's ambiguous position, balancing an ostensibly secular socialism with a religious nationalism based on Islamic values and a largely unavowed deference to *sharia* law, was euphemisitically termed 'specific socialism' (see Hadj-Moussa 2009: 119). The construction of mosques and Qur'anic schools further increased under Chadli Benjedid in the 1980s, and in 1984 the patriarchal Family Code was passed, influenced by concepts from the *sharia* (see Chapter 4 for a powerful critique of the code in the film *La Citadelle*). The code remains in place, having been amended but not abrogated by President Bouteflika in February 2005 (see Khanna 2008: xiii).

The 1980s saw a repositioning of Algeria away from socialism (even of a 'specific' kind) after Boumediene's death, and is generally viewed as a period of increasing corruption and the alienation of the youth population, in contrast with the more nostalgically remembered Boumediene era. The disjuncture between the Algerian people and the state reached a nadir in Black October of 1988, 'the autumn of the six hundred dead' (Djebar 2000: 140). For the first time in the history of the independent Algeria the violence of the regime became undeniably explicit as the army fired on the people, with hundreds

of protestors killed and many survivors tortured in incarceration. As Ratiba Hadj-Moussa notes, the protests and strikes of autumn 1988 were in part a consequence of liberal economic policies which saw the country's growing energy wealth kept in private hands: 'the International Monetary Fund (IMF) and the World Bank dictated a regime of progressive liberalization [. . .]. The contradictions of this liberalization translated into the events of October 1988' (Hadj-Moussa 2009: 120). The mythologising of the Algerian revolution in FLN ideology, with its parade of martyrs, was in effect destroyed by the state's own creation of hundreds of young martyrs in Black October:

> La jeunesse algérienne [. . .] neutralise, en octobre 1988, par equivalence, le signe fondateur et légitimant du pouvoir nationaliste, 'le sang des martyrs', sa rente symbolique, en versant son propre sang, en subissant la torture et les prisons [In October 1988 Algerian youth neutralised or cancelled out the founding, legitimising sign of nationalist power, its symbolic payment, namely 'the blood of the martyrs', by paying its own blood, by suffering torture and imprisonment]. (Mediene 1992: 72)

In the aftermath of the unrest President Chadli Benjedid offered limited reforms: the constitution of 1989 officially ended the one-party state and gave increased freedom to the media. As regards television, for example, 'Political programs of a new type were aired, in which political opponents were invited to express their views', as 'the national channel echoed the debates among Algerians on taboo subjects, such as corruption' (Hadj-Moussa 2009: 121). But this situation was short-lived. Only three years later the electoral process was shut down, a state of emergency declared, and propaganda, censorship and counter-terror became common practice as the state confronted a rise in Islamic fundamentalism. The catalyst for this reassertion of autocracy was the popularity of the FIS (Front islamique du salut), a party which channelled much of the post-1988 dissent of Algeria's disempowered youth, winning 188 out of 231 seats in the first round of elections in late 1991. By foreclosing the electoral option and criminalising the FIS, the FLN and the army (the latter ensuring Chadli was soon removed) simply drove the movement underground. A sense of generational betrayal also fed the rise of fundamentalist terror. The independent Algerian state had disempowered its massive, overwhelmingly young population while parading a legitimacy based not on democratic representation but on the glorification of the 'martyrs'

who died fighting the French (amongst whom were many covertly killed by the FLN in internecine struggles during and after the war). The state's long and bloody history of oppression and torture of its own people (which, as Djebar explains, began as early as the FLN purges of 1958) fuelled the resentment of Black October and of the black decade that followed. Hence Djebar, writing in the 1990s, found it 'Hardly surprising that the revolt and anger [. . .] of today's "madmen of God" should be directed first and foremost against the cemeteries, against the tombs of the *chahids* [martrys], yesterday's sacrificial victims' (Djebar 2000: 127). A major factor in the rise of the FIS was also clearly the failure of the neo-colonial Algerian state to provide secure, bearable and pluralistic forms of national identity, given the one-party system (at least until 1989 and, in practice, beyond), the suppression of dissent, the massive inequalities, corruption, unemployment and poverty, the refusal of democratisation, the control of power by a politico-military elite, the disenfranchisement of the majority, the inept Arabisation policies used as a means of legitimising the state once the celebration of the liberation struggle had worn thin, and so on. In *Algerian White*, her lament for dead Algerian writers, Djebar cites Jean Genet's assertion about the failings of a memorialising history based on denial: 'A people that is remembered only by periods of glory [. . .] will always be in doubt about itself, reduced to being an empty vessel. The crimes of which it is ashamed are what make its true history' (see Djebar 2000: 83). As Djebar's narrative reveals, the 'empty vessel' of Algerian history after 1962, hollowed out by FLN rhetoric and state terror, was to be filled with the 'black blood' of fundamentalist terror in the 1990s (see Djebar 2000: 39).

The conflict of the 1990s between the state and Islamist terrorist groups such as the GIA (Groupe islamique armé) resulted not just in up to two hundred thousand deaths but also in the internal displacement of a similar number of Algerians and the emigration of up to 450,000 more (see Change 2009: 20). Assassinations, massacres, rapes and counter-terror atrocities spiralled. In June 1992 the reformist president Mohammed Boudiaf was assassinated after only five months in power, possibly with the collusion of the army. In May of the following year two hundred assassinations took place. Among those targeted by the GIA were reformist writers and journalists, including activists for women's rights and for Berber issues. The many victims in the cultural field included the poet Tahar Djaout, killed in 1993, and the singer Cheb Hasni, killed in 1994. By the end of the 1990s,

the bloodshed was finally ebbing and state troops largely in control. When Algeria's current president, Abdelaziz Bouteflika, was elected in 1999 (with the support of the army) he immediately insitituted the Civil Concord, an amnesty for the crimes committed during the black decade (but which still sought to prosecute those involved in massacres, rapes and bomb attacks). As Khanna observes, 'Bouteflika has created a semblance, therefore, of confrontation of violence, but in fact he has simply agreed to forget – performing thereby the amnesia that informs all amnesty laws' (Khanna 2008: 248, n.7). This organised forgetting recalls in some ways the memorialising of the liberation struggle during the 1960s and 1970s (the better to forget those excluded elements such as the MNA, women, Berbers), and it continued in 2005 with the Charter for Peace and Reconciliation. Although by the year 2000 the state had reasserted its power over regions such as the Mitidja plain and the so-called 'triangle of death' south of Algiers, previously controlled by the GIA, unrest continued especially in Kabylia where riots erupted in 2001. For Evans and Phillips, the Algerian state was again 'tottering on the edge of chaos' and 'isolated on the international scene' after its brutal suppression of the 2001 Kabyle protests, but was 'saved' by '9/11' and the subsequent repositioning of Algeria as a friend of the West in the 'war on terror' (see Evans and Phillips 2007: 277). This in turn has strengthened Bouteflika's position in power: he has been elected for a third term.

Questions remain, however, about the legitimacy of his regime. In November 2008, after the constitution was rewritten to permit presidency for life, the newspaper *El Watan* declared 'Algeria is jumping backwards . . . even as society has evolved considerably, having, in just one half-century, confronted three huge tests, those of the colonial yoke, the single party and terrorism' (cited in Anon. 2008: 11). To these concerns one might add the continuing use of torture for terror suspects, and the repression of press freedoms. As a UK government report drily noted in 2009, 'There is no direct censorship, but there are laws in place that can result in imprisonment for insulting or defaming the president, MPs, judges and the army' (Change 2009: 46). The state of emergency established in 1992 – and under which public demonstrations are banned – was still in place at the end of 2010. However, January and February 2011 saw demonstrations against the regime, encouraged by the apparent success of the 'jasmine revolution' in Tunisia and the toppling of Mubarak in Egypt. The reaction of the Algerian state to the so-called Arab Spring was initially

authoritarian and uncompromising, echoing the repression of previous unrest in the years since Black October 1988. A major demonstration set for 12 February was banned by the authorities, and press reports suggested that on the day as many as 28,000 security forces were deployed in Algiers to limit the protests. The resultant clashes saw hundreds of arrests. But in tandem with massive police activity, Bouteflika drew the sting of the embryonic protest movement by lifting, on 24 February 2011, the state of emergency. Nonetheless doubts remain as to the democratic significance of this move. Although welcomed by many politicians in the West, on the ground in Algeria it was felt to be a cynical measure to maintain power and to ensure the continuing privatisation – rather than democratisation – of the state. A cartoon in *El Watan* suggested that such a gesture was like Bouteflika casually throwing a bone to protestors who had wanted an entirely new political system. The relationship between the state and the people is still being contested. It is in this volatile context, and with this troubled history, that film-making continues to take place in Algeria.

References

Anon., 'Guerre d'Algérie, combien de morts?', *L'Histoire*, 140, special issue: 'Le temps de l'Algérie française' (January 1991), p. 107.

Anon., 'Algerian constitution', *The Independent*, 14 November 2008, p. 11.

Ageron, Charles-Robert, 'Français, Juifs et Musulmans: l'union impossible', *L'Histoire*, 140, special issue: 'Le temps de l'Algérie française' (January 1991), pp. 52–8.

Ageron, Charles-Robert, 'Naissance d'une nation', *L'Histoire*, 140, special issue: 'Le temps de l'Algérie française' (January 1991), pp. 86–94.

Bourdieu, Pierre, 'Révolution dans la révolution' (1961), in Bourdieu, *Interventions, 1961–2001: Science sociale & action politique* (Paris: Agone, 2002), pp. 21–8.

Bourdieu, Pierre, 'Dévoiler et divulguer le refoulé', in Joseph Jurt (ed.), *Algérie – France – Islam* (Paris: L'Harmattan, 1997), pp. 21–7.

Change Institute, *The Algerian Muslim Community in England* (London: Department for Communities and Local Government, April 2009).

Colonna, Fanny, 'The phantom of dispossession: from *The Uprooting* to *The Weight of the World*', in Jane E. Goodman and Paul A. Silverstein (eds), *Bourdieu in Algeria: Colonial Politics, Ethnographic Practices, Theoretical Developments* (Lincoln, NE, and London: University of Nebraska Press, 2009), pp. 63–93.

Djebar, Assia, *Algerian White* (translated by David Kelley and Marjolijn de Jager) (New York and London: Seven Stories, 2000).

Djebar, Assia, *So Vast the Prison* (translated by Betsy Wing) (New York and London: Seven Stories Press, 2001).

Droz, Bernard, 'Main basse sur les terres', *L'Histoire*, 140, special issue: 'Le temps de l'Algérie française' (January 1991), pp. 34–44.

Evans, Martin and John Phillips, *Algeria: Anger of the Dispossessed* (New Haven and London: Yale University Press, 2007).

Fanon, Frantz, *The Wretched of the Earth* (translated by Constance Farrington) (London: Penguin Classics, 2001).

Goodman, Jane E., 'The proverbial Bourdieu: *habitus* and the politics of representation in the ethnography of Kabylia', in Jane E. Goodman and Paul A. Silverstein (eds), *Bourdieu in Algeria: Colonial Politics, Ethnographic Practices, Theoretical Developments* (Lincoln, NE, and London: University of Nebraska Press, 2009), pp. 94–132.

Goodman, Jane E. and Silverstein, Paul A. (eds), *Bourdieu in Algeria: Colonial Politics, Ethnographic Practices, Theoretical Developments* (Lincoln, NE: University of Nebraska Press, 2009).

Hadj-Moussa, Ratiba, 'The undecidable and the irreversible: satellite television in the Algerian public arena', in Chris Berry, Soyoung Kim and Lynn Spigel (eds), *Electronic Elsewheres: Media, Technology, and the Experience of Social Space* (Minneapolis: University of Minnesota Press, 2009), pp. 117–36.

Hottinger, Arnold, 'Le pouvoir de l'armée algérienne. Passé, présent et futur', in Joseph Jurt (ed.), *Algérie – France – Islam* (Paris: L'Harmattan, 1997), pp. 205–12.

Khanna, Ranjana, *Algeria Cuts: Women and Representation, 1830 to the Present* (Stanford, CA: Stanford University Press, 2008).

Lazreg, Marnia, *The Eloquence of Silence: Algerian Women in Question* (New York and London: Routledge, 1994).

MacMaster, Neil, *Burning the Veil: The Algerian War and the 'Emancipation' of Muslim Women, 1954–62* (Manchester: Manchester University Press, 2009).

Mediene, Benamar, 'Un etat déconnecté', in *Le Nouvel Observateur*, Collection Dossiers, 9: 'La Guerre d'Algérie trente ans après' (1992), pp. 72–3.

Mengedoht, Ulrike, 'La politique d'arabisation de l'Algérie et ses conséquences sur l'islamisme', in Joseph Jurt (ed.), *Algérie – France – Islam* (Paris: L'Harmattan, 1997), pp. 77–93.

Michel, Marc, 'Une guerre interminable', *L'Histoire*, 140, special issue on 'Le temps de l'Algérie française' (January 1991), pp. 20–5.

Moatassime, Ahmed, 'Islam, arabisation et francophonie. Une interface possible à l'interrogation "Algérie – France – Islam?"', in Joseph Jurt (ed.), *Algérie – France – Islam* (Paris: L'Harmattan, 1997), pp. 55–75.

Niehoff, Johannes, 'Identité arabe et acculturation française: l'Algérie entre colonialisme et indépendance', in Joseph Jurt (ed.), *Algérie – France – Islam* (Paris: L'Harmattan, 1997), pp. 47–53.

Pervillé, Guy, 'La tragédie des harkis', *L'Histoire*, 140, special issue: 'Le temps de l'Algérie française' (January 1991), pp. 120–3.

Schreier, Joshua, ' "They swore upon the tombs never to make peace with us": Algerian Jews and French colonialism, 1845–1848', in Patricia Lorcini (ed.), *Algeria and France 1800–2000: Identity, Memory, Nostalgia* (Syracuse, NY: Syracuse University Press, 2006), pp. 101–16.

Shohat, Ella and Robert Stam, *Unthinking Eurocentrism: Multiculturalism and the Media* (New York and London: Routledge, 1994).

Silverstein, Paul A. and Jane E. Goodman, 'Introduction: Bourdieu in Algeria', in Jane E. Goodman and Paul A. Silverstein (eds), *Bourdieu in Algeria: Colonial Politics, Ethnographic Practices, Theoretical Developments* (Lincoln, NE, and London: University of Nebraska Press, 2009), pp. 1–62.

Vigier, Philippe, 'Qu'allons-nous faire à Sidi-Ferruch?', *L'Histoire*, 140, special issue: 'Le temps de l'Algérie française' (January 1991), pp. 12–18.

Yacine, Kateb, *Nedjma* (Paris: Editions du Seuil/Points, 1996).

Zarobell, John, *Empire of Landscape: Space and Ideology in French Colonial Algeria* (University Park, PA: Pennsylvania State University Press, 2010).

2

A brief history of Algerian cinema

It has become a commonplace that 'Algerian cinema was born out of the war of independence and served that war' (Salmane 1976: 5). Film in Algeria also preserved the memory of that war, legitimising the FLN regime after independence by mythologising the liberation struggle. State-controlled culture played an important role in the formation of a national imaginary after 1962, thus fulfilling Fanon's prediction that the leaders of former colonies would use the memory of resistance to put the people to sleep (see Fanon 1991: 210). Cinema, in particular the *cinéma moudjahid* or 'freedom-fighter cinema' of the 1960s and 1970s, was central to post-independence cultural policy. The term *post-independence* 'evokes an achieved history of resistance' but also allows 'questioning of that history, opening up analytical space for such explosive "internal" issues as religion, gender, and sexual orientation' (Shohat and Stam 1994: 40). By moving beyond the diktats of the FLN and the officially sanctioned memorialising of resistance in *cinéma moudjahid*, this is what Algerian cinema has achieved over the five decades since independence. In short, it not only celebrates the new nation-state but also interrogates the discontents of the new Algeria.

At the moment of independence in 1962, Algeria boasted 424 cinema screens for a population of 15 million: three times the provision of its neighbours Morocco and Tunisia put together (see Anon. 2003: 82). Film was all the more important as a means of engaging the population since it was a non-print medium. If Benedict Anderson asserts that print capitalism was crucial in the formation of Western 'imagined communities', then in Algeria, as Khanna has noted, the high illiteracy rates at independence (80–90 per cent in 1962) and the diverse languages spoken meant that cinema was central to the

formation of a homogenous national identity (see Khanna 2008: 107). During the war, cinema – along with radio broadcasts – had been recognised by the French authorities as a key means of communicating colonial propaganda to the largely illiterate Algerian population. Mobile screenings of films and newsreels were organised in the rural hinterland, while cinema exhibition was subject to censorship, including a ban on Egyptian films from 1958 (see MacMaster 2009: 160). Meanwhile, the dissident French film-maker René Vautier worked with the independence movement, helping to train film-makers from the FLN. Vautier himself made the short films *Une nation, l'Algérie* (1955) and *L'Algérie en flammes* (1957). The latter, shot at Fanon's suggestion, was edited by Vautier in East Berlin (see Spaas 2000: 134). This early example of the Eastern Bloc's involvement in independent Algerian cinema was followed by significant influence on the work of Mohamed Lakhdar Hamina. In 1961 the Algerian provisional government or GPRA established a cinema service which produced, in the space of a year, several shorts including the early films of the future Palme d'or-winning director Lakhdar Hamina. From 1963 until 1974 the newsreel office known as the OAA (Office des actualités algériennes) was directed by Lakhdar Hamina, who went on to head the powerful ONCIC (Office national pour le commerce et l'industrie cinématographiques) in the early 1980s. The imbrications between this type of official state-sanctioned role and the activity of film-making in Algeria indicate how the system worked after the film industry was nationalised in August 1964. This might also explain how Lakhdar Hamina's epic *Chronique des années de braise* (1974, see below) secured its vast funding while certain directors (for example Abderrahmane Bouguermouh with his project to adapt the Berber novel *La Colline oubliée*) had to wait years and even decades for a scenario to be approved or to receive any form of technical assistance from the industry. Meanwhile the ONCIC maintained a monopoly on film distribution from the mid-1960s to the late 1980s, a situation that resulted in the Hollywood boycott of Algerian screens between 1967 and 1973. ONCIC productions in the 1960s and 1970s included *Le Vent des Aurès*, *Les Hors la loi*, *Chronique des années de braise*, *Omar Gatlato* and William Klein's documentary on the inaugural Panafrican Festival of 1969. The organisation also co-produced French films such as *Z* (Costa-Gavras, 1968) and *Elise ou la vraie vie* (Drach, 1970). By the mid-1970s, however, the only Algerian films to have covered their costs were Gillo Pontecorovo's 1965 classic *La Bataille d'Alger* and Lakhdar

Hamina's 1968 comedy *Hassan Terro* (see Salmane 1976b: 22), both of which focused on the revolutionary stuggle, albeit from divergent perspectives.

The representation of the war was partial. While the Egyptian director Youssef Chahine made *Jamila the Algerian* (*Jamila al Jazairiyya,* 1958), the role of female fighters (the *moudjhidat*) was often neglected in Algerian cinema. Jamila Bouhired, for instance, the subject of Chahine's film, was not celebrated in Algerian cinema, although her example was used in FLN propaganda during the war (see MacMaster 2009: 319). The first and most well-known Algerian feature film on the conflict, *La Bataille d'Alger*, while including a famous sequence where three Algerian women plant bombs in the French quarter of Algiers, presents the women as 'heroic, but only in so far as they perform their service for the "nation"' (Shohat and Stam 1994: 255). As many have observed, the women in *La Bataille d'Alger* are practically silent. Their voices are barely heard. Nonetheless, and despite a recent critique of gender representation in the film (Khanna 2008), *La Bataille d'Alger* has been received as a pioneering anti-colonial statement and the epitome of militant 'third cinema'. It has been claimed that third cinema, in contrast with colonial and Western cinema, achieves an all-encompassing liberation: 'the viewer or subject is no longer alienated because recognition is vested not only in genuine cultural grounds but also in an ideologicial cognition founded on the acknowledgement of the decolonisation of culture and total liberation' (Gabriel 1989: 37). But *La Bataille d'Alger* does not reflect 'total liberation', although it does conclude with a celebration of Algerian independence (gendered as feminine in the form of a flag-waving female protestor). In fact, the cloud of light that rises from the casbah after the deaths of its FLN protagonists seems to herald the mythologising of the struggle in official Algerian culture and the glow of martyrdom that Assia Djebar has called 'The tribute in warm bodies to the new Algeria' which then begins 'to gleam in that sunlight: the *chahids* or *chouhadas*, as they were known, that is, literally, "the martyrs in God's name"' (Djebar 2000: 104; see also Chapter 3).

We might call the *cinéma moudjahid* the filmic reflection of this glowing official martyrdrom. In Teshome Gabriel's influential taxonomy of Third World cinema, *cinéma moudjahid* has been cited as an examplar of the 'second phase', while the replication of Hollywood or Western models is the first phase, and the militant, combative cinema of *La Bataille d'Alger* exemplifies the third. The second phase

is the 'remembrance phase', where representing the struggle against the colonial oppressor is central. The film industry in this phase tends to oversee the 'Indigenisation and control of talents, production, exhibition and distribution' (Gabriel 1989: 32). This was the role played by the ONCIC. Gabriel's assertion that the ONCIC can also be related to the 'combative' third phase of Third World cinema (a phase also known as 'third cinema') is debatable, however. To see ONCIC as 'not only owned by the nation and/or the government, [but] also managed, operated and run by and for the people' (Gabriel 1989: 33) is to overstate the identification between the Algerian people and both the state (FLN) and its film industry (ONCIC). Far from allowing 'a cinema of mass participation, one enacted by members of communities speaking indigenous languages', ONCIC ensured that the indigenous Berber languages were not heard even when films were shot in Berber-speaking regions, such as the Aurès mountains. The representation of a unitary, Arab-speaking, patriarchal Algerian identity in the *cinéma moudjahid* left many Algerian identities off-screen. Since *cinéma moudjahid* was an official history of the liberation struggle, it centred on the FLN and tended to marginalise the MNA, along with the contribution of the *moudjahidat*, and was always filmed in Arabic. Its ossifying formula grew to alienate even Arab audiences, let alone Berber viewers. Hence the inability of audiences to recognise themselves in this type of film – just as when watching Western cinema, according to Gabriel, 'an alienated identity ensues from it precisely because the spectator is unable to find or recognise himself/herself in the images' (Gabriel 1989: 36). Moreover, an indigenous film style was hard to establish. Within the *cinéma moudjahid*, Soviet influence can be observed in Lakhdar Hamina's *Le Vent des Aurès* (1966), which won best scenario prize from the Union of Soviet Writers in Moscow (as well as the award for best first film at Cannes), while the Berber film-maker Azzedine Meddour trained at the VGIK film school in the USSR. Paradoxically, however, the Hollywood Western informed certain *moudjahid* films such as *Les Hors-la-loi* (Fares, 1969) and *L'Opium et la bâton* (Rachedi, 1969). For Algerian audiences, then, cultural liberation post-1962 was far from total, and the decolonisation of culture was not achieved, except in so far as French power was replaced by the FLN (referred to as *le pouvoir* by the Algerian public, and classified by Bourdieu as 'une sorte d'imitation servile de l'Etat à la française' [a sort of servile imitation of the state in its French form] (Bourdieu 1997: 24)).

In 1965, at the same time as Pontecorvo was filming *La Bataille d'Alger*, a military coup against Algeria's first president Ahmed Ben Bella saw Colonel Houari Boumediene seize power. Such internecine conflicts, the patriarchal make-up of the FLN, and the socialist ideology of the regime under both men ensured that the plural identities at large in Algeria were not easily accommodated or represented. Homi Bhabha has asked 'how do we fix the counter-image of socialist hegemony to reflect the divided will, the fragmented population?' (Bhabha 1989: 122). The one-party state run by the FLN was not interested in the answer to Bhabha's question. Algeria's disenfranchised, fragmented population – especially but not exclusively its impoverished youth – eventually found reflection not via the FLN but in the protests of the late 1980s and the rise of the Islamists in the early 1990s. In cinematic terms, the 'fragments' found occasional representation in the rare exceptions to *cinéma moudjahid* from the 1960s and 1970s before the watershed of October 1988 saw an increase in films on division, fragmentation and the discontents of the nation-state, heralded by Mohamed Chouikh's *La Citadelle* (1988, see Chapter 4).

In the cinema of remembrance or second-phase cinema, territory is literally and figuratively reclaimed from colonial occupation. The representation of Algerian landscapes as inhabited, fought for, possessed by Algerians becomes crucial. As late as 1988, in a comedy called *Hassan Niya*, what we might call a postcolonial indexicality is at work, with the opening sequence celebrating the city of Algiers as a vast panorama seen from the skies. In effect this sequence takes scopic and political repossession of the capital after its annexation by the French, and replaces the meaning of French colonial panoramas – 'It is real and it is French' (Zarobell 2010: 109) – with an assertion that *This is real, and it is Algerian*. The technological means of cinema combine with those of aviation; the use of helicopters for this spectacular aerial sequence displays a new mastery, replicating and replacing the French use of helicopters in the Algerian war as well as in *La Bataille d'Alger*. According to Gabriel, in second-phase cinema, 'the landscape depicted ceases to be mere land or soil and acquires a phenomenal quality which integrates humans with the general drama of existence itself' (Gabriel 1989: 33). In the *cinéma moudjahid*, this drama is less general and existential than historical and anti-colonial. The integration of Algerian land and Algerian people, a reaction against the violent dispossession enacted by colonialism, is at the heart

of *Le Vent des Aurès* (Lakhdar Hamina, 1966), in particular via the village scenes and the harvest sequence (see Chapter 3). Similar emphasis on the harvest and on activities that bind the people to the land is to be found in *Machaho* (Hadjadj, 1996) and the Berber cinema of the 1990s. This phenomenon suggests that a delayed entry into the second phase, a belated engagement with folk memory, was finally achieved by Berber film-makers thirty years after the *cinéma moudjahid* performed a similar purpose for Arabic-language film (see Chapter 5). The reason for this delay, as we have suggested, was the control of film-making via the ONCIC by the one-party state that the FLN had established in post-independence Algeria. Seeking to legitimise itself firstly by celebrating the liberation struggle against the French and secondly by promulgating the use of Arabic rather than French or the regional Berber languages, the FLN oversaw the gradual alienation of Algerian audiences from their own cinema, with a repetitive and mythologising cinema of remembrance that rapidly became ossified and schematic. There were however moments when a different Algeria was shown on screen, an Algeria where issues such as women's rights, poverty and the anxieties surrounding gendered identity were aired. In the 1970s, examples of this came from Merzak Allouache's debut film *Omar Gatlato* (1976, see Chapter 4), the novelist Assia Djebar's *La Nouba des femmes du Mont Chenoua* (1978, see Chapter 4) and the short-lived movement known as *cinéma djidid*.

Cinéma djidid or 'young cinema' was rooted in the 1971 agrarian revolution which 'marked a shift to the left by the Algerian regime and opened doors for filmmakers of whom many [were] of peasant origin and all [were] committed partisans of socialism' (Hennebelle 1976: 31). The most well-known example is Mohamed Bouamari's *Le Charbonnier* which was screened at the Cannes festival in 1973. The *cinéma djidid* prioritised topics related to social issues such as unemployment, industrialisation and the role of women in Algerian society, rather than rehearsing myths of the war against the French. Both the agrarian revolution and the films that came of out of it tended to replicate Pierre Bourdieu's view of 'a broken and marginalized peasantry that could only be characterized in terms of loss' (Silverstein and Goodman 2009: 20). But there was also in these films a belief in the technological and industrial possibilities of the future, as long as the peasantry were willing to engage with them. This tendency was critiqued at the time as follows:

what today's film-makers are showing us is limited to the simple
destruction of archaic structures which impede the progress of the
people as much as the bourgeoisie. [. . .] However, if it is in the people's
interest to destroy feudal social structures, it is equally in their interests
to destroy the new structures which have replaced them (hierarchy, a
technocratic view of development). (Mocki 1976: 44)

No such destruction of new technocratic structures was forthcoming,
however, and the 'young cinema' lasted only three years.

The end of the *djidid* impulse can be located in 1974, with the return
of the war film as a state-sponsored means of commemorating the
twentieth anniversary of the start of the liberation struggle, and the
release and international success of Lakhdar Hamina's *Chronique des
années de braise*, which secured Africa's first ever Palme d'or at the
Cannes festival. A historical epic tracing the origins of the war of
liberation, *Chronique* cost a massive $2 million. (The FLN's previous
biggest commission, *La Bataille d'Alger*, had cost $800,000 ten years
earlier.) It has been said that the film used up nearly three years' worth
of the budget for the OAA and the ONCIC (Armes 2005: 97). *Chronique*
features hundreds of extras, numerous locations (deserts and dams,
mountains and towns), and contributions from the established names
of the Algerian film industry: Tewfik Fares, director of *Les Hors-la-loi*
(1969), co-wrote the film, Abderrahamne Bouguermouh, future direc-
tor of *La Colline oubliée* (1996), was assistant director, while Lakhdar
Hamina as well as directing and producing also starred as Miloud,
the mad hermit who provides a chorus on the action. The positive
reponse to the film in France, culminating in the award of the Palme
d'or in 1975, has been attributed to the lack of any explicit critique
of French rule, and the inclusion instead of 'a class of Algerians
complicit with the colonial authority' (Armes 2005: 104). However,
although the focus is rarely on the French, the narrative is driven by
the enforced poverty and dispossession of the indigenous population
enacted under colonial occupation – hence the importance of the
struggle for resources in the first half of the film. The epic qualities
of *Chronique* (landscape, cinematography, music, narrative scope and
length) are relieved by the performance of Lakhdar Hamina as Miloud,
whose satirical frenzy breaks the frame of the genre. Indeed one might
read Miloud as undercutting the dominant discourse in the film, that
of a didactic, FLN-sanctioned commemoration of the struggle towards
independence – and one which erases the MNA and other factions
from Algeria's history, since Lakhdar Hamina, 'working on behalf of

a government whose slogan was national unity, could show none of this' (Armes 2005: 102). It is significant that Miloud lives outside the city walls, in a cemetery for the indigenous Algerian population, and is usually seen wandering among the graves. We might compare the hermit to Kheira, the 'living dead' homeless woman and victim of gang rape by French soldiers who, by the 1980s, 'was living like a ghost in a cemetery' and who is taken by Ranjana Khanna as a personification of those excluded from power in Algeria (Khanna 2008: 2). For Khanna, Kheira's case demonstrates 'how shadow figures of the war are violently cut' from official history, leaving 'a generation of women silenced through amnesty and madness' (Khanna 2008: 4). Although her comments refer principally to women in Algeria, they evoke to a degree Miloud's position, characterised by madness and a certain distance from the narrative of history (he is not involved in any of the nationalist action). Khanna contrasts Algeria's 'living dead' with the martyrs' monument of Makam al-Shahid, erected by the FLN in 1982 to celebrate twenty years of independence. The monument is 'a single location through which to channel a process of mourning, loss, and victory' but which ultimately celebrates the state's disregard for the 'disposable bodies' of its subjects (Khanna 2008: 18, 20). In contrast, Kheira represents a melancholia that is 'so much more transitional and disposable than the monument', exemplifying the 'excess' that can be read in 'the leavings, the uncounted, the utterly disposable' of Algeria (Khanna 2008: 21, 20). Although Miloud's case is not as extreme as Kheira's, to an extent he – and the excess of Lakhdar Hamina's restless, ranting performance – represents a disposable melancholia that cuts through the official discourse of mourning, of the film as monument.

Cinemagoing in Algeria peaked in 1975 with 45 million film tickets sold across a population of 20 million. This was helped by the lifting in 1973 of the boycott of Algeria by US film distributors, perhaps rather more than by *Chronique des années de braise* winning the Palme d'or. The 1970s was also a high point in the volume of film production: a decade when on average two to three entirely Algerian-produced films were released each year, with peaks of nine films in 1972 and five in 1978 (see Hadjebi 2008). The film industry was however still ramshackle and hence dependent on technical expertise from other nations. Writing in the mid-1970s, Hala Salmane observed, 'There are no 35mm labs and no equipment to complete films shot in this ratio. 35mm films, as well as the weekly newsreels, have to be sent to

Paris to be developed and edited' (Salmane 1976b: 19). The audience's alienation from state culture and from the state itself began to grow, particularly after President Boumediene's death in 1978. Algerian cinema still often confronted domestic spectators with much *moudjahid*-style output and with the persistence of the mythologising of the war's martyrs, the 'one million dead'. The year 1982, the twentieth anniversary of independence, saw domestic feature film production increase to twelve films (from the usual level of two a year) and the building of the vast monument to the martyrs of the revolution, Makam al-Shahid, described by Khanna as commemorating the loss of 'the hope associated with independence' as much as the loss of the dead (Khanna 2008: 19). In this context, films which deviated from the FLN narrative of unity and nationalism were anathema. Okacha Touita's *Les Sacrifiés* (1982) was banned because it dealt with the MNA, a rival to the FLN within the independence movement.

But the disempowerment enacted by the colonial and the post-colonial regimes was also subject to comic representation. Azzedine Meddour's 1985 television documentary *Combien je vous aime* is a farcical black comedy that uses music and sound for comic effect over otherwise disturbing archive footage of the colonial period. Developments in Algeria from the war against the French to the rise of the bureaucratic and technocratic middle classes were ridiculed in the popular *Hassan* film series, initiated by Mohamed Lakhdar Hamina's *Hassan Terro* in 1968 and concluding with Ghaouti Bendeddouche's *Hassan Niya* in 1988 (see Chapter 6). Benamar Bakhti's comic road movie *Le Clandestin* (1991) reflects the diversity of Algerian identity with its collection of travellers (old and young, male and female, traditional and modern) crammed into a car which represents the nation. The film also comments on the competing cultural models that Algerian identity has to negotiate between. Myths of history are mediatised throughout, with the car journey interrupted by scenes from a TV Western and a war movie about the liberation struggle, complete with combat and torture sequences that ridicule the genre of the *cinéma moudjahid*. Key among Algerian film comedies is *Omar Gatlato* (Allouache, 1976) with its resolutely non-heroic depiction of everyday social realities in Algiers in the Boumediene years (see Chapter 4). The film was also innovative in its celebration of popular music (in this case, *chaâbi*). Where Omar is never without his cassette recorder playing local *chaâbi* or songs from Bollywood movies, subsequent comedies such as *Hassan Niya* and *Le Clandestin* (Bakhti, 1991) include

scenes of *raï* being listened to on ghetto blasters as a shorthand for popular taste and the rejection of traditional, conservative values. *Raï* had developed in the port of Oran, and while musically hybrid with influences from traditional forms alongside Western idioms such as disco and rap, lyrically it articulated 'the language of the Algerian street'; angry, melancholic, at times erotic, by 1988 *raï* had became the soundrack to the uprising of Black October (Evans and Phillips 2007: 112). *Raï*'s constituency was described by the singer Chab Ahmed as the *mrifiziyn* or misfits, a group that included youth and women (Lazreg 1994: 170). Popular music thus reflected the concerns of the dispossessed in a way that cinema – largely still controlled by the state – had generally failed to do.

The development of free market economics in the 1980s began to erode the state monopoly on film production, 'so that film-makers could now set up their own production companies' (Armes 2005: 39). This, along with a brief relaxation of state censorship of the media in the aftermath of October 1988, facilitated the development of an indigenous Berber cinema which was to flower for the first time in Algeria during the mid-1990s with films such as *La Colline oubliée* (Bouguermouh, 1996) and *Machaho* (Hadjadj, 1996; see Chapter 5). A corollary of market reforms was however the selling-off of state assets. In the 1980s around 250 screens were sold into private owner-ship and many were rapidly lost to film distribution. Former cinemas began to be used for pornographic video screenings, for cabarets or for private functions. With the rise of Islamic fundamentalism in the 1990s, cinemas themselves became targets, with attacks in Algiers on the Casino and the Midi-Minuit (see Tesson 2003: 38). The wide-spread and chaotic violence of the civil war that followed the state's shut-down of the electoral process in 1992 saw film-making in Algeria collapse. According to the director Ahmed Lallem, for five years in the late 1990s no Algerian film crews were operating in the country, while Boujemaa Karèche, director of the Cinémathèque in Algiers, has asserted that in the year 2000 not a single film was distributed or a single cinema ticket sold (Lallem 2004: 205; Tesson 2003: 38). The Cinémathèque itself was the only cinema in Algeria to continue screen-ing films throughout the civil war, thus ensuring the barest form of continuity for cinemagoing in the so-called 'black decade' of the 1990s. Created in 1964, the Cinémathèque had played a key role in generating an Algerian film culture that was both domestically and internationally embedded, as a screening space, a venue for film

seasons and festivals, and as a member of the International Federation of Film Archives. The current archive includes ten thousand feature length films and five thousand shorts (see Tesson 2003: 37).

Despite the continuation of the Cinémathèque, attempts to kick-start the industry in the aftermath of the 'black decade' have not all been successful. Not a single film subsidised by the 1999 Algerian millenium scheme was completed. The Franco-Algerian co-productions financed by a joint scheme in 2002/3 proved more successful, with key support from the French Ministry of Culture. The results included *Viva Laldjérie* by Nadir Mokneche (2004) – whose debut film, *Le Harem de Madame Osmane* (2000), had been shot in Morocco because of the instability in Algeria. Algiers's role as Arab capital of culture in 2007 generated partial funding for several films including *La Maison jaune* (Hakkar, 2007). International co-productions remain crucial to the ongoing health of Algerian cinema, but raise questions about the national identity of the resultant films (see Chapter 9). On the global stage, the most visible filmic representations of Algeria currently seem to come from Rachid Bouchareb, with *Indigènes* (2006) and *Hors-la-loi* (2010). But Bouchareb is French, as is most of the funding for his films. *Indigènes* was co-produced by France, Algeria, Morocco and Belgium – and filmed in Morocco and France alone. *Hors-la-loi* was co-produced by France, Algeria and Belgium – and set mainly in Paris. This did not prevent it from being nominated at the 2011 Oscars as best foreign film – from Algeria. One can read this as welcome recognition for a film which illustrates the bloody struggle between the FLN and the MNA within the Algerian independence movement of the early 1960s, and in a sly aside seems to suggest that these internecine divisions would haunt the independent Algeria (hence the refrain 'See you later, alligator' is heard during a murder orchestrated by the FLN). But the visibility of Bouchareb's films should not obscure the diversity and dynamism of Algerian cinema of the last fifty years or so, explored in the rest of this book.

An additional issue at stake in any account of Algerian cinema is that of distribution and audiences. Not only do film-makers working in Algeria often need international co-production support, they also need foreign audiences. Even a film as popular as Lyes Salem's 2007 comedy *Mascarades* (see Chapter 4) will struggle to make substantial returns at the domestic box office because of the frailty of distribution and exhibition structures in Algeria. As *Le Monde* reported in December 2008, prior to the film's release in France, *Mascarades* barely reached

ten thousand spectators in Algeria, its box office limited by the fact that only seven copies were distributed across the country. *Le Monde* also asserted that only around ten cinema screens were fully functional in the whole of Algeria, contrasting this with the four hundred screens in operation in 1962. This is a problem that Algerian filmgoers are well aware of. An internet thread from 2006 discusses the varying merits of half a dozen cinemas in Algiers (from the Dolby digital sound at El Mougar to the mono sound at L'Algeria and the screenings with the lights on at the Ibn Zeydoun), celebrates the high-tech facilities at the Magma in Annaba, and bemoans the disappearance of all three of Tlemcen's screens. As one film fan writes, no Algerian screen merits the name 'salle de cinéma' [movie theatre] when compared to those in other countries (Harrachi 2006). The most widespread means of watching Algerian films thus remains on television, often not so much via Algerian TV as through the popular French satellite channels. Even these however are under a degree of threat, with the obsolescence of the satellite dishes that have been prevalent in Algeria since the 1990s. From 2011, French satellite stations have required new digital decoders. It is anticipated that television will remain the primary source of film spectatorship in Algeria, alongside a certain degree of consumption via DVD, including pirate copies. But perhaps the greatest challenge facing Algerian cinema currently remains the challenge of how to reach a significant domestic audience, in particular via movie screens.

References

Anon., 'Quarante ans de cinéma algérien', *Cahiers du cinéma*, Hors-série: 'Où va le cinéma algérien?' (2003), p. 82.

Armes, Roy, *Postcolonial Images: Studies in North African Film* (Bloomington: Indiana University Press, 2005).

Bhabha, Homi, 'The commitment to theory', in Jim Pines and Paul Willemen (eds), *Questions of Third Cinema* (London: BFI Publishing, 1989), pp. 111–32.

Bourdieu, Pierre, 'Dévoiler et divulguer le refoulé', in J. Jurt (ed.), *Algérie – France – Islam* (Paris: L'Harmattan, 1997), pp. 21–7.

Djebar, Assia, *Algerian White* (translated by David Kelley and Marjolijn de Jager, New York and London: Seven Stories, 2000).

Evans, Martin and John Phillips, *Algeria: Anger of the Dispossessed* (New Haven and London: Yale University Press, 2007).

Fanon, Frantz, *Les damnés de la terre* (Paris: Gallimard, 1991).

Gabriel, Teshome, 'Towards a critical theory of Third World films', in Jim Pines and Paul Willemen (eds), *Questions of Third Cinema* (London: BFI Publishing, 1989), pp. 30–52.

Hadjebi, Djillali, 'Crise de scenarios, dites-vous?', *El Watan*, 7 October 2008, at www.elwatan.com/Nouvel-article, 105761, unpaginated, accessed 21 October 2008.

Harrachi 78, internet posting at www.algerie-dz.com/forums/showthread. php?t=17835 (2006), accessed 30 September 2011.

Hennebelle, Guy, 'Cinema Djidid', in Hala Salmane, Simon Hartog and David Wilson (eds), *Algerian Cinema* (London: BFI Publishing, 1976), pp. 28–36.

Khanna, Ranjana, *Algeria Cuts: Women and Representation, 1830 to the Present* (Stanford, CA: Stanford University Press, 2008).

Lallem, Ahmed, ' "On disait simplement que je n'étais pas sérieux . . ." ' [interview with Jeanne Baumberger], *CinémAction*, 111 (2004), pp. 204–8.

Lazreg, Marnia, *The Eloquence of Silence: Algerian Women in Question* (New York and London: Routledge, 1994).

MacMaster, Neil, *Burning the Veil: The Algerian War and the 'Emancipation' of Muslim women, 1954–62* (Manchester: Manchester University Press, 2009).

Mocki, Ali, 'Reflections on Algerian cinema', in Hala Salmane, Simon Hartog and David Wilson (eds), *Algerian Cinema* (London: BFI Publishing, 1976), pp. 37–47.

Salmane, Hala, 'Historical background', in Hala Salmane, Simon Hartog and David Wilson (eds), *Algerian Cinema* (London: BFI Publishing, 1976a), pp. 5–7.

Salmane, Hala, 'Structure of Algerian cinema', in Hala Salmane, Simon Hartog and David Wilson (eds), *Algerian Cinema* (London: BFI Publishing, 1976b), pp. 19–23.

Shohat, Ella and Robert Stam, *Unthinking Eurocentrism: Multiculturalism and the Media* (New York and London: Routledge, 1994).

Silverstein, Paul A. and Jane E. Goodman, 'Introduction: Bourdieu in Algeria', in Jane E. Goodman and Paul A. Silverstein (eds), *Bourdieu in Algeria: Colonial Politics, Ethnographic Practices, Theoretical Developments* (Lincoln, NE, and London: University of Nebraska Press, 2009), pp. 1–62.

Spaas, Lieve, *The Francophone Film: A Struggle for Identity* (Manchester: Manchester University Press, 2000).

Tesson, Charles, 'Boujemaa Karèche' [interview], *Cahiers du cinéma*, Hors-série: 'Où va le cinéma algérien?' (2003), pp. 36–41.

Zarobell, John, *Empire of Landscape: Space and Ideology in French Colonial Algeria* (University Park, PA: Pennsylvania State University Press, 2010).

3

The war of liberation on screen: trauma, history, myth

Case studies: *La Bataille d'Alger* (Gillo Pontecorvo, 1965), *Le Vent des Aurès* (Mohamed Lakhdar Hamina, 1966), *Les Hors-la-loi* (Tewfik Fares, 1969)

As we have suggested, *cinéma moudjahid* (militant or 'freedom fighter' cinema) was the dominant form in the first wave of films made after Algerian independence in 1962. Yet there remains a debate to be had about how these films (often dismissed by French critics as propaganda) represented the struggle, and what their legacy was to Algerian cinema. What is the relationship between *La Bataille d'Alger* (Pontecorvo, 1965) and the *cinéma moudjahid*? What were the influences at work on Algerian war films of the 1960s, films that were in a sense tasked with the creation of an embryonic national cinema? To what extent were ahistorical concerns (for example the representation of traditional, precolonial activities) able to find representation? Finally, how could film represent the trauma of a nation without rapidly transforming history into myth? At play here are not just the external influences of Italian neorealism, of Hollywood and of Soviet cinema, which lend their iconography to images of Algerian resistance against the French colonial presence, but also the tropes of indigenous tradition, culture and landscape, including the important role of the rural peasantry – not just the urban fighters of *La Bataille d'Alger* – in the struggle. The personification of the Algerian revolution in the three case studies chosen encompasses a discourse of martyrdom – and of Arabisation – in line with the FLN policy of representing the war by means of 'one single hero: the people', but it also gives rise to questions about trauma and representation, about gendered and regional identities, individualism and collectivism, that were to subtend much Algerian cinema after the *moudhajid* period.

Crucial to the legitimacy of the newly independent regime were memories of the struggle and the corralling of history into myth, as Evans and Phillips explain:

> On 20 September 1962 elections to the National Assembly saw the single list of official candidates receive 99 per cent of the vote [. . .]. But the nature of the ballot meant that the new regime enjoyed no electoral legitimacy; instead, legitimacy was derived from the war of liberation and the figure of Ben Bella as one of the historic leaders of the FLN. (Evans and Phillips 2007: 74)

A year later Ben Bella was elected as Algeria's first president, only to be removed in the 1965 military coup led by Houari Boumediene. Under both men, but especially the latter, 'the Algerian army became the embodiment of the regime and the custodian of the revolution. This was reflected in a cycle of remembering where, in the quest for an uncomplicated national memory, much of the historical truth was lost' (Evans and Phillips 2007: 84). Or, as the novelist Boualem Sansal has put it, 'La lutte du peuple algérien pour son indépendance a été privatisée [. . .], elle est devenue la propriété exclusive du FLN' [The struggle of the Algerian people for independence has been privatised, it has become the exclusive property of the FLN] (Sansal 2006: 43). Cinema played its part. The Algerian film industry was nationalised as early as August 1964, and soon became aligned with the FLN's mythologising cultural policy. Nonetheless the Algerian films of the 1960s are not simply examples of state propaganda. Two films in particular show an engagement with the trauma of the war while at the same time refusing to demonise the French or to oversimplify the representation of Algerian identity. One of these stands as the most well-known of all Algerian films, the remarkable FLN-commissioned *La Bataille d'Alger*, by the Italian director Gillo Pontecorvo. The other remains much less well known, but also encapsulates the traumatic experience of the conflict before such experience was completely ossified into state-sanctioned myth: a rural masterpiece to match Pontecorvo's urban masterpiece, *Le Vent des Aurès* (Lakhdar Hamina, 1966). To these will be added a more generic portrayal of the war in the form of an Algerian 'Western', *Les Hors-la-loi* (1969), directed by Tewfik Fares, co-writer of *Le Vent des Aurès*.

The Algerian war or Algerian revolution, a largely guerilla-based struggle to overthrow French colonial occupation, lasted eight years (1954–62) and resulted in hundreds of thousands of deaths, with the

FLN citing the figure of a million martyrs (see Chapter 1). The trauma of the nation is reified culturally in a kind of repetition compulsion, a repeated return to the conflict in Algerian cinema and other media after independence. This repetition is a means whereby the one-party state could maintain the official version of history, in Fanon's terms intoxicating the people with the independence epic and sending them to sleep (see Fanon 1991: 210). But it can also be seen as a psychological reaction to trauma, since 'the impact of past crimes in a nation-state may evidence itself in the form of "cultural symptoms" analogous to those in individuals' (Kaplan 2005: 68). Hence the series of flashbacks that constitutes the *cinéma moudjahid*. Although trauma narratives are often written or spoken texts, trauma is a largely visual experience for the sufferer. This means that visual forms such as cinema, drawing, and theatre are well positioned to express the experience. As Kaplan puts it, there is a 'match between the visuality common to traumatic symptoms (flashbacks, hallucinations, dreams) and [. . .] visual media like cinema' (Kaplan 2005: 69). While narrating trauma, group therapy, game playing, dancing and drawing all testify to trauma in order to move beyond it, some theorists suggest that the traumatic event cannot be consciously testified to but only ever acted out, repeatedly: 'The experience of the trauma, fixed or frozen in time, refuses to be represented *as* past, but is perpetually reexperienced in a painful, dissociated, traumatic present' (Leys 2000: 2, italics in original). The function of Algerian films on the liberation struggle seems closer to the narrativisation of trauma as a means of remembering to forget, hence a 'working through', an articulation of national identity that seeks to commemorate suffering but thereby to move onwards and to build new power structures (the FLN state), rather than as a traumatised perpetual present. As Ranjana Khanna has indicated, memories of colonial trauma can serve 'hegemony or counterhegemony': 'It is as if national cohesion could be achieved only by "remembering to forget", allowing trauma to be articulated in the service, ultimately, of what Ernest Renan said was necessary: for all nations to will themselves each day as a daily plebiscite' (Khanna 2008: 97) Certainly the *cinéma moudjahid* seems to fit the needs of Algerian hegemony after 1962, since in accordance with FLN ideology it tends to marginalise elements within the revolution such as women, Berbers, and non-FLN groups like the MNA while creating a sense of shared suffering and shared identity at a national (albeit Arab-dominated, largely patriarchal) level. We do also find in Algerian films

on the war an emphasis on bearing witness to the injustice of the colonial regime and French measures to maintain it, most infamously via the use of torture. If as Kaplan states, ' "Witnessing" involves not just empathy and motivation to help, but understanding the structure of injustice' (Kaplan 2005: 23), then the film that lays bare such structures at work in the Algerian war is its most famous filmic representation, *La Bataille d'Alger*.

La Bataille d'Alger (Pontecorvo, 1965)

Filmed in the locations where the original battle for control of Algiers took place in 1957, *La Bataille d'Alger* is renowned as a stunningly realistic and apparently even-handed account of the conflict – despite being commissioned by the FLN just three years after independence. The film recounts the struggle between secret FLN cells and French paratroopers for control of the city, with the apparent victory of the French followed by a coda in which the mass demonstrations of December 1960 presage Algerian independence. It has become a totemic film not just within Algeria but globally, respected as a power-ful non-propagandist representation of colonial conflict, famously screened at the Pentagon during the Iraq War (although for debatable reasons – see MacMaster 2009: 399). Its reception in France has not however been without controversy: although it won the Critics' Prize at Cannes in 1966, the film was not given a full release in France until 1971, and cinemas screening it over the subsequent decade were often attacked by opponents of Algerian independence. An Italian-Algerian co-production based on the memoirs of Yacef Saadi of the FLN but directed by an Italian (Gillo Pontecorvo), the film has a slightly am-biguous position in regard to Algerian national cinema, and hence some critics consider Lakhdar Hamina's *Le Vent des Aurès* to be the first ever Algerian feature film (see below). Pontecorvo himself has stated that *La Bataille d'Alger* cannot be considered Algerian since 55 per cent of production costs came from Italy (see Meflah and Marx 2004). All the same, we will consider this to be an Algerian film, because of its commissioning by the state, its co-production and co-authorship (Saadi's ideas, reworked by Franco Solinas). In the con-text of a national cinema which has not always been able to actually film on home soil (see for example the use of Morocco as a safer loca-tion at times during the 1990s) it is also worth noting that *La Bataille d'Alger* is embedded in Algiers itself, presenting what Cathy Caruth in

another context has called 'a seeing and a listening *from the site of trauma*' (Caruth 2006: 214, italics in original).

Set in the casbah of Algiers, *La Bataille d'Alger* famously restages events on the very streets where they had taken place just eight years previously (including the very house where militants Ali la Pointe and Hassiba ben Bouali were killed). Pontecorvo evokes the realist film style of the documentary newsreel with his use of location shooting, grainy black and white photography, and frequent hand-held camerawork. Also contributing to the sense of authenticity is the casting – amateur actors in all the roles but one (Jean Martin as Colonel Mathieu), while the FLN leader Jaffer is Saadi playing a fictionalised version of himself. These factors, along with a narrative based on clandestine resistance against an occupying power, show how much Pontecorvo owes to Italian neorealism and in particular to Roberto Rossellini's *Rome, Open City* (Italy, 1945). Rossellini's film is a significant intertext both ideologically – film as resistance, and as expression of the masses via the use of amateur actors and local crowds, in effect recreating their own wartime experiences – and stylistically. Its imprint on *La Bataille d'Alger* is apparent in the following tropes: overhead shots of soldiers searching the rooftops of the city; the topographical division of urban territory into sectors policed by the occupying forces; torture sequences, largely off-screen; a young boy as resistance helper (Little Marcello becoming Little Omar); and underground settings for the meetings of resistance cells. *La Bataille d'Alger* concentrates on the story of Ali la Pointe (Brahim Haggiag), often working under Jaffer's guidance. The narrative also devotes space to the role played by women in the struggle, principally in the well-known sequence wherein three women undertake bombings against French civilians. Another clear intertext here is Eugène Delacroix's famous representation of Algeria embodied via incarcerated, passive femininity in his 1834 painting *Femmes d'Alger dans leur appartement*. But while imitating the composition of that colonial image, Pontecorvo inverts the meaning so that the three women of Algiers we see posed in an apartment are not figures of submission and enclosure but active revolutionary fighters on the point of leaving the casbah in order to plant bombs in the European quarter (see Chapter 4).

At the heart of *La Bataille d'Alger* is the representation of power in the struggle for control of Algiers. The disparity between the means open to the French army (napalm dropped on villages) and to the FLN (bombs hidden in baskets) is the topic of a famous exchange between

Colonel Mathieu, head of the paratroopers, and the FLN leader Ben M'Hidi. But most resonant throughout the film is the visualisation of power and vulnerability. The pre-credit sequence is exemplary in this regard. It shows a solitary Algerian man, almost naked, wretched and skinny, shaking and terrorised, with burn marks on his chest. Around him are a group of uniformed soldiers (French paratroopers), some smoking, all relaxed and in control. Their victim, we learn, has just been tortured and has revealed where Ali la Pointe is hiding. The composition here and the binaries it employs (clothed/naked; armed/unarmed; control/impotence; colonisers/colonised; and so on) resembles very closely other notorious images of torture (itself an activity which above all others is predicated on a power differential between human beings). Firstly, this sequence recalls a photograph of a torture centre in Constantine, Algeria, dated 1959, which depicts two French officers in uniform laughing and pointing at two Algerian detainees (one naked, one all but naked), who are stood below them in a ditch full of water. Secondly, the sequence predicts the infamous photos of prisoner abuse taken at Abu Ghraib in Iraq during 2004. (For these photos, and for comparisons between torture in Algeria and torture in Iraq, see *Le Monde* 2004.) At the start of *La Bataille d'Alger* the act of torture is elided (it has just finished). The paratroopers are led to Ali's hideout and prepare to blow him up with his three comrades. Then a freeze-frame on Ali's face returns us to 1954 and the origins of the narrative. Hence the film is literally framed by torture.

Complementing the framing of power and vulnerability is a dichotomy that opposes the high and the low. This recalls Georges Bataille's assertion that the conflict between high and low values is a universal dynamic, and that these values can be identified with two competing conceptions of revolutionary activity: an idealised 'lumière rédemptrice s'élevant *au-dessus* du monde' [redemptive light rising *above* the world] figured as an imperial eagle, against the underground action (reworking Marx) of 'la révolution "vieille taupe" [qui] creuse des galéries dans un sol décomposé et répugnant' [the revolution as an 'old mole' which digs tunnels in disgusting, decomposing soil] (Bataille 1970: 95, 96, italics in original). In an Algerian context, the former image recalls French imperial ambitions (and Bataille associates the eagle with Napoleon), in tandem with the colonial rhetoric of bringing light to darkness. Meanwhile the underground activity of the revolutionary mole, digging in the darkness, evokes the importance of caves as a site of Algerian origins and resistance, from the *enfumades*

of the 1800s – alluded to in *Tahia ya didou* (Zinet, 1971) and *La Montagne de Baya* (Meddour, 1997) – to the symbolism of 'la grotte' in the novel *Nedjma* (Yacine 1996) and the allegorical cave sequences in *La Nouba des femmes du Mont Chenoua* (Djebar, 1978) and *Youcef* (Chouikh, 1993). What is fascinating in *La Bataille d'Alger* is the way that this symbolic opposition is maintained until the moment of Ali la Pointe's death and his elevation to the status of revolutionary martyr. For most of the film there is a clear distinction between the low (the dark, uterine hiding places of the FLN, the cells, wells and low-lit rooms where Ali and Jaffer are positioned, the narrow streets and enclosed courtyards of the casbah), and the high (the light, elevated balconies, the broad staircases and whirring helicopters associated with French colonial power). When the paratroopers first arrive, they parade through wide streets in blazing sunlight. Later, when the French are clearly in the ascendancy, a helicopter hovers against a white sky, broadcasting the names of those FLN leaders who have been arrested, reminding us of the symbolic association in Bataille between elevation, illumination, and the imperial eagle. Meanwhile, Ali and Jaffer often meet under cover of darkness, and remain hidden within the tunnel-like streets and hiding places of the casbah, like Marx's 'old mole' or like a tapeworm in the body of the city, to use Mathieu's analogy.

The spatial opposition between high and low clearly expresses the power relations of colonisers and colonised (one above the other), again as in the 1959 photo from the torture centre near Constantine – soldiers on the bank, victims in the ditch. At key points throughout *La Bataille d'Alger* Pontecorvo uses a pan across, up to, or down from, the rooftops of the casbah to demonstrate which side has the upper hand. Usually it is the French, beginning with the exhilarating but threatening credit sequence which sees paras flooding across the roofs of the casbah to literally occupy this contested space. Subsequent low angled shots show the elevated positions of the guards at the prison and of the French citizens on their balconies berating the old Algerian in the street below them. We can equate these compositions to the French panoramas of Algiers – paintings and photographs – that were popular in the colonial period, offering a view of the colonised city from a perspective that evoked 'the domination of a territory, a position uniquely available to a conquering power' (Zarobell 2010: 25). But there is a moment in the film when the terraces of the casbah are populated by Algerian figures, listening to the prayers from the hidden wedding ceremony, in an indication that the casbah does not

yet belong to the French. At the climax of the narrative, when Ali is trapped and Mathieu about to blow up his hide-out, Pontecorvo shows both the inhabitants of the casbah and the French soldiers looking down at the site, albeit with the former positioned on terraces and the latter, above, standing sentry on the very highest roofs. This is the key ambiguous moment in a famously ambivalent film, a pan(orama) that signals Mathieu's triumph and yet also Ali's martyrdom – a pyrrhic French victory that will be followed by the coda depicting the apparently inexplicable continuation of resistance, and the achievement of independence.

The climatic scene of *La Bataille d'Alger* begins with Ali getting up early in the morning, looking up from the house to a glowing white sky, empty of French helicopters for once. The use of light here, in a composition seen from Ali's point of view and not impinged upon by the French, is the first indication that Ali is on the point of entering the elevated, illuminated realm of the ideal (in this case, of martyrdom). The glimpse of light is followed by the opening strains of the Bach-inspired sacred music (by Ennio Morricone) that has soundtracked moments of suffering and trauma throughout the film. This is interrupted by the drums of the opening credits and the arrival of the paras, as the flashback finally closes and we are back in the time of the frame narrative, with Ali, Omar, Mahoud and Hassiba trapped in their cell behind the bathroom wall. Pontecorvo then introduces the rooftop shot which in effect combines French and Algerians as spectators to Ali's imminent death, as Morricone's haunting main theme is heard. This is the point at which history becomes myth, and Ali leaves the realm of the low to enter the elevated realm of light. It is also, via the metonymic status of Ali, the moment when the Algerian revolution will cease to be a subversive 'burrowing' and will be consecrated as a higher, quasi-imperial power . . . After the explosion, the white glow that filled the sky when Ali looked up now fills the space where his hiding-place was. As the dust clears, the glow (and the sacred music) signals that Ali has joined the 'lumière rédemptrice s'élevant *au-dessus* du monde'. A similar glow surrounds the protagonist of *Le Vent des Aurès* at certain moments in her traumatic journey (see below). This moment also suggests the mythical status that the liberation struggle would enjoy in the *cinéma moudjahid* as well as in the discourse of the independent state more generally. As Assia Djebar has observed, already by the summer of 1962 the new nation-state was making use of the *chahids* or 'martyrs in God's name', constructing a 'suspicious consensus' and

a glowing 'hyperbole' around 'the tribute in warm bodies to the new Algeria' (Djebar 2000: 104). In Djebar's history of the struggle, for every 'phosphorescent' death 'offering its light and its thirst for sacrifice', there was a 'murky' death 'clouded by a tangle of lies' (Djebar 2000: 115). But FLN rhetoric allowed only the former – of which Ali la Pointe's death at the hands of the French is a founding example.

The glow of his martyrdom is not the only use of sacred imagery to evoke the suffering of Ali and his followers. Indeed, one could say that this Islamic fighter is presented as a Christ-like figure. In an early scene we see Ali grabbed by a French mob, beaten and dragged along the street, like Christ on the way to Calvary. The haunting main theme is heard as the camera focuses on Ali's bleeding face. References to Christ's suffering merge with an allusion to the bloodied faces of Algerian fighters memorable from photos of the conflict – in particular the image of an FLN fighter taken prisoner in 1960 (see *Le Monde* 2004: viii). It is in fact characteristic of *La Bataille d'Alger* to create an iconography of trauma from allusions to sacred martyrdom (with Christian overtones, presumably due to Pontecorvo's and Solinas's cultural background) combined with echoes of Italian neorealism and of contemporary still images from the Algerian war. (The latter two influences may also have influenced Pontecorvo's choice of black and white rather than colour.) The centre of the film's representation of suffering is the torture sequence prior to Jaffer's arrest. Here Pontecorvo (having elided the torture implicit in the film's opening scene) is confronted with the question of how to show pain, and thereby do justice to physical suffering rather than dissimulating or minimising it: 'The act of misdescribing torture or war [. . . is] partially made possible by the inherent difficulty of accurately describing any event whose central content is bodily pain or injury' (Scarry 1985: 13). Moreover, 'Physical pain does not simply resist language but actively destroys it, bringing about an immediate reversion to a state anterior to language' (Scarry 1985: 4). If language is destroyed by torture, it is for the image and the (non-spoken) soundtrack to convey the enormity of the experience. Hence the importance of framing and music in the torture sequence from *La Bataille d'Alger*, a sequence in which we hear no dialogue whatsoever. The imagery is fragmented, and removed from the narrative to the extent that we see various unidentified Algerians being tortured in a variety of ways in different locations. The result is a kind of compendium of atrocities (water torture, blow torching, hanging upside down, the notorious electrical

shocks known as *la gégène*) which risks being simply too difficult to watch. Pontecorvo takes two steps to bring this pain closer to the spectator, while also paradoxically making the sequence more bearable. The first is to place spectators within the frame, so that we glimpse not only shadowy figures (Algerian family members, it seems) on a balcony in the background, but also striking close-ups on spectators watching from close range what we ourselves are seeing: a woman who cries as she watches the water torture, then later a single eye staring over the shoulder of a paratrooper, and finally a return to the crying woman, but with a zoom in on her eyes as if to reinforce the significance of the act of watching. The effect of this foregounded act of watching torture is surely akin to what Ann Kaplan has said of witnessing and trauma: '"witnessing" happens when a text aims to move the viewer emotionally but without sensationalizing or overwhelming her with feeling that makes understanding impossible' (Kaplan 2005: 22–3). The second key element of the mise en scène here is the music, which bridges the various images (linking them together, as do the bookended shots of the female spectator) and replaces diegetic sound, which would risk being unbearable, with Morricone's Bach-inspired organ score. Christ's passion on the cross is thus evoked in an attempt (again, derived from the film-makers' Christian culture) to describe the undescribable, to objectify what has no object, to bridge the 'absolute split' that pain establishes 'between one's sense of one's own reality and the reality of other persons' (Scarry 1985: 4). It is the power of this attempt to understand another's pain, to understand also 'the structure of injustice' whereby that pain was inflicted, that has made *La Bataille d'Alger* a touchstone for committed cinema in Algeria and beyond. For all that, the film was subject to reinterpretation by later directors. While Ali's house (rebuilt for the filming and then exploded) was rebuilt once more to become a tourist attraction and a site of national commemoration, films such as *Omar Gatlato* (Allouache, 1976) and *Youcef* (Chouikh, 1993) were to express a growing frustration with the way that memories of the war were repeatedly mobilised by state discourse to justify the FLN's continuing hold on power (see Chapters 4 and 6).

Le Vent des Aurès (Lakhdar Hamina, 1966)

If *La Bataille d'Alger* concerns a political and military struggle between French paratroopers and the underground FLN network, *Le Vent des*

Aurès is a simple, allegorical story of an Algerian mother whose family is destroyed by the colonial occupiers. Although much less well known, *Le Vent des Aurès* is more representative of the conflict in terms of setting and narrative, since it shows the war as a rural phenomenon. This is combined with a more sustained representation of how the struggle affected women, via the central character of the unnamed mother. These two factors together reflect the fact that '77.9 per cent of the total female population that participated in the war was comprised of rural women' (Lazreg 1994: 120). The mother in *Le Vent des Aurès* is not one of the *moudjahidat* (female combatants) but, more accurately, one of the *moussebilate*, the women who gave food and support to the ALN or Armée de libération nationale. These numbered in their thousands, while by contrast the *fidayate* or urban-based fighters (represented in *La Bataille d'Alger*) officially numbered just sixty-nine (see MacMaster 2009: 239, n.35). By focusing on a mother and on the territory she inhabits – her home village in the Aurès, the plains where she wanders later in the film, and, by a process of metonymy, the whole of Algeria – *Le Vent des Aurès* presents the national as gendered female, thus shifting constructions of nationalism away from the patriarchal discourse of the FLN and towards what Spivak has called in another context 'the coming together of mother and land' (Spivak 1996: 299). Thus while the film might be said to conform to FLN ideology whereby there is a single hero in the Algerian revolution, the people, it mobilises a female embodiment of the Algerian people. This is not unproblematic: Sheikh Ben Badis's prewar nationalist rhetoric, for example, had posited the needs of the nation as 'co-extensive with men's needs' while granting a symbolic status to women which translated as the role of supporter, subordinate, wife and mother (the role played by the protagonist of the film, in effect); he wrote that ' "wife and children are the bonds that tie patriotic man to his motherland, and reinforce his faith" ' (Lazreg 1994: 84). But all the same in filmic terms, *Le Vent des Aurès* represents a rare example from the immediate postwar period of a narrative that focuses on the impact of the war as experienced by an Algerian woman.

The film has epic, mythic elements, both in terms of narrative (a quest across Algeria) and characterisation (the mother embodies the nation) but representations of military struggle, torture and political structures are almost entirely absent. By focusing on the story of one witness – a mother who loses her husband and her son – the film realises directly and intimately the trauma of those who experienced

the conflict even if not actively engaged in it. And since the action follows the mother's suffering so closely, we are able to see the form itself (especially the camerawork) become increasingly dislocated as it reflects the mother's trauma. To a large extent, while also keeping a simple linear plot, the film illustrates via its increasingly fragmented and disjointed style the commonly accepted idea that narratives of trauma are 'meaningful yet fragmentary' (Janet Walker cited in Kaplan 2005: 43). *Le Vent des Aurès* also reflects the specific traumas visited on the rural Algerian population by the French army during the war, including *regroupement* or the removal of villagers from their land, the mass imprisonment of males of fighting age and communal punishment via the destruction of entire villages suspected of aiding the *fellaghas* or nationalist fighters. Indeed, specifically in the Aurès mountains, where the film begins and where the first shot of the rebellion had been fired on 1 November 1954, the French regional commander General Parlange had initiated reprisals against suspected rebel communities, a policy rapidly extended to all of Algeria by the summer of 1955 (see MacMaster 2009: 222). Unsurprisingly, given the culture of silence around sexual violence, and the prevalence of the patriarchal honour code, the one form of trauma that remains unrepresented in this film, and indeed in most Algerian cinema generally, is rape, an act often perpetrated by French soldiers as well as, during the recent civil war, by certain Islamist groups. The use of rape as a weapon of terror in the 1990s civil conflict is addressed to a degree in *Al-Manara* (Hadjadj, 2004) and *Rachida* (Bachir-Chouikh, 2002; see Chapter 7).

The debut feature of Mohamed Lakhdar Hamina, *Le Vent des Aurès* was mainly shot in Lakhdar Hamina's home region of the Aurès mountains in eastern Algeria, a traditionally Berber area, although the language used in the film is Arabic in accordance with the language policy of the FLN regime (see Chapter 5). The narrative operates allegorically, having two levels. Firstly it tells the tale of a peasant family: when the father is killed in a French air raid and the son Lakhdar (Mohamed Chouikh) is arrested for helping supply the *moudjahidin* fighters, the mother (Kheltoum) sets off on foot across Algeria in search of her son, wandering from one prison camp to another until she finally finds him, only to lose contact with him again and to die in a dust storm at the foot of the wire that surrounds the camp. In this realist reading, the wind of the title is a natural phenomenon, part of the storm in which the mother meets her death. Symbolically, however, the mother is the personification of Algeria and her quest a

metaphor for the journey to freedom from colonial rule (a journey the director would revisit in his 1974 historical epic *Chronique des années de braise*). Her suffering stands for the suffering of the nation, and her death makes her one of the 'martyrs' who died for the revolution. On this level, the wind of the title is symbolic, a figure for national liberation, the uprising of the Algerian people and the inevitability of their path to independence. It is worth noting how easily and smoothly the allegory works. Because of the vast amount of everyday detail in Lakhdar Hamina's quasi-ethnographic filming of peasant life (the Berber house, the harvest, the mother's work at her loom, her cooking methods, even her superstitions), the film does not feel propagandist or didactic. That said, there are moments when the compositions recall Soviet cinema (see below), or when the characters speak of the need for national solidarity: for example, the son declares that helping the *moudjahidin* is 'everyone's duty'; the mother is told by a man who offers her advice and shelter, 'In difficult moments we must all help each other'. It is at these points that the film most obviously displays not just the collectivist viewpoint at stake in Algerian culture (see Chapter 9), but also the FLN-sponsored mythologising of the war, with its slogan 'Un seul héros: le peuple' [a single hero: the people]. But for the most part, the film eschews dialogue altogether, relying on camerawork and music to track the traumatised mother's journey.

In the opening scenes of *Le Vent des Aurès* the functioning of the family and of the village is shown as ordered, patriarchal, secure. The depiction of space conforms to the Berber traditions catalogued by Pierre Bourdieu. Hence there is a clear dichotomy between the indoor 'feminine' world of the house and the outdoor 'masculine' world of the fields. Moreover, entering the house is a movement associated with women, and leaving it an action associated with men: 'La sortie est le movement proprement masculin [. . .]. Sortir ou, plus exactement, ouvrir (*fatah*) est l'equivalent de "être au matin" (*sebah*)' [Going out is a purely masculine movement. Going out, or rather, opening (*fatah*) is the equivalent of 'being in the morning' (*sebah*) (Bourdieu 1972: 78). In this context, it is notable that, in the film's first scene, father and son are outside working while the mother walks past them and into the house. The next morning, an establishing shot shows the father exiting the house to gaze at the dawn, then squatting outside the doorway to wash, followed by his son, while the mother remains, unseen, inside the house. (Similar compositions are used in the recent Berber film *La Maison jaune* – see Chapter 8.) The strong cultural

association between masculinity, morning and working in the fields is all the more resonant here since the men of the village proceed to discuss arrangements for the harvest which will take place the following day. But Lakhdar Hamina's most effective evocation of harmony within the Berber village – with none of the gender tensions that surface in, say, Mohamed Chouikh's *La Citadelle* (1988) – is in the opening credit sequence. In a continuous take, with gently gliding camera, he films the mother as she leaves the house and walks downhill to the stream to wash and collect water (an element symbolically linked to femininity in Berber culture). A sense of belonging, routine and security is evoked by the smooth camerawork, the positioning of the mother in the centre of both the shot and her environment, and the guitar theme that accompanies her steps down to the water. Everything is in its place. Closing in on the mother, the camera frames her as she crouches by the stream, while the trees on the banks also frame her as central. Finally there is a cut, and a slow zoom to her thoughtful face. Such silent zooms to facial close-ups are used regularly throughout *Le Vent des Aurès* to suggest the mother's emotions, as we shall see shortly. At this point the effect is calm and harmonious, like the motion of the camera and the pace of the editing. This reflective moment is also part of the mother's daily routine and in fact a response to her husband's command that she get up and begin her tasks. It is only when both husband and son have been removed (one killed, the other arrested), and the home destroyed by French soldiers, that the mother out of desperation ventures out into the deserted empty spaces beyond. Her mobility is thus authorised only by the absence of the menfolk. Leaving what Bourdieu calls 'the full space' of the home, the village and the fields, she enters what is known to the Berbers as *lakhla*, the empty and sterile space beyond the village (see Bourdieu 1972: 73). It is this vast empty landscape that she must cross in order to find her son. Her status as a mother synthesises the functions of narrative, action and symbolism. Assia Djebar has noted that the Qur'an situates paradise at the feet of mothers, with the mother, by virtue of her age and function, a desexualised figure evocative of tenderness rather than desire, and therefore free to move, to look, and to express Algerian cultural identity even under colonialism (see Djebar 1980).

The symbolism of light and dark, a highly gendered contrast in Berber culture according to Bourdieu, is employed by Lakhdar Hamina to express the mother's crossing the threshold between her previous domestic role and her subsequent odyssey. Darkness is associated with

femininity, superstition and evil powers, while light is linked with masculinity, good fortune and the sun (see Bourdieu 1972: 73–4). Anxious about Lakhdar's disappearance to take supplies to the *moudjahidin*, the mother tries to predict his fate by blackening one side of an egg and placing it in the fire to see which side will burst. The black half breaks, signifying bad luck. Unable to sleep for worry, she then crosses to the door and is framed for a moment in the middle of the house, the central axis in a divided composition with light on one side (the door to the outside world) and shadow on the other (the dark, animal side of the home where the goats are tethered). At this point the mother is suspended, as is the narrative, between dark and light, night and day, private space and public space, the world of the feminine and the world of the masculine. Her literal crossing of this threshold is shown from outside the house as she, like her husband earlier in the film, walks out to the dawn. This subtle symbolism is rooted in local traditions but also realistic in tone. The same cannot be said for certain heavily symbolic compositions which recall Soviet cinema, reminding us that Lakhdar Hamina trained as a film-maker in Czechoslovakia, and that the FLN regime was officially socialist. At several points in *Le Vent des Aurès* the mother is framed against the sky, her form rising clearly above the flat landscape around her, dominating the space and providing a powerful embodiment of the nation. The first such composition occurs when she brings food to the harvesters, in a sequence reminiscent of Soviet iconography. While the mother hence becomes archetypal and mythical, the villagers are presented as a collective group, rather than individualised as they might be in Western cinema tradition. None of them has a name, for instance, and each is framed briefly and for the same amount of time before the camera passes on to the next, in a series of almost ethnographic shots of workers harvesting and then pausing to eat. Apart from the mother, the only other villager privileged by the camera is her husband, who is one of the elders and in charge of organising the harvest. The mother's journey to find Lakhdar is punctuated with four more compositions framing her against the sky or against a flat landscape, with two of these presenting her in silhouette against the sun. The earliest of these images is the most impressive, evoking her determination as she sets out for the prison camps, and presenting an extremely powerful, clear-cut image in which she walks into the rising sun. It is matched by a more pessimistic shot late in the film when, leaving the camp where Lakhdar is held, she is silhouetted

walking into the setting sun, and shot from a slightly higher angle so that she no longer dominates the terrain in the same way: her journey is over and night is at hand. More open and intriguing than these monumental, mythologising images are the repeated slow zooms on the mother's face. Until the final sequence in the dust storm, Kheltoum's performance is relatively restrained, and there is very little dialogue to reveal her thoughts. This means that the immediate context, the editing which situates the facial close-ups, is what carries the key to their meaning. In other words, these images convey meaning via the technique developed by the Soviet film-maker Pudovkin, which has become known as the Kuleshov effect. The technique is described thus by Hitchcock:

> You see a close-up of the Russian actor Ivan Mosjoukine. This is im-
> mediately followed by a shot of a dead baby. Back to Mosjoukine again
> and you read the compassion on his face. Then [. . .] you show a plate
> of soup, and now, when you go back to Mosjoukine, he looks hungry.
> Yet, in both cases, they used the same shot of the actor; his face was
> exactly the same. (in Truffaut 1986: 321)

The slow zooms reveal Kheltoum's face as almost always pensive, and the juxtaposition of these images with shots of her surroundings or her interlocutors is what allows us to read meaning into them. Hence in the opening credits, she seems thoughtful and at peace – a function of the smooth camerawork and strumming guitar music leading up to the zoom on her face. Later facial close-ups seem to express anxiety (she gives Lakhdar a talisman then watches him leave to visit the *moudjahidin*) or despair (after not finding her son at the barracks). It is only when reunited with Lakhdar at the final camp that she smiles, and we see repeated examples of the shot/reverse shot composition that expresses their loving communication (unable to speak across the wire, they gesture or simply stare at one another).

The spatial assurance expressed in the Soviet-style compositions is eroded by the mother's ongoing trauma. Symbolic of this trauma is the glimpse, during the bombing of the village, of an explosion in the stream – the focus of the harmonious credit sequence, a place culturally associated with motherhood and femininity. Her experience of the war is not just a matter of seeing her village bombed, her husband killed, her home ransacked and her son arrested – it is prolonged by her journey, and by her vigil outside the barracks and the various camps until she sees Lakhdar again. Thus the mother lives and relives

the trauma during the entire second half of the film (which covers a period of months): 'the event is not assimilated or experienced fully at the time, but only belatedly, in its repeated possession of the one who experiences it. To be traumatized is precisely to be possessed by an image or event' (Caruth 1995: 4–5). The first hint at her 'possession' by trauma is when we see the mother pacing back and forth in her house awaiting Lakhdar's return from the *moudjahidin*. In the absence of scenes of grieving (there is no funeral sequence, and the death of the father is immediately followed by a focus on the entire village attempting to put out a fire) the loss of her husband seems to have been accepted. However the camera motion tracking her backwards and forwards expresses her increased anxiety about her son, and predicts the disorienting and hysterical movements that characterise the final scenes of the film.

Throughout *Le Vent des Aurès* the mother's sense of alienation and suffering is realised principally by means of camera movements, which become increasingly disjointed as the film progresses. The editing also speeds up and the music becomes more discordant. The gliding camera of the long, smooth credit sequence is gradually replaced by fragmented, dislocated camerawork, until the final scene where cuts on tracking shots, disrupted camera motion and grotesque tilting camera angles convey the collapse of the mother's sense of self. The repeated, obsessive camera motion glimpsed earlier, in the house, becomes more and more prominent as the mother visits various camps. A brief tracking shot of her walking left to right along the wire at one camp is immediately followed by a shot of her walking right to left at what we suppose is another. This to-ing and fro-ing (objective shots of the mother alternating with subjective shots of the camp seen through the wire) increases in frequency and pace at the camp where Lakhdar is finally discovered. Once he is seen, the camerawork calms again and there are many fixed shots, with gentler music and a mise en scène closer to the scenes of village life at the start of the film. Rather than wandering up and down the wire, the mother now sits gazing happily at her son in the yard or at the widow of his cell, and the restless tracking shots cease. But when he disappears (we never know where to or why) the traumatised mise en scène returns in intensified form, with discordant music and frenetic tracking shots along the wire. The mother's final visit to the camp is in a dust storm, the sound of the wind joining the clanging percussion and her desperate cries of 'Lakhdar!' Rapid cuts from one tracking shot to another

disorient the viewer and repeat the obsessive motion that is the central trope of the mother's trauma. As night falls she stops opposite her son's dark window, then throws herself on the wire and dies, apparently electrocuted, in the howling storm. The framing of these last moments is almost terrifying, with tilted angles, rapid editing and sudden close-ups on her hands and face. Only after the mother's death does the camera move gently away in a long final take showing her body in the gloom at the foot of the wire.

This ending might be interpreted as the moment when trauma's cycle of repetition is mercifully or tragically ended by death. It might perhaps also generate a sense of transcendence, the return of the mother to the earth as the wind from the Aurès blows around her, evoking 'the transcendental figuration of [. . .] the coming together of mother and land' (Spivak 1996: 299). Certainly, as throughout the film, questions of territory, identity and dispossession are central. *Le Vent des Aurès* is thus the working-through of an identity crisis generated not just by the war but by colonialism more generally. The French colonial law of 1865 had 'codified a radical difference between Europeans [. . .] who had full French citizenship and Algerians who were given second-class status as "subjects"' (MacMaster 2009: 50). Giorgio Agamben has written on what it means to be a 'subject' in relation to the experience of Auschwitz: 'It is nothing less than the fundamental sentiment of being *a subject*, in the two apparently opposed senses of this phrase: to be subjected and to be sovereign [. . .], self-loss and self-possession, servitude and sovereignty' (Agamben 2002: 107, italics in original). Agamben's theorising of sovereignty in the Holocaust has been compared to the experience of colonised peoples, with Khanna (after Achille Mbembe) noting that 'some colonialisms have to be understood as similarly forming a systematization through which [. . .] bodies are deemed disposable' (Khanna 2008: 25). We might say that emblematic of the subjected and sovereign colonial subject is the mother in *Le Vent des Aurès*. In her journey she embodies agency and self-possession (in silhouetted shots of her crossing the landscape), but also servitude and self-loss – lost among the ruins in long shot, staggering back and forth beside the prison fence, and finally dying in the dust. She is both subjected and sovereign.

During the war, two million Algerians were displaced, with the result that a total and brutal 'dépaysement' is the defining characteristic of the conflict for Algerians (see Bourdieu 1961: 24). Bourdieu notes that depopulation during the conflict (due to fighting, flight and

the French policy of displacement and resettlement) even reached those remote mountainous regions that had to some extent escaped the colonial system:

> Des milliers d'hommes sont au maquis, dans les camps d'internement, dans les prisons ou bien réfugiés en Tunisie et au Maroc; d'autres sont partis pour les villes d'Algérie ou de France, laissant leur famille dans le centre de regroupement ou au village; d'autres sont morts ou disparus. Des régions entières sont presque vides d'hommes. [. . .] Les femmes et les vieillards sont restés au village avec les enfants [Thousands of men are in the resistance, in internment camps, in prison or refugees in Tunisia or Morocco; others have gone to the cities of Algeria or France, leaving their families in regroupment centres or villages; still others are dead or missing. Entire regions are almost devoid of men. The women and the old men have stayed in the villages with the children]. (Bourdieu 1961: 26)

As we have seen, this is the subject matter of *Le Vent des Aurès*. The film also depicts the collapse of the traditional family structure under conditions of conflict: 'La famille patriarcale [. . .] est dispersée et souvent déchirée' [the patriarchal family is dispersed and often torn apart] (Bourdieu 1961: 26–7). While *Le Vent des Aurès* expresses the themes of familial change, dispossession, and a struggle to hold on to a sense of Algerian identity via the figure of the lone mother, a recourse to masculine heroism is more typical of 1960s Algerian film-making, as in the *cinéma moudjahid* action film *Les Hors-la-loi*, directed by the co-writer of *Le Vent des Aurès*, Tewfik Fares.

Les Hors-la-loi (Fares, 1969)

The historical conceptualisation of space differs between Arab and European traditions. As Viola Shafik reminds us, traditional Islamic art refused 'figurative spatial representation' while the Renassiance bequeathed to European art the masterful viewpoint of central perspective, giving the observer 'not only the feeling that he [*sic*] comprehends reality completely, but also a sense that he is able to control it' (Shafik 2007: 55, 56). Hence the European colonial project is one of spatial mastery, disciplining space. This project has been served by visual media such as painting, photography and cinema, creating an 'empire of landscape', a 'form of image production in which the force of technology sustains the illusion that progress is a definitive result of colonial development' (Zarobell 2010: 131). Or as Richard Dyer

observes, 'Even the wildest, most dwarfing landscapes may also sug-
gest Western man's heroic facing up to the elements' (Dyer 1997: 37).
As these quotations suggest, space is gendered in European tradition,
especially so in representations of exploration, colonialism, and pioneer
narratives. Dyer notes that in cinema, 'The Western as (man-led,
woman-inspired) success myth allows us to experience a sense of
white historical mastery over time and space' (Dyer 1997: 36) And
the spatial codes of the Hollywood Western were in fact re-appropriated
by the *cinéma moudhjahid* with a view to reclaiming such 'mastery'.

Fares's outlaw narrative *Les Hors-la-loi*, set in the years just prior to
the outbreak of the independence struggle in 1954, uses the Hollywood
Western as a narrative and aesthetic template in order to link the
outlaws of colonial Algeria with the fighters of the *moudjahidin*.
Referencing the Western genre was also a means of reaching out to a
wider audience at a time when *cinéma moudjahid* was seeking to retain
a presence at the domestic box office. The film's ideological connection
with the FLN struggle is signalled immediately after the opening credits
in a brief but significantly placed cameo by Brahim Haggiag, the actor
who plays Ali la Pointe in *La Bataille d'Alger*. When the protagonist,
a deserter called Slimane (Sid Ahmed Agoumi) is given a lift on the
former's cart, he is figuratively and intertextually climbing on to
the (band)wagon that is the fight for independence, the vehicle of
the *cinéma moudjahid*. Like the mother in *Le Vent des Aurès*, Slimane
journeys alone across the rural landscape of the Aurès region; as in
the earlier film, and in Rachedi's *L'Opium et le bâton* (1969) set in
Kabylia, the FLN's Arabisation policy ensures that we hear Arabic
rather than the local Berber language. At times, the mother in *Le Vent
des Aurès* and Slimane in *Les Hors-la-loi* are framed as a solitary figure
against the background of hills and mountains, with similar, repeated
low angle shots of the silhouetted protagonist, even though the inspi-
ration for the cinematography is Soviet cinema in the first film, the
American genre of the Western in the second. In one particularly
striking instance from *Les Hors-la-loi*, Slimane is framed in the exact
centre of the screen, on horseback, riding off into the mountains to
seek revenge for his inprisonment. This sequence exemplifies Fanon's
comment on the colonial occupation of the landscape: 'The French are
down in the plains with the police, the army and the tanks. On the
mountains there are only Algerians' (cited in Haddour 2000: 187).

If the horse-riding, gun-toting Slimane can be read as a rough
Algerian approximation of the Western hero, his comrade Ali

(Mohamed Chouikh) is a clear avatar of Clint Eastwood's 'man with no name' persona. Wearing blue jeans and a denim shirt, Ali has perfected a moody stare, and is so taciturn that his cell-mate Moh describes him as mute. When Ali does speak, his laconic delivery and practical expertise again evoke Eastwood. Even the soundscape of *Les Hors-la-loi* is reminiscent of the Hollywood Western. Georges Moustaki's score is at times traditional (blending drums, lutes and flutes), but it also makes use of guitar and clip-clopping percussion to accompany Slimane as he makes his way on horseback into the hills. Guitar themes are again used for the recurrent images that evoke the 'dissident landscape' (Evans and Phillips 2007: 25) of the Aurès mountains, and to underline key turning points in the narrative, as when Slimane is captured by the local *caïd* (tax collector) and delivered to the French gendarmes. At various moments doors and boots creak, the wind whistles, crickets set up a crescendo of noise. Set-pieces familiar from Westerns include the pursuit of a wild horse with a wounded hero on its back, the tending of the wounded hero by a potential love interest (Slimane's female cousin, Dawda) and a climactic shoot-out (with the sons of the treacherous *caïd*). Slimane, the avenger dressed in dark colours, is contrasted against the bleached stone walls and ground of the yard in front of his mother's house. Again, he is framed in the centre of the screen, dominating the space around him, standing tall, while his enemies lie low and unseen. In gender terms, their position inside the house is feminised: they have no honour and do not fight like men. As such, their fate is sealed.

While the critical reception of the film in France tended to emphasise its reliance on the generic conventions of the Western, the Algerian press read it as an anti-colonial statement, seeing in the outlaws a form of political *engagement* and a precursor of the rebellion of 1954 (see *La République* and *El Moudjahid* cited in Aissaoui 1984: 65, 66). Certainly a discourse of rebellion runs throughout *Les Hors-la-loi*, from the pre-credit sequence where Slimane quits the French army to the successful rescue of Ali from a French prison that concludes the film. The outlaws' rebellion becomes explicitly political when they encourage villagers not to pay taxes to the colonial authorities. Slimane then drives the gendarmes out of his home community, clearly a micro-cosmic version of the war of liberation, while when Ali is captured the issue of torture is raised. A key scene of Slimane, Ali and Moh stealing rifles and ammunition from their French gaolers is an explicit reference to the theft of arms from a French police station that sparked

the liberation struggle in November 1954. Symbolically, the occupa-
tion of Slimane's mother's home by the sons of the *caïd* (killed by
Slimane) recalls the French occupation of Algeria, while the cycle of
betrayal and revenge that drives the narrative may evoke the vicissi-
tudes of the war, although it is based more squarely on the *nif*, the
honour code so essential to Algerian (Berber) conceptions of mascu-
linity (see Bourdieu 1972, 2001, and Chapter 5). Indeed it is the
ingenious combination of the violent logic of the *nif* with the revenge
plot of the Western which really powers the narrative of this unusually
hybrid film.

Conclusion

Martyrdom was central to the FLN discourse legitimising the post-
colonial Algerian state via perpetual reference back to the war against
the French (a reference which became ubiquitous in everyday life, in
the names of streets and cemeteries, as well as in the education system
and the rhetoric of politicians). It is a measure of the tenacity of this
discourse, despite its alienating effect on the people, that on screen it
was ridiculed as early as 1976 – via the war veteran in *Omar Gatlato*
(Allouache) – and yet it is still being mobilised by the teacher in the
classroom sequences from the 2008 documentary *La Chine est encore
loin* (Bensmaïl). The apotheosis of this discourse, as Khanna has
shown, is Makam al-Shahid or the Martyrs' Monument, built in Algiers
in 1982 to commemorate twenty years of independence, but also to
obscure the disparity between the ideals of the revolution and the
realities of the independent state, which was becoming all too evident
at a historical moment when

> the economy of Algeria was beginning to shift from its socialist model,
> when concessions were given to Islamists on such important issues as
> women's rights [. . .], when corruption in the ruling party [. . .] was at
> its height, and when Berber demands were greatly suppressed. (Khanna
> 2006: unpaginated)

If Makam al-Shahid, in Khanna's words, serves 'the assimilation of
the dead [. . .] into the national body', relegating the hundreds of
thousands who died in the struggle to 'the garbage can of modern
nationalism' or a giant chimney 'in which they burn' (Khanna 2008:
18, 27), the crucible where the discourse of martyrdom was forged
is the *cinéma moudjahid*. Khanna reminds us that cinema was crucial

to the formation of national identity in a country with diverse languages, and with illiteracy rates in 1962 of 80–90 per cent (see Khanna 2008: 107). Following on from the critical success of pioneering films about the war such as *La Bataille d'Alger* and *Le Vent des Aurès*, the *cinéma moudjahid* of the late 1960s rapidly mythologised and ossified the representation of the liberation struggle. Funded by the state-run ONCIC (Office national pour le commerce et l'iindustrie cinématographiques) which had been set up in 1967, the *cinéma moudhajid* was exemplified by films such as *La Voie* (Mohamed Slim Riad, 1968), *L'Opium et le bâton* (Ahmed Rachedi, 1969), and *Patrouille à l'est* (Amar Laskri, 1971). The last, most expensive, most successful and perhaps most pessimistic avatar of this trend, Mohamed Lakhdar Hamina's *Chronique des années de braise*, won the Palme d'or at Cannes in 1975. The official discourse surrounding these films was that they represented national unity. The newspaper *El Moudjahid* described *L'Opium et la bâton* as featuring 'un "TOUT" qui résiste [. . .], ce "tout" c'est le village, donc l'Algérie' [a WHOLE which resists; this whole is the village, hence Algeria], and saw *Chronique des années de braise* as presenting 'tout un people [comme] acteur et héros' [an entire people as actor and hero] (Aissaoui 1984: 78, 160). The discontents of the national stuggle (the MNA or Mouvement national algérien, the female fighters or *moudjahidat*, various Berber-speaking communities) had no place in this monolithic, memorialising cinema. Certain groups had to wait until the 1980s or 1990s to find representation in Algerian cinema, as with Okacha Touita's account of the MNA in *Les Sacrifiés* (1982 – the same year as the building of Makam al-Shahid, and immediately banned by the state) or the Berber cinema of the 1990s (see Chapter 5). Possibly the most taboo subject pertaining to the conflict, the treatment of the *harkis*, was addressed in Touita's *Le Rescapé* (1986) which, as has been noted with some understatement, 'seems not to have been released' (Armes 2005: 41). But in the midst of the *cinéma moudjahid* a brilliant glimpse of an other, unofficial Algerian cinema is provided by the remarkable French-language experiment *Tahia ya didou* (Mohamed Zinet, 1971).

Tahia ya didou occupies a pivotal position between fiction and documentary, as indeed between the certainties of *cinéma moudjahid* and the complexities of the new Algeria. It captures the hectic modernisation of the Boumediene era while reflecting back on the aftermath of historical trauma and providing an experimental formal example for 1970s classics such as *Omar Gatlato* (Allouache, 1976) and *La Nouba*

des femmes du Mont Chenoua (Djebar, 1978). The outlaw status of the film is apparent from the history of its reception. Commissioned and funded by the city of Algiers as a municipal celebration, *Tahia ya didou* was rejected on completion and never given a proper cinema release, while Zinet never made another feature. Despite this, and its never being shown on Algerian television, the film was screened from time to time at the Cinémathèque in Algiers and gradually generated a cult following. (Allouache's *Bab El-Oued City* (1994) includes a deliberate *hommage* in the scenes where two French tourists revisit Algiers.) The capital city represented nearly ten years after independence in *Tahia ya didou* is caught between tradition and modernity – as in the very first sequence where a line of mounted tribesmen contend with a jet taking off from Algiers airport. The new, independent Algeria is being built throughout the film, evident in the shots of construction sites and the almost abstract sequences showing the neon lights of the city. This is a place of bourgeois leisure – not just for the Algerian middle class at play but also for a French tourist couple, Simon and his wife. But it is also a city that has not entirely divested itself of the past, personified in the peasants driving their mules through the streets. Moreover, this past includes the national trauma of the conflict with the French, evoked in the images of women tending graves in the cemeteries. But this is not the militant, unified city of national struggle realised in *La Bataille d'Alger* or the site of state-sponsored mourning as at Makam al-Shahid. Here Algiers is fragmented, plural, playful. Public spaces and discourses are interrupted by the emergence of personal, individual voices. The FLN's rituals are mocked when a ceremony at a sports stadium is interrupted by a woman shouting from the crowd. The casbah is represented – in colour, and ofen in *cinéma vérité* footage – as a ludic space where children repeatedly play football, and where, in a comic strand that runs throughout the film, a gang of boys, with the tiny Didou last in line, are perpetually chased by a rotund policeman. The kaleidoscopic tone of the film includes the performance of Arabic poems by local writer Himoud Brahimi, also known as Momo (with added French voiceover, as if in defiance of the FLN's Arabisation policy). But it is via the representation of the aftermath of the war that *Tahia ya didou* most clearly sets itself apart from conventional representation.

The ominous opening sequence of *La Bataille d'Alger* – when paratroopers pour over the rooftops of the city – is here repeated as a memory that now inscribes itself in the postwar relations between

Algeria and France, symbolised by the visit to Algiers of the French couple. On a terrace overlooking the city and the port – evoking the opening credits of Pontecorvo's film – Simon's wife asks a young Algerian woman where the soldiers were. The Algerian's response – 'là, là, là, là, partout' [there, there, there, there, everywhere] – is illustrated by jump-cuts to sites across the city. But she adds, 'Tout ça, c'est du passé maintenant' [all that is in the past now], and then refers to the French tourist as 'my sister'. Even the death of her brother and his ascent to paradise – 'il est au paradis maintenant' [he is in paradise now] – is only sketched briefly, with the language of martyrdom here rendered personal and casual, far removed from the language of the state, the monumentalism of the *cinéma moudjahid* or of Makam al-Shahid. In this regard *Tahia ya didou* is half-way to the iconoclasm of *Omar Gatlato*, where the dramatic drums of *La Bataille d'Alger* are parodied on the soundtrack, and with blasé humour Omar recalls a protest against the French occupiers only because he lost a shoe, and was smacked by his mother. The crux of *Tahia ya didou*'s engagement with memories of the war comes in the climactic flashback sequence initiated by a chance meeting in a restaurant between Mohamed, an Algerian veteran (played by Zinet), and Simon, who is revealed as this man's former torturer. In a gesture that recalls Fanon's observation in *Les Damnés de la terre* that the French torturers have been traumatised by their own brutality, Zinet ultimately reveals that the bloody memories flashing across the screen are in fact Simon's. In one of Fanon's case studies, a French torturer also meets his victim (in a hospital) and each recognises the other: while the Frenchman has an anxiety attack, the Algerian in despair attempts to commit suicide, since he believes he is about to be tortured again (Fanon 1991: 318–19). But in Zinet's film there is a twist. The French torturer has recognised his victim and not vice versa because, as we realise at the end of the sequence, Mohamed is blind. Hence the parade of French violence – from ninetheenth-century depictions of the fall of Algiers and the infamous *enfumades* of the colonial campaigns to a torture sequence led by Simon and other paratroopers – is revealed as brutalising and traumatising the perpetrator. And although we surmise that Simon's victim has been blinded by the torture, he at least is accompanied by a child (Didou himself) who symbolises a route to the future. By contrast, the French couple are childless, locked into a brutal past (expressed in Simon's memories as traumatised flashback) or a bland touristic present (his wife's uncomprehending consumption of the

new Algiers). Without monumentalism or mourning, then, *Tahia ya didou* moves beyond memories and mythologies of the war and presents an Algerian future symbolised – as in later films such as *L'Arche du désert* (Chouikh, 1997), *Rachida* (Bachir-Chouikh, 2002) or *Lettre à ma soeur* (Djahnine, 2008) – by the symbolic figures of children.

For Sheikh Ben Badis, 'wife and children are the bonds that tie patriotic man to his motherland' (cited in Lazeg 1994: 84). Even in his absence (imprisoned, missing, martyred), 'patriotic man' seems to still determine conceptualisations of the nation and of the national struggle against colonial rule. This is manifest in the films we have considered: Didou embodies the war veteran's survival in the newly independent Algeria in *Tahia ya didou*; the mothers in *Les Hors-la-loi* and *Le Vent des Aurès* personify the motherland and the ties between people and territory. Patriotic man is also at the centre of the heroic narratives of *La Bataille d'Alger* and *Les Hors-la-loi*. If *Le Vent des Aurès* comes closest to breaking the androcentric mould of the *cinéma moudjahid*, it remains ambiguous, according to whether one reads the mother as sovereign or as subjected. And it is not irrelevant to note that none of these films was made by a woman. The masculine domination of Algerian cinema in the 1960s, echoed in its representations of the war, reflects the power structures of the resistance movement itself during the conflict: 'there [was] no explanation provided by the FLN for the near-absence of women (0.5 per cent) in political positions inside the country, as well as in the Algerian Government in Exile established in Tunis, which remained an all-male insititution' (Lazreg 1994: 125). This androcentric polity was to remain in place after 1962, determining gender relations in the independent Algeria and ensuring that liberation from French rule did not mean liberation from patriarchy.

References

Agamben, Giorgio, *Remnants of Auschwitz: The Witness and the Archive* (translated by Daniel Heller-Roazen) (New York: Zone Books, 2002).

Aissaoui, Boualem, *Images et visages du cinéma algérien* (Algiers: ONCIC, 1984).

Armes, Roy, *Postcolonial Images: Studies in North African Film* (Bloomington: Indiana University Press, 2005).

Bataille, Georges, 'La "vieille taupe" et le préfixe "sur" dans les mots "surhomme" et "surréaliste"', in *Oeuvres complètes, II: Ecrits posthumes 1922–1940* (Paris: Gallimard, 1970), pp. 93–109.

Bourdieu, Pierre, 'Révolution dans la révolution' (1961), in Bourdieu, *Interventions, 1961–2001: Science sociale & action politique* (Paris: Agone, 2002), pp. 21–8.

Bourdieu, Pierre, *Trois études d'ethnologie kabyle/Esquisse d'une théorie de la pratique* (Paris: Editions du Seuil, 1972).

Bourdieu, Pierre, *Masculine Domination* (translated by Richard Nice) (Cambridge: Polity Press, 2001).

Caruth, Cathy, 'Introduction', in Caruth (ed.), *Trauma: Explorations in Memory* (Baltimore: Johns Hopkins University Press, 1995), pp. 3–12.

Caruth, Cathy, 'Literature and the enchantment of memory: Duras, Resnais, *Hiroshima mon amour*', in Lisa Saltzman and Eric Rosenberg (eds), *Trauma and Visuality in Modernity* (Hanover, NH, and London: Dover College Press, 2006), pp. 189–221.

Djebar, Assia, 'Regard interdit, son coupé', in Djebar, *Femmes d'Alger dans leur appartement* (Paris: Des Femmes, 1980), pp. 145–66.

Djebar, Assia, *Algerian White* (translated by David Kelley and Marjolijn de Jager) (New York and London: Seven Stories, 2000).

Dyer, Richard, *White* (New York and London: Routledge, 1997).

Evans, Martin and John Phillips, *Algeria: Anger of the Dispossessed* (New Haven and London: Yale University Press, 2007).

Fanon, Frantz, *Les damnés de la terre* (Paris: Gallimard, 1991).

Haddour, Azzedine, *Colonial Myths: History and Narrative* (Manchester: Manchester University Press, 2000).

Kaplan, E. Ann, *Trauma Culture: The Politics of Terror and Loss in Media and Literature* (Piscataway, NJ: Rutgers University Press, 2005).

Khanna, Ranjana, 'Post-palliative: coloniality's affective dissonance', *Postcolonial Text*, 2:1 (2006), at http://postcolonial.org/index.php/pct/article/view/385/815, unpaginated, accessed 21 April 2010.

Khanna, Ranjana, *Algeria Cuts: Women and Representation, 1830 to the Present* (Stanford, CA, and London: Stanford University Press, 2008).

Lazreg, Marnia, *The Eloquence of Silence: Algerian Women in Question* (New York and London: Routledge, 1994).

Le Monde, 'Dossier: la torture dans la guerre', 9/10 May 2004, pp. i–viii.

Leys, Ruth, *Trauma: A Genealogy* (Chicago: University of Chicago Press, 2000).

MacMaster, Neil, *Burning the Veil: The Algerian War and the 'Emancipation' of Muslim women, 1954–62* (Manchester: Manchester University Press, 2009).

Meflah, Nadia and Mathilde Marx, 'Rencontre avec Gillo Pontecorvo pour *La Bataille d'Alger*' (May 2004), at www.objectif-cinema.com/interviews/322.php, unpagimated, accessed 21 March 2006.

Sansal, Boualem, *Poste restante: Alger. Lettre de colère et d'espoir à mes compatriotes* (Paris: Gallimard, 2006).

Scarry, Elaine, *The Body in Pain: The Making and Unmaking of the World* (Oxford: Oxford University Press, 1985).

Shafik, Viola, *Arab Cinema: History and Cultural Identity* (revised edition, Cairo and New York: The American University in Cairo Press, 2007).

Spivak, Gayatri (1996), 'Subaltern talk: interview with the editors' in Donna Landry and Gerald MacLean (eds), *The Spivak Reader* (New York and London: Routledge, 1996), pp. 287–308.

Truffaut, François, *Hitchcock* (revised edition, London: Paladin, 1986).

Yacine, Kateb, *Nedjma* (Paris: Editions du Seuil/Points, 1996).

Zarobell, John, *Empire of Landscape: Space and Ideology in French Colonial Algeria* (University Park, PA: Pennsylvania State University Press, 2010).

4

Representing gender: tradition and taboo

Case studies: *Omar Gatlato* (Merzak Allouache, 1976), *La Nouba des femmes du Mont Chenoua* (Assia Djebar, 1978), *La Citadelle* (Mohamed Chouikh, 1988)

Gender is one of the most vexed questions in modern Algeria and has been approached in diverse films of different genres and periods. The three chosen here represent an awareness of the loss caused by the segregation of the sexes and the patriarchal nature of Algerian familial and social relations. The context for these films is to a large extent derived from not just Islamic traditions and taboos but also state policies in both colonial and postcolonial Algeria. Each film approaches the question of gender from a distinct perspective: in the popular comedy *Omar Gatlato* (Allouache, 1976) it is masculinity that is at stake, while the mise en scène ultimately demonstrates the impossibility of breaking the barriers that separate men and women. In a very different genre, *La Nouba des femmes du Mont Chenoua* (Djebar, 1978) presents a hybrid of documentary and art cinema in order to listen to the voices of generations of women long silenced or ignored. Finally *La Citadelle* (Chouikh, 1988) explores the tragic violence of gender relations in Algeria under the constraints of the 1984 Family Code and *sharia* law.

The gendered look is a staple of Western film theory; it is also central to the construction and management of gender in Islamic societies. Be they Arab or Berber, Algerian films engage with a series of taboos and traditions that centre on how women are looked at. A young woman in *Bab El-Oued City* (Allouache, 1994) is incarcerated by her brother for fear that she be seen by male eyes – a powerful, quasi-magical, performative gaze that he literally underlines by putting on heavy black eyeliner. In the Berber film *La Montagne de Baya* (Meddour,

1997) the protagonist, once widowed, blackens a mirror to symbolise that she is no longer an appropriate object even for her own gaze. Veiling is a closing-off of women as objects of desire from the threat of the male gaze. In pre-colonial Algeria, the veil was less prevalent, although vision was still central to constructions of gender difference: for example, Algerian women did not veil themselves before Christian captives, believing that 'these men "could not see"' (Lazreg 1994: 22). Under colonialism, the veil became more widely worn:

> The veil became women's refuge from the French denuding gaze. However, its form changed, becoming longer, and it acquired a new significance as a symbol of not only cultural difference but also [. . .] of virtue among many Algerian girls growing up during the colonial era. Thus, *hijab* (protection) became the antidote to *kefsh* (exposure). (Lazreg 1994: 53–4)

Spatial segregation can be seen as an extension of the veil, and the spatial and social separation of the sexes is a perennial feature of Algerian cinema. Gender segregation is a given in the urban Algiers of Allouache's *Omar Gatlato* and *Bab El-Oued City* as well as in the rural villages of *La Citadelle* or *Rachida* (Bachir-Chouikh, 2002) and the historical settings of *La Montagne de Baya* (Meddour, 1997) or *La Colline oubliée* (Bouguermouh, 1996). Even in the more liberated Western-style sexuality of *Viva Ladjérie* (Mokneche, 2004), gender divisions and prohibitions remain powerful. There is little in Algerian cinema comparable to the playful celebration of childhood pleasures in *Halfaouine* (Boughedir, Tunisia, 1990), where the boy protagonist savours his last moments of sensual pre-adolescence in the feminised private space of the *hammam* or women's baths, before he is inducted into the world of men and enters what in Lacanian terms we would call the symbolic realm, governed by the law of the father. In Algerian cinema that moment of schism, of loss, of segregation has always already happened.

As the mother in *Le Harem de Madame Osmane* (Mokneche, 2000) declares, 'l'extérieur, c'est le monde des hommes, l'intérieur, c'est celui des femmes, chacun sa place' [the outside is the world of men, the inside the world of women – each in their own place] (see Kummer 2004: 115). In her novel *Vaste est la prison* Assia Djebar describes the way that gendered bodies function under this code: women imprisoned, men 'imposing their bodies on space' (Djebar 2001: 303). The genders are kept apart. In the film *Le Soleil assassiné* (Abdelkrim Bahloul, 2003),

set in the early 1970s, the young actress Brigitte is told that she cannot perform alongside male actors, and hence Hamid has to play the female role in their production. Public spaces such as the neighbourhood or *houma* are encoded as masculine: 'The public spaces that constitute the *houma* are places *par excellence* for the deployment of masculinity' (Hadj-Moussa 2009: 124). Hence in *Les Hors-la-loi* Slimane manfully stands up to his enemies in a public space within the village. This representation of heroic masculinity thus does not just match the conventions of the Western (see Chapter 3), but overlays them with the 'mythico-ritualistic' meanings that Bourdieu identifies in Kabyle culture, where the masculine is associated with height, heat, day, noon, the sun, public space and the colour white (see Bourdieu 2001: 10). This illustrates the commonality of many elements within the representation of gender and space: 'The same system of classificatory schemes is found, in its essential features, through the centuries and across economic and social differences' (Bourdieu 2001: 81). The creation, division and policing of space gives rise to what Bourdieu calls symbolic violence: 'space is one of the sites where power is asserted and exercised [. . .] as symbolic violence that goes unperceived as violence' (Bourdieu 1999: 126). The symbolic violence of Algerian culture is often predicated on massively powerful and strongly embedded gender constructions, notably the opposition between 'la sexualité féminine, coupable et honteuse, et la virilité, symbole de force et de prestige' [guilty and shameful feminine sexuality, and virility, a symbol of power and prestige] (Bourdieu 1972: 49). Djebar in her brilliant essay 'Regard interdit, son coupé' has sketched the history of the two codes that traditionally governed Algerian women, the law of invisibility and the law of silence (see Djebar 1980). She locates an increasing dispossession of women vis à vis men in the modern colonial era (1900–54), and describes the Algerian woman under colonialism as 'doublement emprisonnée donc dans cette immense prison' [doubly imprisoned in this immense prison] (Djebar 1980: 159). Gayatri Spivak states that 'If, in the context of colonial production, the subaltern has no history and cannot speak, the subaltern as female is even more deeply in shadow' (Spivak 1988: 287). Elsewhere, French colonial rule in Algeria has been described as visiting upon indigenous women a 'triple colonial oppression' effected by means of 'racial discrimination, class and gender' (MacMaster 2009: 27). Peasant women in particular (the vast majority of Algerian women) lived under simultaneous patriarchal systems, both indigenous and colonial. An

example of the perpetuation of the latter even in the closing years of French rule was France's insistence in 1953 that a clause be added to the UN Convention on the Political Rights of Women, declaring that 'The French government, given the customs and religious traditions in existence in its territories, reserves the right to suspend the execution of the present Convention in relation to women residing in these territories' (cited in MacMaster 2009: 56). Thus one form of oppression doubled and cynically maintained another, since it was politically expedient for the French to placate hardline Islamic and patriarchal opinion in colonial Algeria by refusing to reform the status of women. According to Djebar the only compensation, if such it is, sees the mother become the voice of history, albeit a voice without a body. Moreover, although the *moudjahidat* managed to temporarily break the hold of patriarchy on Algerian women, after the war against the French was won, silence was again imposed: 'Le son est de nouveau coupé' [the sound was cut again] (Djebar 1980: 184).

Women functioned meanwhile as symbols or guarantors of national identity and cultural authenticity. Under colonialism, according to Lazreg, 'being largely bypassed by the nineteenth century colonial educational policy, women were less prone to experiencing doubts about the validity of their culture [. . .]. In this sense, women kept Algerian culture whole and cohesive' (Lazreg 1994: 79). By the time of the Algerian revolution, 'married women, as the educators of children [. . .] and guardians of the sacred space of the household, were widely regarded as the transmitters of core identity' (MacMaster 2009: 262–3). But symbolic violence limited the actual spaces where women were free to operate. As clearly stated by an ALN captain during the war, 'In an independent Algeria the freedom of the Muslim woman will stop at her threshold' (cited in MacMaster 2009: 338). And so it proved. The official numbers of the *moudjahidat* were recorded by the Algerian government in 1974 as roughly eleven thousand (see MacMaster 2009: 239, n.35). But no room was found for women in the politics of the one-party state: Boumediene's suggestion 'that a woman should be appointed to the top executive [. . .] was rejected, and the most prominent women, like Mamia Chentouf [. . .] and Djamila Rahal, were largely restricted to symbolic acts of international solidarity that served the purposes of FLN propaganda' (MacMaster 2009: 333). Meanwhile, on the ground the condition of women changed little, apart from advances in the education of girls. Women's employment, for instance, remained extremely limited: in 1954 only

2 per cent of women were in paid work; this rose to just 2.6 per cent by 1977 (see MacMaster 2009: 370). In the legislative elections of December 1991, only 1 per cent of the 5,700 candidates were women (see Mediene 1992: 73). Literacy rates among women have however vastly improved: where in 1980 a vast 75.5 per cent of women were illiterate, by 2003 the figure was 39.9 per cent, while by 2008 there were more female than male students in secondary and tertiary education (Change 2009: 41).

In terms of the film industry, women's involvement as writers and directors remained rare until the late 1990s. The major pioneer was Djebar herself, whose first film, 1978's *La Nouba des femmes du Mont Chenoua*, called into question gender roles while recording women's stories of resistance and survival (see below). The result in many ways fulfils Teshome Gabriel's call for a 'hetero-biography', that is, 'a multi-generational and trans-individual autobiography' where 'the collective subject is the focus' (Gabriel 1989: 58). More recently, gender roles are inverted in *Barakat!* (Sahraoui, 2006) where the two travellers are women and the home they come across, with its hearth fire, is the space of the (admittedly widowed) male farmer. In *Délice Paloma* (Mokneche, 2007), the protagonist known as Madame Algeria has more or less vacated the domestic space in order to enter, with a degree of defiance, the 'masculine' space of business (and corruption). The gendering of space and of function is depicted as being more fixed in rural Berber communities, as in the Aurès settings of *La Maison jaune* (Hakkar, 2007) and the documentary *La Chine est encore loin* (Bensmaïl, 2008). In all male-dominated societies, as Bourdieu has observed, women are assigned to 'continous humble, invisible tasks' (Krais 1993: 159). The work of film-makers such as Malek Bensmaïl, Mohamed Chouikh and Assia Djebar makes visible those 'invisible tasks'. This is all the more important since, in the case of the newly independent Algeria, it was the labour of the female revolutionary fighters, the *moudjahidat*, that was gradually erased from history and from its representation as myth in the *cinéma moudjahid* (see Chapter 3). The women fighters in *La Bataille d'Alger* (1965) rarely speak, and, although active militants, they remain under the leadership of men. However, Pontecorvo's film does at least subvert the colonial imagery of entirely passive, objectified Algerian women. The sequence featuring three Algerian women placing bombs in cafés is well known, but Pontecorvo seems to deliberately include in this sequence an ironic allusion to the passive femininity displayed in Eugène Delacroix's

famous painting of 1834, *Femmes d'Alger dans leur appartement*. This iconic colonialist image (painted four years after the French occupied Algeria) is emblematic of national and gendered power structures: 'In portraying the Algerian women as submissive, sensual and inviting, he is implicitly saying that the country is a place of fertile riches and therefore ripe for colonization' (Evans and Phillips 2007: 4; see also Djebar 1980). Pontecorvo references the painting and its assumptions via a narrative context that could hardly be less passive or submissive: his three Algerian women wait in their apartment (in a fixed tableau shot that recalls the Delacroix) for the delivery of the bombs whereby they will wage war on the French. Moreover, the role of disguise is also inverted – via a mirroring that is signalled by the mirror that appears in both the painting and the film sequence. Where Delacroix used 'three French models dressed in North African costumes' (Evans and Phillips 2007: 4), Pontecorvo has his *moudjahidat* disguise themselves in Western dress in order to pass freely through the checkpoints and to the heart of the European quarter of Algiers. In *La Bataille d'Alger* the women can attack the French only by modelling themselves on Western codes of femininity (putting on make-up and more revealing cothes, dyeing their hair) in order to pass the checkpoints, and by carrying the bombs as part of their new apparel (in a handbag, a beach bag, a little basket). Their enclosure (both cultural and political) will be transcended as they leave the casbah and enter the European districts, circulating with freedom while working to dismantle the constraining colonial occupation.

But despite the agency accorded the bomb-carrying women in *La Bataille d'Alger*, the women remain instrumentalised by their role in the struggle and above all by their function within a male-dominated FLN structure. At no point do they take control of the strategy themselves, they simply follow male-voiced commands in an almost complete silence. The limitations of this form of representation are clear when we compare *La Bataille d'Alger* with Rabah Laradji's *La Bombe*, one of three episodes from the portmanteau fiction film *Histoires de la révolution* (1969). Where the women of *La Bataille d'Alger* remain nameless and voiceless, the protagonist of *La Bombe*, Fatima (Dalila Ouyed), is characterised as a speaking and thinking subject who makes a series of existential choices that structure the narrative. After her brother is murdered by the French terror group the OAS (Organisation de l'armée secrète), Fatima decides to plant the bomb that he was due to carry. As she travels into the European district of Algiers, first on foot

and then on a bus where she is surrounded by drunken French soldiers, repeated facial close-ups iterate her agency and her decision-making. A glimpse of one of her fellow passengers at the bus-stop reveals one of the three women from *La Bataille d'Alger* who again remains mute, as if to contrast with the vocal assertiveness of Fatima herself. At three key moments in the narrative Fatima has to assume a form of performative responsibility when confronted with masculine authority: taking upon herself her dead brother's mission within the FLN cell; negotiating with the French soldiers for the return of her bag (with the hidden bomb inside); and finally, at the café which is her target, asserting her gendered national identity in the face of the four OAS killers by declaring 'Je suis algérienne' [I am an Algerian woman]. Fatima's sacrifice involves not just her death at the end of the film but also a certain humiliation at the hands of the soldiers and the killers, but these moments are chosen by her as existential steps towards the completion of her mission. Her final decision – to return to the café and slap the OAS leader – buys sufficient time for the bomb to explode and her mission to be accomplished. She thus stands alongside the mother in *Le Vent des Aurès* as a rare example from the *cinéma moudjahid* period of a martyred female hero.

One of the great disappointments of the independent Algeria was that the freedom of women to dress and move freely (authorised in the militant activity of *La Bataille d'Alger* and *La Bombe*) was restricted, despite their role in the liberation struggle. The erasure of the *moudjahidat* from the representation and celebration of the war is addressed in *Barberousse, mes soeurs* (1985, Hassan Bouabdallah), financed like Djebar's *La Nouba des femmes du Mont Chenoua*, by Algerian television, the RTA. As Ranjana Khanna notes, 'The film is a documentary about women's responses to a feature film called *Barberousse* (Hadj Rahim, 1982) in which no women are depicted [. . .]. The women, many of whom were prisoners in Barberousse, respond to the film, and then go on to tell their own stories about the prison' (Khanna 2008: 283, n.55). After independence, Algeria could turn to a number of Islamic states for models of progressive laws encouraging women's rights and restricting the more repressive elements of religious tradition, as in Kemalist Turkey in the 1920s, the Syrian Code of 1953, or the Tunisian Family Code of 1956, which established a minimum age for marriage, required the consent of both partners, banned polygamy and also banned the husband's right to divorce simply by repudiation. But these examples were not followed. As Neil MacMaster has shown,

both during the war and afterwards, FLN policy was further removed from socialist secularism than some historians have suggested; instead it was complicit with hardline Islamist opinion in maintaining a deeply embedded patriarchal system which blocked any possibility of granting women's rights. A powerful mixture of the FLN's perennial need for legitimation (which, in the absence of democracy, it sought in Islam as well as elsewhere), nationalist ideology, and paranoia about 'Western' or 'French' models of modern identity, including feminism, ensured the maintenance of the status quo. Patriarchy was moreover sacralised, or at least appeared to be so, by religion: 'since Islam provided the crucial ideological formation, the sacred [. . .] doctrinal base for family regulation (notably through the *sharia* and customary law), most Algerians *believed* that the defence of patriarchy was a religious obligation' (MacMaster 2009: 19, italics in original). Hence the rapid closing down of any glimpse of greater liberty for Algerian women. The neo-colonial independent state thus acted in a very similar fashion to the colonial occupiers when ignoring Algerian claims for greater freedom in the aftermath of an earlier Liberation, that of France in 1945. And as MacMaster notes, 'it is possible to trace a link between this fatal [FLN] pact with conservative Islamist forces and the bloody civil war after 1992 during which extreme levels of [. . .] violence were directed specifically against "modern" women who were perceived as a threat to patriarchy' (MacMaster 2009: 20; see Chapter 7).

The context for our chosen films, the Boumediene presidency and its aftermath, was a time of major achievements in education: 'From 1964 to 1978 the number of girls in school almost trebled', and by the early 1980s the literacy gap between the sexes was 'most certainly narrowing'. All the same the expectation remained in traditional, often rural, households that at puberty girls were to be removed from school, after which point 'it may be dangerous for the girl to move about outside the home, and it is time for her to prepare for her marriage' (Inger 1983: 202). Under President Boumediene's stewardship, the 1976 National Charter and the subsequent new constitution had enshrined rights such as freedom of expression and assembly. It had also decreed that the sexes were equal and that both should enjoy freedom of movement and the right to participate in national life. However, the years after Boumediene's death saw women's rights in Algeria gradually eroded, with a ministerial decree in 1980 'prohibiting women from leaving Algeria without a male chaperone' (Evans and

Phillips 2007: 137). This was followed by the projected Family Code which President Chadli sought to introduce in 1984 (after previous failed attempts under Boumediene in 1972 and 1979). Inspired by *sharia* law, the Family Code as initially passed by the National Assembly in June 1984 was a total assault on women's rights:

> In the Code women did not exist as individuals in their own right but only as 'daughters of', 'mothers of', 'sisters of' or 'wives of'. The Code made them dependent on their father, brother or closest male relative for work, marriage, education, divorce and inheritance. Polygamy was authorized, whilst women could not arrange their own marriage or marry a non-Muslim. Women were not allowed to travel without the approval of a male family member. At every level the Code contradicted the Constitution. (Evans and Phillips 2007: 126–7)

After feminist demonstrations led by the group Collectif Femmes, invoking the role that female veterans had played in the liberation struggle, Chadli withdrew the bill that would have made the Code law. But in 1986 a new National Charter was passed, displaying hardline Islamic influence and emphasising 'the centrality of Islam to the Algerian identity' (Evans and Phillips 2007: 127). Women's rights were again under threat.

The greatest hope for women's rights prior to the 1990s civil war – or *guerre virile* in Jacques Derrida's phrase (see Khanna 2008: xiii) – and the innumerable rapes and murders that ensued was the brief presidency of Mohammed Boudiaf, a former resistance leader who returned to Algeria in early 1992 after twenty-eight years of exile in Morocco. A key moment in his presidency saw him invite a delegation of women to meet him on International Women's Day, 8 March 1992 – the first and only Algerian head of state to make such a gesture. Less than four months later he was assassinated. Boudiaf's murder, as well as hampering the development of women's rights, also contributed to a sense of Algeria as a country without trusted paternal figures: in Djebar's formulation, 'Land of the vanished fathers' (Djebar 2000: 222). More generally, the relation between the genders in Algeria can be described in the terms used by Djebar for a missed encounter with a male writer: it is a 'non-meeting', in fact a series of non-meetings, governed by the 'ossification' of both parties in their traditionally segregated positions (Djebar 2000: 135). This ossification is central to the representation of gender in the pioneering comedy *Omar Gatlato*.

Omar Gatlato (Allouache, 1976)

Omar Gatlato has been described as a comedy about the absence of women in a phallocratic society (Boughedir 2004), and as one of North African cinema's recurrent attempts to explore the network of barriers between inside and outside, private and public, the realm of the feminine and the realm of the masculine (De Franceschi 2004). By concentrating on a man who is present in every scene and who cannot find a way to communicate with women, the narrative explores the invisible code, what Bourdieu would call the symbolic violence, that governs gender relations in the Algeria of the 1970s. The film bypasses the mythologising conventions of *cinéma moudjahid* (see Chapter 3) to present an engaging but ultimately pathetic male protagonist who struggles to make contact with women. Allouache's handling of a socially relevant subject in a fresh and innovative way (with humour and playful to-camera address) ensured a huge success for this, his first film, on its release in 1976. It was watched by three hundred throusand spectators in Algeria and broke domestic box office records (see Armes 2005: 105).

The film begins with Omar (Boualem Bennani) getting dressed for work, introducing himself and his surroundings direct to the camera. The construction of masculinity is immediately apparent in his appearance and his words. Explaining that his nickname 'Gatlato' refers to his obsession with machismo, Omar declares that virility is all that counts in life. He does this while arming himself with the props of a fashionable and spectacular masculinity: boots, tight trousers, shirt open to reveal chest hair and medallion. The story that follows will test this hyperbolic, theatrical masculinity against the constraints and fears of gender relations in 1970s Algeria. Where the films of Nadir Mokneche thirty years later concern female display (see Chapter 8), *Omar Gatlato* presents repeated examples of male display (at the beach, at the wedding, in the football crowd), while contrasting this with restrictive Islamic codes governing female appearance. When Omar leaves his apartment at the start of the film, for example, we see him moving with speed and ease down to the street, framed for a moment next to two women, identical in white robes and veils, their slow gait and covered bodies juxtaposed with his eager mobility, revealing clothes, and half-bared chest. Carrying with him at all times his comb (to style his appearance) and his tape player (to soundtrack his activities), Omar is closer to the disco fan played by John Travolta in

Saturday Night Fever (Badham, USA, 1977) than to the austere freedom fighter heroes of the *cinéma moudjahid*. The memorialising of the war against the French is moreover gently ridiculed in scenes where Omar recalls being punished by his mother for losing his shoes during an FLN demonstration, or has to hear for the umpteenth time his uncle's exaggerated reminiscences of heroic combat (see below). Such generational clashes are part of the modernity of the film's vision. Omar's loquacious narration also demonstrates a rejection of traditional constructions of Algerian masculinity. The classic Algerian model of masculine authority – the father – never reveals his interiority: 'IL n'exprime jamais ses emotions [. . .] ne dit jamais rien, ne partage aucun sentiment' [HE never expresses his emotions, never says anything, never shares his feelings] (Begag 1986: 144, 150). In contrast, at least in the first half of the film, Omar shares with the audience his hopes and fears via his insistent voiceover.

Masculinity idealised in the form of the *chouahada* (martyrs of the war) is introduced at the start of the film by images of a memorial plaque and graves in the cemetery, but these brief glimpses are simultaneously undercut by Omar's narration. These are ancient history, relics of his childhood when he escaped from the French gendarmes' blows but not from those of his mother. This sequence also reveals that Omar's father is dead, killed during the struggle, an absence that mirrors the loss of a generation but also allows the evacuated space to be filled with the FLN's mythologising and misrepresentation:

> Land of the vanished fathers, always absent and who can now be invoked ad nauseam, masked, betrayed, who can be forgotten! From here on in orphaned sons abound, overshadowed, [. . .] sons without fathers, each one forever fearing the resuscitated gaze of the latter should he come back by some misfortune, alive, to weigh on them! (Djebar 2000: 222)

Exemplifying this invocation of the past – and weighing heavily on Omar but also ridiculed by him – is Uncle Tahar, a war veteran uncle whose exaggerated accounts of his own glorious heroism put the old grandfather to sleep, as if Tahar personifies the alienating effects of the culture of martyrdom, the *cinéma moudjahid*, and the state discourse that created the monumental Makam al-Shahid. This putting to sleep of the populace after the achievement of independence is precisely what Fanon predicted: 'Pendant la lutte de libération le leader réveillait le peuple et lui promettait une marche héroïque et radicale.

Aujourd'hui, il multiplie les efforts pour l'endormir' [during the libera-
tion struggle the leader woke the people and promised them a heroic
and radical journey. Now, he makes very effort to put them to sleep]
(Fanon 1991: 210). All that remains of the revolution in *Omar Gatlato*
are the war graves, the lies of Uncle Tahar, and the sound of drums
– the latter an echo of *La Bataille d'Alger* but here applied either to
evocations of ancient history ('that was a long time ago' says Omar)
or to the trivial everyday struggles of the present, as the 'orphaned
sons' of the city try to avoid being mugged, confront women selling
counterfeit jewellery, and chase off intruders who threaten their piece
of urban territory. As a woman on the bus declares, there are no real
men any more. Omar is an infantilised male, unmarried and feckless,
bonding with his quasi-adolescent buddies, afraid of the touch of the
gendered other (he shrinks when a woman's hand accidentally touches
his on the bus). The cassette recording of Selma's voice comforts him
with the reassurance of a maternal ideal (the feminine as voice but
not sexualised body). Meanwhile the new Algeria, the young Algeria
of the Boumediene years, is symbolised not just by the infantilised
Omar but also in the figure of his young cousin, a half-naked little
boy (reminiscent of Didou in *Tahia ya didou*) who stands perplexed in
the crowded apartment, a shot that carefully deploys the national
colours of red, green and white to emphasise that here – in an everyday
space in Bab El-Oued rather than in the monolithic official discourse
of martyrdom – is the future of Algeria.

The first women that Omar introduces are his mother and his sisters.
In accordance with cultural convention, they are associated with
domestic space and are seen only in the apartment or on the terrace.
They are moreover silent, and hence seem disempowered. Omar, mean-
while, talks incessantly, acting as a guide to the spectator while moving
freely through the streets of Algiers. The impression of gendered power
thus created will however be undermined as we witness Omar's fear
of women and growing emasculation. The trope of the woman at the
window, also used by Allouache in *Bab El-Oued City* (1994), illustrates
the distance between Omar and women. He glances up at Zheïra
(a name he has invented since he has never spoken to her) each time
he walks to work, and sometimes she looks back at him, but that is the
limit of their interaction. In almost every other activity he undertakes,
Omar remains in an all-male world: the workplace, the cinema, the
café, the beach, the football match. Omar is the avatar of a society
that separates the sexes, and hence is intimidated by actual physical

contact with women. During the wedding sequence (as is characteristic in Algerian films) the genders are kept apart: the men are seen outside listening to music, dancing and talking while the women remain off-screen, their celebratory cries heard but their bodies unseen. The same is true of Selma – the woman that Omar falls in love with – until the final sequence. She is heard (on the tape, on the phone) but not seen. Her body remains invisible; she is a disembodied presence and only as such can she enter Omar's world. When she assumes embodied form, in Omar's imagined version of their meeting, a blue filter and disorienting camerawork present this as a form of living nightmare.

The narrative hinges on the discovery of the gendered other, when Omar comes across the tape with Selma's voice recorded on it. Up until this point, women have remained a more or less voiceless homogeneous mass – ofen veiled and robed, as with the black market jewellery sellers, who are shown as so many interchangeable and anonymous white-robed figures, in contrast with Omar's all-male team from the office, each of whom he has introduced and characterised and each of whom has his own nickname, his own particular physical appearance. Selma however is individualised: she has a name, a work-place, a story, a voice (not an identity fantasised by Omar). Every night Omar listens to her brief message on the tape. He later tells her on the phone that her voice soothes him to sleep. In this connection it is no coincidence that we never hear the voices of other women in the film. Omar's sisters and mother, as we have noted, remain silent. If Omar's mother has no voice, then Selma does: she replaces the maternal voice, and generates a desire for the encounter with the gendered other. But when the possibility of something other than a maternal fantasy arises – that is to say, when Omar is due to finally meet Selma – he panics and runs away.

If real women are unapproachable, kept at a distance by a mixture of gender conventions and Omar's own anxieties, fantasy women circulate throughout the film. These provide glimpses of a femininity which is not constrained, enclosed or covered head to foot. Like the belly dancers in Mokneche's films, these women appear on a stage or in a frame, for a predominantly male audience. Hence the pin-up of a woman inside the door of Omar's treasure chest of cassettes, the photos of 'a girl in every port' kept by the ex-sailor Mal-de-mer, the princess in the amateur dramatics sequence, or the singing, dancing women of Omar's beloved Indian films. Unlike the still images, or the stiff theatricality of the play, the latter example shows a non-Algerian

femininity as active, mobile and spectacular. It is Hindu rather than Islamic, enjoying a freedom of movement and a degree of display that is otherwise limited to men in *Omar Gatlato* (we see men swimming, playing football, chanting, dancing). The extract of Indian cinema that Omar watches includes scenes of a singing action heroine riding a horse and carrying a sword. Dressed in revealing clothes not unlike those of Mokneche's belly dancers, the Indian heroine is frozen mid-song when the film reel gets stuck, and as the male audience boos, this celebratory image of female performance melts away, as if burned or corroded by the toxic gender tensions of Algeria. Omar is at once the product and the vehicle of these tensions. He exists in a society where gender segregation channels and codifies contact between the sexes. But it is his voice, his narration, that calls forth the images of women (and men) that we see, almost as if he were creating the women on the terrace, the men in the office, by speaking of them. This is exemplified by Zheïra: a framed image, into which Omar can read his own fantasy of the idealised, unapproachable woman in the window.

A similar ambiguity concerns Omar's own identity. Throughout the film, passivity and emotion are characterised as feminine. Omar declares his love of Indian film music by saying that, if he was a woman, he would cry when he hears it. The love affairs dramatised in a TV soap opera are eagerly consumed by his mother and sisters, sat mute and immobile in front of the television. Securely positioned with his uncle on the opposite (masculine) side of the frame, Omar mocks the women for this pastime. But he himself is revealed as passive and emotional: he is unable to arrest a female jewellery seller, is beaten and robbed by thieves, cries in despair and pain when drunk, and remains paralysed by fear when confronted by Selma in the flesh. His collection of tapes includes live recordings of music from weddings – a sign of his love for *chaâbi* music, but also an indication that he dreams of marriage (an entry into adulthood which he is unable or unwilling to achieve). Above all, in his dealings with Selma, Omar is disempowered and emasculated. The cyclical narrative reinforces this feeling: Omar ends up exactly where he begins. As Roy Armes notes, '*Omar Gatlato* is a story of defeat' (Armes 2005: 104). Masculinity here is unable to reach out and cross the barriers of gender and space. It prefers to stick to its own, in all-male groups such as the football crowd or the office team. The buddy movie elements of the film derive from this motivation, as when Omar gets mugged when out with Coco, or drunk when out with Moh. Omar's failure is also the failure of his

male colleagues, since – with the exception of Moh, who works with Selma – they appear sufficiently ill at ease with women to turn up at the end and mock his efforts, calling out at Omar to leave Selma and join them. When Omar turns away from Selma without daring to meet her, a tracking shot follows him slowly and mournfully uphill from left to right. This shot reverses the exuberant tracking shot, right-to-left, which followed Omar dancing with joy downhill after his successful phone call asking to meet Selma. The sense of progress expressed in this camerawork (right-to-left is the direction of reading and writing in Arabic cultures, and *Omar Gatlato* is filmed in Arabic) is revealed as illusory. The cycle closes and the film ends as it began, with Omar back where he started, in his mother's overcrowded apartment, dressing for another day at the office.

The impossibility of gender relations in Algeria, comic terrain for Allouache here, becomes tragic in Mohamed Chouikh's *La Citadelle* from a decade later. Marriage is the only authorised form of relationship between the sexes in *La Citadelle*, but in the shadow of the Family Code marrriage is shown to reiterate patriarchal power, enshrine polygamy and disempower women (see below). Chouikh's protagonist Kaddour is as naive and infantilised as Omar. Both men are characterised in part via the association between innocence and masculinity that Bourdieu identifies in traditional Algerian culture: 'man is situated, within the system of oppositions that links him to woman, on the side of good faith and naivety (*niya*), the perfect antitheses of *thah'raymith* [devilish cunning]' (Bourdieu 2001: 51, n.79). Other examples of masculine innocence in Algerian cinema are the hapless Hassan in a comedy series that includes the well-named *Hassan Niya* (Bendeddouche, 1988), and the ubiquitous figure of the young male child, from *Tahia ya didou* (Zinet, 1971) via *L'Arche du désert* (Chouikh, 1997) to *La Chine est encore loin* (Bensmaïl, 2008). Female children are much more rarely represented – although there are exceptions at the end of *La Citadelle* and in recent films by women such as *Rachida* (Bachir Chouikh, 2002) and *Lettre à ma soeur* (Djahnine, 2008) – while the demonization or abuse of adult women is critiqued in *La Citadelle*, *Youcef* (Chouikh, 1993), *Rachida*, *Al-Manara* and *Lettre à ma soeur*. The key precursor for female directors such as Yamina Bachir-Chouikh and Habiba Djahnine is the novelist and film-maker Assia Djebar. Her first film, critiquing and subverting traditional constructions of gender while celebrating the transmission of female memory down the generatons, is the remarkable *La Nouba des femmes du Mont Chenoua*.

La Nouba des femmes du Mont Chenoua (Djebar, 1978)

Written and directed by Assia Djebar, *La Nouba des femmes du Mont Chenoua* is in many ways an exceptional film, 'an outstanding formal feminist experiment' (Armes 2005: 122). Ambitious, complex, combining documentary and fictional elements, filmed by a woman about women's history, it presents a clear contrast with the mythologising action films of the *cinéma moudjahid* and the socialist realism of the *cinéma djidid* (see Chapter 2). Above all it replaces the male gaze of Algerian cinema with a female gaze, thus challenging scopic hegemony: 'Une femme [. . .] qui regarde, n'est-ce pas en outre une menace nouvelle à leur exclusivité scopique, à cette prérogative mâle?' [Isn't a woman who looks a new threat to their scopic monopoly, their male prerogative?] (Djebar 1980: 152). But the film's official standing is slightly ambiguous. Its production was funded by Algerian state television (the RTA), and it was according to Djebar the first film to have a colour print developed in the country rather than abroad. But despite this the film was screened only once on domestic TV, and omitted from the otherwise comprehensive celebration of Algerian cinema published by ONCIC in 1984 to mark thirty years since the beginning of the liberation struggle (Aissaoui 1984). Although Djebar went on to make another film, *La Zerda ou les chants de l'oubli* (1980), also funded by the RTA, it took some years for her lead to be followed by other female directors, in part because of the retrograde influence of the Family Code in the 1980s and of the civil war in the 1990s. Certainly in the early 1980s she was still Algeria's 'sole woman filmmaker' (Armes 2005: 40). Her influence can however be seen in the more recent emergence of a new generation of female film-makers in Algeria since the end of the black decade, including Yamina Bachir Chouikh (*Rachida*, 2002), Djamila Sahraoui (*Barakat!*, 2006) and Habiba Dhjanine (*Lettre à ma soeur*, 2008).

La Nouba des femmes is set in the Berber region of Chenoua, a mountain between Cherchell and Tipasa, west of Algiers and near the Mediterranean coast. This is Djebar's home region but as she laments in her novels (see for example Djebar 2001) she is unable to speak the local Berber language. Hence the film is shot primarily in French. The narrative concerns Lila (Sawan Noweir), a 'Westernised' Algerian woman who has recently returned from abroad to live with her wheelchair-bound husband Ali and their daughter Aïcha. Initially presented as trapped in this domestic setting, Lila begins to visit the villages

nearby, gleaning stories and memories from the women of her tribe. She thus engages with a local oral history which is explicitly gendered – a marginalised history which *cinéma moudjahid* for instance had excluded from its state-sponsored narratives. Lila's mobility is spatial (she has lived 'beyond the sea' and is shown undertaking various journeys, by jeep and by boat) and also temporal (she travels back into the past, into the marginalised history of Algerian women). The film culminates with a sequence symbolising the transmission of oral testimony down the generations as a line of grandmothers, mothers, daughters and granddaughters whisper their stories across a long space representing Algerian history. This remarkable scene literalises the passing of experience from generation of women to another – a process explored in a more recent context by Mokneche's *Viva Laldjérie* (2004) – and thus reminds the spectator of this female tradition: 'Throughout the colonial era and before the advent of television, storytelling was the quasi-monoploy of women' (Lazreg 1994: 108). In *Vaste est la prison / So Vast the Prison*, her novel based partly on the film shoot, Djebar explicitly links memories of the past to hope for the future, and uses the spatial trope of the threshold: 'this introspective, backward-looking gaze could make it possible to search for the present, a future on the doorstep' (Djebar 2001: 306). As we know from Bourdieu, in Berber culture the threshold is a strongly gendered site. Woman is guardian of the threshold, while 'La sortie est le movement proprement masculine, qui conduit vers les autres hommes' and 'le déplacement seuil au foyer [. . .] incombe à la femme' [Going out is a purely masculine movement, leading to other men; it is the responsibility of women to move from threshold to hearth] (Bourdieu 1972: 78, 80). In *La Nouba des femmes*, these gender conventions are inverted. Lila's assertive agency and her decision to cross the threshold of her own house to go out into the region collecting stories is contrasted with the immobility of her estranged husband, Ali, who is in a wheelchair and spends most of the film, silent, brooding in the house.

The gender code that incarcerates women is established at the start of the film but gradually undone as the narrative follows Lila out of the house (and into the past and stories of female resistance). When the couple are first introduced Djebar is careful to show Lila as if imprisoned, inside looking out through a barred window, and uses a very similar composition to those in *La Maison jaune* (Hakkar, 2007, see below) in order to depict the codified, separate gendered spaces of the house with a central axis dividing the couple. The difference here

is that Ali will remain inside (hence emasculated) while Lila will leave, in search of both the past and the future. The film thus represents resistance not just against actual violence (the stories of the *moudja-hidat* fighting against the French) but against the symbolic violence of gendered space. Where *Le Vent des Aurès* (Lakhdar Hamina, 1966) traces a mother's journey across a largely deserted and ruined Algeria in the grip of French oppression, *La Nouba des femmes* presents an agricultural landscape which is inhabited by predominantly female workers. Repeated images show women at work in the landscape, emerging from the fields, carrying burdens. To some extent, like the opening sequences of *Le Vent des Aurès* before the French attack, the Algeria represented in *La Nouba des femmes* is a land of plenty. It is also a land of resistance. The fields and hills, cliffs and caves explored in the film by Lila and by Djebar's wandering camera, form a 'dissident landscape' that facilitated Algerian resistance against the French, be it in the 1870s or 1950s (see Evans and Phillips 2007: 11–25). As the local doctor tells Lila, 'This is our land; on these mountains we were free'. The female voice-over that narrates sections of the film emphasises the contribution of the *moudjahidat*, including the local heroine Zoulikha, declaring 'You were the strength of the struggle'. Women are also shown in prison, and coping with post-independence poverty in the local villages. Historical reconstructions focus on the cave of Dahra where women sheltered during Sidi Malek's 1871 revolt, while a fantasy sequence sees Lila drifting on a boat and dreaming of the various women she has met, listened to and heard about. The cave in particular is a resonant metaphor, a space associated with origins, whether uterine, national (see the cave symbolism in Yacine 1996) or epistemological, recalling Plato's *Republic* where 'the *Hystera* or cave-womb' is 'a metaphor for the origins of knowledge' (Khanna 2008: 13). The cave also reminds us of the importance of dark under-ground spaces in the resistance struggle as depicted in *La Bataille d'Alger* and as theorised by Bataille after Marx (see Chapter 3). In Djebar's film, the cave is above all a feminine space of refuge which is also a kind of echo-chamber evoking the knowledge and history passed down from one generation of women to the next.

Meanwhile masculinity is represented as damaged and impotent. The garrulous energy of the ultimately indecisive and pathetic anti-hero in *Omar Gatalto* has here become a truculent silence. Ali broods as he sits imprisoned in the home and the wheelchair. Early in the film he looks out of the barred window as Lila stands outside by the

beach. The traditional gendering of space has been inverted. Although there is a slight change in Ali's physical condition and hence his mobility – he begins to walk with crutches towards the end of the film, taking up his work as a vet, and visiting a farm to treat a cow – he remains mute throughout. The only sound he makes in the film is to 'Shhh!' Lila in the farm sequence. Moreover, Ali's gaze is constructed as desiring of Lila but impotent and despairing. Djebar calls the film's opening sequence 'The gaze of the paralyzed man: This is the dance of impotent desire. [. . .] The first "shots" of my work show clear defeat for the man' (Djebar 2001: 178). Ali's desiring gaze is not reciprocated; there is no physical closeness or reconciliation between the couple, and Lila leaves him behind on most of her journeys around the region. Indeed Ali is entirely absent from the closing episodes of the narrative. Where physical closeness is shown in the family home, it is between mother and daughter, as when Lila tells Aïcha a folk tale in the bedroom, or they share a bath and Ali watches from the threshold of the room. A complex interrelation of gazes is explored throughout the film, with a series of intricate compositions framing multiple spectators. When Ali watches Lila sleeping, the framing separates them, with the central axis of the door-frame acting as a symbolic barrier between the couple. When a band of musicians pass by the house, Djebar shows a mise en abyme of four looks: Lila watches from above and behind Ali, who gazes at their daughter on the other side of the frame. She in turn looks out of the window at a peasant woman who is staring off-screen at the unseen musicians. Multiple viewpoints are always at stake in the film, notably the viewpoints of women. Djebar sees *La Nouba des femmes* as born out of a historically aware sense of female solidarity: 'As if all the women of all the harems had whispered "action" with me' (Djebar 2001: 179). It is by engaging with other women's memories that the film narrativises Lila's escape from the imprisoning gaze of her husband: 'she herself trying to free herself gradually from this gaze [. . .] by beginning to look at others' (Djebar 2001: 306).

Divided into sections like the movements of the traditional Algerian musical form the *nouba*, Djebar's narrative is also constructed as an enigma, so that the opening images are decoded only via an understanding of history provided by the women's stories and especially by reference to the local revolts of 1871 and 1959. The soundtrack combines voice-over and documentary interviews, Western classical music and traditional Algerian music. A mysterious and slightly menacing

suite by Bartók, inspired by the composer's visit to Algeria, haunts the soundtrack while Ali watches Lila and Aïcha, and later evokes the 'masculine' domain of street scenes and public spaces. As Viola Shafik has noted, the choice of Bartók indicates that Djebar 'is not interested in a folkloric imitation of her own cultural heritage, but in reconditioning it according to the present' (Shafik 2007: 120). Local flutes and drums feature too, providing both diegetic and non-diegetic accompaniment to Lila's journeys. The soundtrack also functions to evoke the liberation struggle against the French, with sounds of gunfire and explosions accompanying enigmatic images of smoke on the hillsides or more explicit scenes of the conflict taken from newsreel footage. The archive footage of the Algerian war and the reconstructions of diverse moments of resistance embed Djebar's film in a sense of historical continuity rather than the ahistorical circularity at times evoked in Berber cinema (see Chapter 5). The historical process addressed by Djebar includes the reappropriation of local territory from the French. The film therefore includes a scene where Lila climbs to the top of a hill where a French tower is situated, the camera's gaze at the village below replacing with an Algerian gaze the scopic and military power of the French, which had been expressed in various photographic panoramas taken from such military sites, images like the nineteenth-century photographs of Félix Moulin, 'taken from a point of view that emphasizes French colonial immersion' in Algeria (Zarobell 2010: 119).

The artifice of Djebar's complex style should not detract from the significance of the oral histories she records in the film. Testimony on women's experience of the liberation struggle remains extremely rare, 'in part because some 96 per cent of all women were illiterate and left very little in the way of written evidence, but also because it has proved particularly difficult to gather and interpret oral evidence' (MacMaster 2009: 14). In particular, deep-rooted codes of honour and silence, plus a tendency to concentrate on the urban, middle-class minority of Algerian women, have seen historical studies often neglect the peasant communities that Djebar engages with. At the film's conclusion a mesmeric song, with lyrics by Djebar, is sung by a group of women, celebrating 'women martyrs' and imminent emancipation: 'women will never return to the shadows'; 'the veil had a reason but the sun of freedom has risen'. The dancing women in the foreground of the cave also recall the closing image of *La Bataille d'Alger* with its personification of the independent Algeria in the form of a defiant

female dancer. The stunning climactic sequence of *La Nouba des femmes*, with its line of women transmitting stories down the generations is briefly evoked, in the context of Islamist definitions of femininity, by the belly-dancing sequence in *Viva Laldjérie* (see Chapter 8) where a grandmother transmits the corporeal memory of female performance from one generation to another, the mirror images of the two dancers reflecting a potential multiplication of female stories like an echo of those from Djebar's film. Djebar glosses the sense of female lineage in *La Nouba des femmes* as follows: 'the white procession of ghost-grandmothers behind me becomes an army propelling me on' (Djebar 2001: 350). The singing of women to commemorate the past, and the transmission of their stories, is repeated thirty years later in *Lettre à ma soeur*. But Djebar's optimistic celebration of women reclaiming a place in national history did not lead to an immediate flowering of female-authored Algerian cinema. Instead, in the mid-1980s the subordination of women in Algerian society was reinforced by the patriachal statutes of the Family Code.

La Citadelle (Chouikh, 1988)

The poster for Mohamed Chouikh's *La Citadelle* shows a woman without a mouth. Written in 1984, although only filmed four years later, *La Citadelle* is a cry of anger and sorrow against the oppression of women under the Family Code and against the suppression of female voices in Algeria – the very voices that Djebar had celebrated in *La Nouba des femmes*. The year 1984, in which the Family Code was proposed, has been described as 'the year of the rupture between women and their government, and [of] women's radical questioning of the state's legitimacy' (Lazreg 1994: 197). Protest groups were set up, such as the Association for Equality between Women and Men under the Law, demanding the abolition of the code, of polygamy and of inequity in property and divorce rights. As for Chouikh, he saw the Family Code as 'allant à l'encontre de tous les slogans, des droits et des libertés supposés de la femme. Ce code fait d'elle une éternelle mineure, tenue d'obéir à son époux et ses parents, vouée à la procréa-tion' [going against all the slogans, the rights, the supposed freedoms of women. This code makes a woman an eternal child, forced to obey her husband and parents, destined only for procreation] (cited in Taboulay 1997: 43). The disempowerment of women is bitterly expressed throughout *La Citadelle*, in two complementary ways: firstly

through a bleak realism that shows women as little more than slaves to their polygamous husbands, and secondly through an allegorical narrative about the outsider figure Kaddour and his mock wedding. Whereas Nadir Mokneche's allegories tend to be comic (see Chapter 8), Chouikh's tend to be tragic, as in the loose trilogy that begins with *La Citadelle* and continues with *Youcef* (1993) and *L'Arche du désert* (1997). Chouikh's films have been characterised by *El Watan* as central to what the newspaper calls revealingly Algeria's 'cinéma féministe au masculin' (Bedjaoui 2006). Although this loaded phrase seems to open a space for female film-makers only to close it again (a feminist cinema . . . made by men), the influence on Chouikh of Djebar's *La Nouba des femmes* is also noted by *El Watan*, as is the existence from the late 1990s onwards of a wave of new female directors. According to Chouikh himself, *La Citadelle* was warmly received by feminist and reformist groups during the unrest of Black October 1988: 'Les gens, les intellectuels, les femmes l'avaient adopté comme porte-drapeau' [The people, intellectuals, women, adopted it as their standard-bearer] (in Taboulay 2007: 41–2; for more on 1988 see Chapter 6).

By setting the film in a remote mountain village known as El Kalaa or 'the citadel', Chouikh is able to portray a reactionary, entirely patriarchal society where men quote the Qur'an to justify their taking of four wives, and proceed to reduce those wives to the level of slaves. While the women in the film are unveiled, this is no measure of emancipation, but rather the reverse. Veiling is largely an urban phenomeneon (see for example *Omar Gatlato* or *Bab El-Oued City*, both set in Algiers), since peasant women in rural Algeria had often gone without the veil, partly because of the hard menial tasks they undertook, but more importantly because remote villages, such as the citadel of the film, 'consitituted quasi-fortified communities which "foreigners" would not enter', thus allowing women to move in public spaces unveiled 'without running the dangers of contacts [with males outside the family group] that might bring dishonour' (MacMaster 2009: 124). Marginalised within the social structures of the village and hence in some ways comparable to the disempowered women of the film is Kaddour (Khaled Barkat), the adoptive son of Sidi, a powerful local elder who is referred to as 'master' by his four wives and by Kaddour, an orphan who has become his factotum. Choukih has explained that he chose a male protagonist who is emasculated in order to come closer as a male director to the suffering of the women themselves (in Taboulay 1997: 44). It is noticeable throughout the

film that Kaddour witnesses and to some extent shares the women's suffering. But he is unable to do anything about it. In fact he rarely speaks: he is almost as voiceless as the symbol of silenced womanhood, the mannequin, which features at key points in the narrative. As in *Omar Gatlato*, the male protagonist introduces his world to the spectator via a daily routine that encompasses family, community, work and so on. But whereas Omar confidently gives a running commentary on his universe, Kaddour merely observes it silently, his mournful face and timid body language revealing that he has no social status in the village. His characterisation also involves an element of transgressive desire, as when he observes passing girls or attempts to gaze on married women, both in contravention of the honour code according to which 'All inhabitants of the village, male and female, as part of a community based on blood ties, understood almost intuitively the unwritten rules that regulated gender roles, segregation and honour' (MacMaster 2009: 124). It is important therefore that Kaddour is adopted: he has no blood ties with the community and despite the master's protection he remains an outsider, breaking the unwritten rules within the strictly codified spaces of the citadel.

The casting of Khaled Barkat is fascinating here, since with his soft voice and forlorn face he incarnates a gentle, emasculated man in an obsessively patriarchal society, while also being known to an Algerian audience for his popular music and playful videos during the 1980s. Kaddour has only about ten lines of dialogue in the entire film, most of them towards the end when his marriage is being planned. Up until his wedding preparations (when he is finally accepted – albeit briefly and with pathetic results – into the society of men), Kaddour is shown repeatedly in the yard along with the women and children, or going about tasks in the village as Sidi's servant. He appears to sleep outside, and at no point does he share the power and privilege that Sidi enjoys. In a key early scene, as the camera drifts over the household walls to follow Sidi beyond the gate where he confronts a delegation of local men complaining about Kaddour's behaviour, the latter remains behind with the wives and children. Like Omar in *Omar Gatlato*, Kaddour often gazes longingly at a woman who appears at her window, and in this case a repeated shot/reverse-shot composition of them smiling at each other suggests there is a possibility of communication between the two, but the gender segregation that hampers Omar is just as strong in *La Citadelle*. Kaddour is chased away by the husband of the woman he adores, and is married off in order to channel his

desiring behaviour. It is, as Kaddour explains, only through marriage that he will be able to gain a sense of identity and social belonging.

Meanwhile, Kaddour undertakes domestic tasks traditionally coded as feminine (collecting and distributing food). One of the most revealing scenes in the film – at once realistic and allegorical – shows him knocking at four doors in turn, giving milk to each of the master's four wives. While Kaddour waits outside, Sidi is shown lying on coloured cushions inside the fourth door, waited on by his youngest wife, who is about to serve him breakfast. The eldest wife appears, and Sidi speaks the film's first words – ordering her to massage his back. Gender, power and exclusion are all succinctly expressed in this little scene. A similar sequence later on shows the three wives of another village elder faced with the arrival of a fourth loom, indicating that a fourth wife is imminent. But the private misery of marriage, as experienced by women (subservience, competition with other wives, drudgery, repeated child-birth, a denial of horizons, mobility and education) is not immediately presented in the film's opening sequences. *La Citadelle* begins (and also ends) with a colourful and spectacular wedding ritual. To the sound of gunshots and music, men singing and women ululating, three grooms in white hoods and robes, sitting on white horses, are led into the village by candlelight. Each is assigned a house where a bride awaits him. As the grooms meet their wives inside for the first time, unveiling them and discovering their identity, a man from the village knocks on each door, impatient to be given a bloodied shirt that can be shown to the crowd as proof that the marriage has been con-summated. For all the spectacle and mood of celebration, this is an index of virility, in which the brides are a kind of sexual test set for their husbands. The repeated gunshots and waving of rifles underline that it is masculinity that is at stake (see Bourdieu 1972: 188, n.10). And as Assia Djebar has observed, the marriage ritual entails violence against women: 'La nuit de noces devient essentiellement nuit du sang' [the wedding night becomes essentially a night of blood] (Djebar 1980: 154). Moreover, for Djebar, the celebratory noise raised by the village during the wedding night serves to mask the silencing and disempowerment of the brides: 'nuit du sang qui est aussi nuit du regard et du silence. D'où le choeur suraigu des longs cris poussés par les autres femmes [. . .], d'où le fracas aussi de la poudre pour mieux envelopper ce silence-là' [a night of blood which is also a night of looking and of silence. Hence the shrill chorus of long cries from the

other women, hence also the roar of gunfire, all the better to cover up that silence] (Djebar 1980: 154). This commotion (and what it hides) is exactly replicated in the opening scene of *La Citadelle*.

The rapid editing of this brilliant sequence – by Chouikh's wife Yamina, who would go on to direct *Rachida* (see Chapter 7) – increases the tension between inside and outside, so that the private is also public, the personal also communal, and the wedding night not a romantic encounter but a social performance. The glimpses of bitterness and violence in the sequence (one groom feels cheated when he sees his bride, another assaults his new wife, a third is fought off and unable to consummate the wedding) culminate in an ironic edit when the shot of tea being poured for a celebratory toast is immediately followed by the image of a horse pissing in the bleak dawn of the next morning. It is, significantly, here in the morning with the livestock that we first see Kaddour, rather than at the public ceremony. He is marginalised, ridiculed and rejected throughout the film and twice is tied up like a dog awaiting his sham marriage. Sidi's wives, too, are identified with animals. Like Kaddour, they are beasts of burden, required to work for their master. Kaddour's imprisonment merely literalises their own. When the family eat a meal, Sidi sits apart consuming the meat that his wives and children (including Kaddour) are denied. When he throws scraps of meat to the dogs, one of his wives cries in fury and despair at her situation, screaming 'C'est une vie de chien' [you treat me like a dog]. Meanwhile Kaddour watches, unable to do anything. This pattern of patriarchal oppression and helpless spectatorship is repeated at the end of the film, via the figure of the little girl who watches Kaddour's death.

Throughout *La Citadelle*, Chouikh ensures that Islamic tradition is seen at the centre of the ideology that controls the village. Boys are seen attending a *madrassa*, men praying in the mosque (while the women and Kaddour pray in the yard). If ancient, mystical forms of belief are presented as superstitious and deluded (the marabout's shrine, the charlatan posing as a wise man), it is *sharia* law that is the yoke under which the women of the village suffer. Under *sharia*,

Women were required to be monogamous, whereas men could have up to four wives at a time. Wives owed obedience to their husbands, who were entitled to keep them at home and to beat them and withhold maintenance for disobedience. Husbands could terminate marriages at their discretion simply by uttering a divorce formula. (Mayer 1999: 99)

Several times in the film wives are referred to as currency in wagers: a playful bet on a game of draughts, or more publicly in Sidi's vow that he will either marry off Kaddour or renounce his four wives. When the old man's three wives discover their husband is about to marry a fourth, Kaddour's first words in the film are to defend their objections: 'Ces trois femmes ont raison [these three women are right]'. But the old man simply responds by declaring that a thousand women don't come up to the level of a man's heel.

The cyclical narrative, like the abortive flight of Sidi's despairing wife, indicates that there is no escape from the citadel, from the *sharia* or from the Family Code. The first establishing shot of the village is a remarkably oppressive composition: a huge boulder blocks our view of the community, with houses visible only in the corners of the frame. Exactly the same image (but this time seen in the yellow light of evening rather than the blue light of dawn) introduces Kaddour's wedding. Again there is the ceremonial robing and the riding into the village, the singing and wailing, then the juxtaposition of public display and private intimacy, as Kaddour is asked to present the evidence of his virility to the entire village. The contrast between inside and outside is underlined here by the contrast between Kaddour's gentle voice as he asks timid questions to his veiled bride and the noise of the crowd. Urged to 'be virile' by men of the village, Kaddour is told to hit his bride in order to make her obey him. When she neither speaks nor moves, he finally strikes her, saying 'Je suis un homme, moi'. But this assertion of masculinity is defeated in the moment of its expression: when he hits his wife, she falls to the ground and is revealed as the female mannequin from Sidi's shop. Staggering outside with his 'bride' in his arms, Kaddour is met by the derision of the crowd. The women, however, are crying – as he is. In the final, tragic sequence, the diegetic noise of the villagers is replaced first by a poignant modern theme by Barkat himself, and then by silence as Kaddour falls to his death. Barkat's theme returns for the final credits as Chouikh freezes the film on a heart-breaking final image which is also, like the mannequin, an allegorical masterstroke. If the mannequin represents the place of women in the Family Code – mute objects, denied a voice and a real existence – then the final image represents the despair of the next generation: it shows a little girl crying at Kaddour's death. Held back by a man's hands, she struggles to break free and cries out 'Let me go' before the freeze-frame too holds her still.

Conclusion

If *La Citadelle* presents gender differences as culturally engrained and patriarchal power as secure, Amor Hakkar's *La Maison jaune* (2007), made twenty years later but also set in a remote mountain community (of the Aurès), shows a gentle erosion of gender conventions which we might interpet as indicative of a slight lessening in the fixity of gender codes. Several key scenes adhere to orthodox spatial constructions, with Hakkar making repeated use of striking compositions where the on-screen space is split between the masculine and the feminine. But at the same time there is a consistent yet subtle transgression of gender norms. *La Maison jaune* is set in a Berber village in the Aurès mountains. In Berber culture, as Bourdieu has observed, the home is feminine, the outdoors masculine, and the threshold a fulcrum between these two worlds (see Bourdieu 1972). Hakkar plays on this dichotomy, and on the symbolism of light and darkness which opposes men and women, outside and inside, future and past: 'le Haut, le Futur, le Jour, le Masculin [. . .] s'oppose[nt . . .] au Bas, au Passé, à la Nuit, au Féminin' [the High, the Future, the Day, the Masculine are contrasted with the Low, the Past, the Night, the Feminine] (Bourdieu 1972: 57). At least four separate scenes reinforce these symbolic divisions by placing the masculine and the feminine on either side of a central axis that splits the frame. Two of these compositions involve shots of the threshold, with the camera inside looking out. Each time the wife is on the right side of the frame, in the interior and in shadow (feminine), while the brighter outside space on the left is lit up by sunlight (masculine). Both shots also show her husband in the bright, outdoor space to the left. These are the gendered constructions of space that Djebar introduces at the start of *La Nouba des femmes*, only to rapidly overturn them. In *La Maison jaune* they remain in play, but there is a consistent transgression of gender norms in the characterisation of the eldest daughter, Alya (Aya Hamdi). Aged about eleven, Alya is on the cusp of adolescence and hence one might expect her to be subject to strict gender codes. Perhaps because of the absence of the only son (whose death is the motor of the narrative), Alya in fact behaves much like a boy. She accompanies her father to the fields and the market, and in the opening scene of the film is seen digging the soil in the family's field. Rather than remaining passive or subordinate, she is active and dynamic, pointing the way to the future (traditionally coded as masculine) and turning her father away

from brooding on the past (coded as feminine). For instance, after the father brings home his son's body, she reminds him of the need to go to market and sell their crops, and later suggests a way of contacting their home to the electrical grid, thus enabling the family to watch the son's video message in the climactic sequence (see Chapter 8).

Alya's free role in the narrative and in film space reinforces, however, the positioning of her mother as entirely congruent with traditional constructions of the feminine (fixated on the past, associated with the home, separated from the masculine public world). While her mother and younger sisters spend most of their screen-time in the house, and wear traditional dresses and scarves, Alya enjoys a much greater freedom of movement, entering public and outdoor spaces constructed as masculine, and presenting an androgynous appearance: she has relatively short hair and is practically always shown wearing trousers. The sense of gender traditions being upheld and challenged at the same time is best exemplified by the funeral scene. The separation of men and women at funerals is very well established in Islamic culture, and can be observed for example in *Rachida*. It seems initially that *La Masion jaune* will stick to this tradition. Hakkar again uses a clearly divided screen, with a central axis separating the masculine on the left from the feminine on the right. Here the central point is the son's body, laid out between the womenfolk on the right (mother, aunts, the two younger sisters) and numerous menfolk on the left, nearer the open countryside and the hills. But as the mourners stand to follow the coffin, we notice that Alya is in the male group, holding her father's arm. Moreover, in the burial scene that follows, she stands at the graveside with her father, greeting the male mourners while her mother and sisters wait out of shot. Only when the menfolk have gone do the women (all in bright dresses and scarves, unlike the androgynous Alya) approach the grave.

Where *La Maison jaune* seems on the whole ambivalent towards traditional constructions of gender, such constructions are more playfully targeted in the robust comedy *Mascarades* (Lyes Salem, 2008). Vigorously portraying life in a small town – again in the Aurès – as a combination of the traditional and the modern, *Mascarades* juxtaposes arid landscapes with luxury hotels, ancient customs with a world of mobile phones, microwaves and video rentals. It is in this context that reactionary and enlightened conceptions of gender clash, when married man Mounir plans to marry off his sister Rym. Played by Salem himself much in the syle of Eddie Murphy (with a stubborn

facial seriousness that breaks into huge smiles or energetic visual comedy), Mounir embarks on a fantastical plan to marry Rym to a visiting Australian celebrity. Feminised by his previous failure to find a husband for her, his family stigmatised by Rym's narcolepsy, Mounir finds his masculinity at stake. He is taunted by neighbours as 'une femmelette' and desperate to prove his patriarchal authority over his 'handicapped' family. The film is thus centred on the desire for social and symbolic capital, for which a successful marriage is the traditional solution. In some ways, then, it is like a comic version of *La Citadelle* (the marrying off of a troublesome relative to maintain social harmony and respect). As one might expect, the gendering of space is central. Hence when Rym and her socially unsuitable sweetheart Ringo meet in secret, she remains inside her room, he out in the yard, and they whisper through the wall to each other, each in their own spatial domain. When Mounir discovers this, his reaction is a hyperbolic parody of patriarchal control: he installs barbed wire in the yard, thus literally imprisoning his sister. The social value of such masculine authority is exaggerated for comic effect when, believing the celebrity wedding to be imminent, the town showers Mounir with absurd gifts. Chairs for the expected guests pile up in Mounir's tiny yard as a parodic reification of the symbolic and social capital that will accrue to the patriarch after a well-made marriage.

If Mounir's fantasy can be read as a critique of patriarchal control and the status of male-authorised marriage as social ritual (again echoing *La Citadelle*), Rym's narcolepsy stands as a metaphor for the enforced submission and passivity of women. By defying Mounir and marrying Ringo at the film's close, she manages to achieve a degree of freedom, and her disability is symbolically cured. But *Mascarades* is essentially conservative in its narrative resolution: the story still ends with a marriage, and social hierarchies are reinforced by the fact that bride and groom are of equally low standing. Nonetheless, the characterisation of Rym and Ringo (modern, enlightened, ignoring traditional constructions of the honour code) and the comic come-uppance of Mounir suggest that gender orthodoxies are susceptible to being overturned in mainstream as well as radical Algerian cinema. Visual culture is also at stake in both *La Maison jaune* and *Mascarades*. Where in *Omar Gatlato* music functions in part to break down Omar's carapace of masculine authority, in the more recent films video plays a similar role. Recent developments in the consumption of images have seen increasing numbers of Algerian men watching satellite TV

in the home, a 'retreat' into the feminised realm of the house, which thereby 'challenges the sexual division of space' (Hadj-Moussa 2009: 126). A similar unsettling of the traditional gendering of space is glimpsed when at the end of *La Maison jaune* the father settles down with his wife and daughters to watch the son's video message. And in *Mascarades* it is noteworthy that Ringo, the unsuitable suitor who together with Rym challenges the patriarchal convention of the arranged marriage, runs a video shop – hence dealing not just in visions of other (screen) identities but in other ways of sharing the gendered space of the home (in order to watch the films).

References

Aissaoui, Boualem, *Images et visages du cinéma algérien* (Algiers: ONCIC, 1984).

Armes, Roy, *Postcolonial Images: Studies in North African Film* (Bloomington: Indiana University Press, 2005).

Bedjaoui, Ahmed, 'Un cinéma féministe au masculin', *El Watan*, 19 January 2006, at www.elwatan.com/Un-cinema-feministe-au-masculin, unpaginated, accessed 2 July 2010.

Begag, Azouz, *Le Gone du Chaâba* (Paris: Editions du Seuil, 1986).

Boughedir, Ferid, 'La victime et la matronne: les deux images de la femme dans le cinéma tunisien', *CinémAction*, 111 (2004), pp. 103–12.

Bourdieu, Pierre, *Trois études d'ethnologie kabyle / Esquisse d'une théorie de la pratique* (Paris: Editions du Seuil, 1972).

Bourdieu, Pierre, *The Weight of the World: Social Suffering in Contemporary Society* (translated by Priscilla Parkhurst Ferguson) (Cambridge: Polity Press, 1999).

Bourdieu, Pierre, *Masculine Domination* (translated by Richard Nice) (Cambridge: Polity Press, 2001).

Change Institute, *The Algerian Muslim Community in England* (London: Department for Communities and Local Government, 2009).

De Franceschi, Leonardo, 'Entre la maison et la ville, la lutte pour l'espace social', *CinémAction*, 111 (2004), pp. 62–6.

Djebar, Assia, 'Regard interdit, son coupé', in Djebar, *Femmes d'Alger dans leur appartement* (Paris: Des Femmes, 1980), pp. 145–66.

Djebar, Assia, *Algerian White* (translated by David Kelley and Marjolijn de Jager) (New York and London: Seven Stories, 2000).

Djebar, Assia, *So Vast the Prison* (translated by Betsy Wing) (New York and London: Seven Stories Press, 2001).

Evans, Martin and John Phillips, *Algeria: Anger of the Dispossessed* (New Haven and London: Yale University Press, 2007).

Fanon, Frantz, *Les damnés de la terre* (Paris: Gallimard, 1991).

Gabriel, Teshome, 'Third cinema as guardian of popular memory: towards a third aesthetics', in Jim Pines and Paul Willemen (eds), *Questions of Third Cinema* (London: BFI Publishing, 1989), pp. 53–64.

Hadj-Moussa, Ratiba, 'The undecidable and the irreversible: satellite television in the Algerian public arena', in Chris Berry, Soyoung Kim and Lynn Spigel (eds), *Electronic Elsewheres: Media, Technology, and the Experience of Social Space* (Minneapolis: University of Minnesota Press, 2009), pp. 117–36.

Khanna, Ranjana, *Algeria Cuts: Women and Representation, 1830 to the Present* (Stanford, CA: Stanford University Press, 2008).

Krais, Beate, 'Gender and symbolic violence: female oppression in the light of Pierre Bourdieu's theory of social practice', in Craig Calhoun, Edward LiPuma and Moishe Postone (eds), *Bourdieu: Critical Perspectives* (Cambridge: Polity Press, 1993), pp. 156–77.

Kummer, Ida, 'Mères et filles dans le cinéma maghrébin ou l'effet de serre', *CinémAction*, 111 (2004), pp. 113–18.

Lazreg, Marnia, *The Eloquence of Silence: Algerian Women in Question* (New York and London: Routledge, 1994).

MacMaster, Neil, *Burning the veil: The Algerian War and 'Emancipation' of Muslim women, 1954–62* (Manchester: Manchester University Press, 2009).

Mayer, Ann Elizabeth, *Islam and Human Rights: Tradition and Politics* (Boulder: Westerview Press, 1999).

Mediene, Benamar, 'Un etat déconnecté', in *Le Nouvel Observateur*, Collection Dossiers, 9: 'La Guerre d'Algérie trente ans après' (1992), pp. 72–3.

Shafik, Viola, *Arab Cinema: History and Cultural Identity* (revised edition, Cairo and New York: The American University in Cairo Press, 2007).

Spivak, Gaytri, 'Can the subaltern speak?', in Cary Nelson and Lawrence Grossberg (eds), *Marxism and the Interpretation of Culture* (Urbana and Chicago: University of Illinois Press, 1988), pp. 271–313.

Taboulay, Camille, *Le Cinéma métaphorique de Mohamed Chouikh* (Paris: K Films Editions, 1997).

Yacine, Kateb, *Nedjma* (Paris: Editions du Seuil/Points, 1996).

Zarobell, John, *Empire of Landscape: Space and Ideology in French Colonial Algeria* (University Park, PA: Pennsylvania State University Press, 2010).

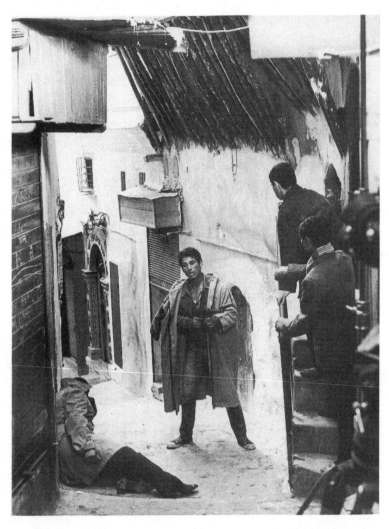

1 The FLN takes control of the casbah in *La Bataille d'Alger* (Gillo Pontecorvo, 1965)

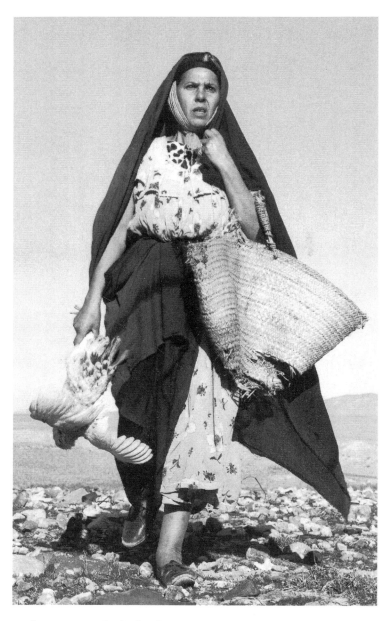

2 The nation embodied as heroic mother in *Le Vent des Aurès* (Mohamed Lakhdar Hamina, 1966)

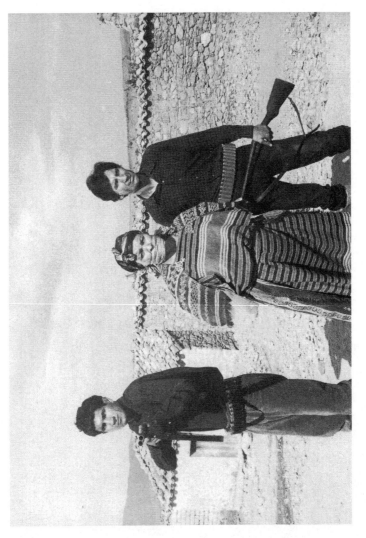

3 Western shoot-out meets Berber honour code in *Les Hors la loi* (Tewfik Fares, 1969)

4 Comic masculinity in *Omar Gatlato* (Merzak Allouache, 1976)

5 Entering the Berber house: 'female' space in *Machaho* (Belkacem Hadjadj, 1996)

6 The cave as site of suffering and resistance in *Youcef* (Mohamed Chouikh, 1993)

7 An allegory of civil war in *L'Arche du désert* (Mohamed Chouikh, 1997)

8 Algeria as incarceration in *Rachida* (Yamina Bachir Chouikh, 2002)

5

Berber cinema, historical and ahistorical

Case studies: *La Colline oubliée* (Abderrahmane Bouguermouh, 1996), *Machaho* (Belkacem Hadjadj, 1996), *La Montagne de Baya* (Azzedine Meddour, 1997)

As exemplified by *La Citadelle* (Chouikh, 1988) from the last chapter, and as reinforced even by the family dynamics of Algerian films where the father is absent, such as *Bab El-Oued City* (Allouache, 1994), where the brother plays the role of patriarch, or *Le Vent des Aurès* (Lakhdar-Hamina, 1966), *Rachida* (Bachir Chouikh, 2002), *Viva Laldjérie* (Mokneche, 2004) and *Délice Paloma* (Mokneche, 2007), where women's mobility is predicated on the death or absence of the father, Algerian cinema tends to reflect the fact that 'The patriarchal Islamic family [is . . .] entirely subordinate to the male head of the household'. To some degree, the Berber family might be said to offer a counter-example, since 'By contrast, the Berber household is effectively ruled by the wife or mother of the eldest male', while the polygamy sanctioned by Islam and by the Family Code is replaced by a tradition of monogamy which 'reinforces the unity of the household' (Brett and Fentress 1996: 242). However, gender distinctions remain central to Berber culture.

In the Mzab region of the Algerian Sahara, 'women are never permitted to leave the oasis, although their husbands spend much of their time away from it'. Moreover, as with the *sharia*-influenced Family Code which grants the husband power to divorce a wife by a performative utterance, so in the Mzab a woman 'can be repudiated at will, and any transgression is severely punished' (Brett and Fentress 1996: 243). In terms of inheritance rights, the passing of the patriarchal Family Code in 1984 apparently represented an improvement for

Berber women living in Kabylia (see Messaoudi 1995: 38). It should be noted in this context that Berber communities are predominantly Islamic, even though their presence in North Africa predates the arrival of Islam in the Arab invasions from 647 onwards. But it would be a mistake to equate Berber culture, tradition and religious customs with those of the Arab majority. Berbers in Algeria have over the centuries embraced dissenting Islamic sects such as Kharijism, and maintained pre-Islamic folk beliefs in holy men or marabouts. Moreover the so-called Kabyle myth propagated by French colonialist discourse sought to distinguish Berbers from Arabs by stressing the Indo-European origins of the former and seeking to place them within a European and even a Christian tradition (see Evans and Phillips 2007: 18, 35–6). In terms of gender, while Arab patriarchy is not replicated as such, Berber identity is constructed on rigid gender binaries. The universe of Berber traditions is saturated with strictly codified distictions between masculine and feminine. This applies in particular to the sexual division of space (see Messaoudi 1995: 42) but applies to all forms and functions of everyday existence. Although there is always a place for the feminine, at the same time the masculine principle is consistently privileged in every binary – for example, light over darkness, right over left, trust over suspicion, openness over secrecy. This 'mythico-ritual system' has been elaborated in detail by Pierre Bourdieu's influential studies of Kabyle Berbers (see Bourdieu 1972 and 2001). It should be noted however that there are certain shortcomings even in Bourdieu's work on Berber culture. For example, orality may seem over emphasised, religion neglected and history replaced by the eternal, cyclical time of 'an enchanted world' (Jenkins 2002: 27). Nonetheless even if the codifications of space, custom and gender that inform Bourdieu's vision of Berber culture have been eroded by modernity, their nostalgic evocation is central to the Berber film-making that finally entered Algerian cinema in the 1990s, as we shall see below.

Representing around 20 to 30 per cent of the Algerian population, the Berber community is an ancient but marginalised one. Berbers are the indigenous inhabitants of Algeria, predating the Roman, Arab, Ottoman and French invasions, and call themselves *Imazighen* meaning 'free men' (see Abu-Haidar 2000: 151). The different communities speak different versions of the Berber language, Tamazight: Kabyle in Kabylia, Chaouia in the Aurès and Mozabite in the Mzab, while the nomadic Tuaregs speak Tamachek. There is also a significant

Berber-speaking Kabyle immigrant population in France. Repeatedly excluded since 1962 by the Arabisation policies of the state, Tamazight was finally granted the status of a national language in Algeria some forty years after independence. Ethnic, cultural and political differences between Berbers and Arabs had been exacerbated under colonialism by French constructions of a commonality between Berbers and a Roman-derived Mediterranean culture. This Kabyle myth, in tandem with the long-standing emigration of Berbers from Kabylia to France during the twentieth century, fed a perception among the Arab majority that Berbers, and in particular Kabyles, were 'friends of France', hence contributing to the marginalisation of Berbers in the liberation rhetoric of the FLN. Independence saw the suppression of Berber studies at the University of Algiers, as well as civil war between the FLN and the FFS (Front des forces socialistes), led by Hocine Aït-Ahmed and fighting for greater autonomy in Kabylia. The defeat of the FFS forced Aït-Ahmed to flee to Europe. In 1964 the Algiers Charter defined Algeria as 'an "Arabo-Muslim country" and decried regional identities as "feudal survivals" and "obstacles to national integration"' (Silverstein 2009: 179). State-enforced 'cultural repression' was fully in train by the mid-1960s, when 'it became illegal to give children Berber names' (Brett and Fentress 1996: 274). The marginalisation of Berber communities by the FLN was not merely linguistic in nature. In the agrarian revolution of the early 1970s 'the FLN established a four-year plan to create 333 collectivised Socialist Agricultural Villages (SAVs) with the goal of disenclaving Kabyle villages and integrating their inhabitants to civic national norms' (Silverstein 2009: 179). It is against this background that one must read the recurrent nostalgia for the apparent timelessness of Berber customs and for the ahistorical spaces of the Berber house evident in the work of Bourdieu and in the iconography of Berber film-making in Algeria.

Significantly, the Berber language remains a predominantly oral rather than written form, although this distinction can be overstated. A Tamazight alphabet has been developed in recent years, and even under colonialism both Arabic and Roman alphabets were at times used to transcribe Berber poems, chronicles and legal codes. Nonetheless the received image of Berber cultural life is centred on orality, folk traditions and the rituals and myths of a type recorded by Bourdieu in his influential but essentially dehistoricised accounts of Kabyle society. Recent critiques of Bourdieu have argued that his work may

have contributed to perceptions of Kabylia and other Berber regions as devoid of written language, and may have even reinforced the exclusion of Berbers from the modern Arab-led nation-state. The marginalisation of Algerian Berber communities by the FLN after 1962 was legitimated by the state 'in part on the grounds that the Berber language lacked writing traditions' (Goodman 2009: 97). One may also ask whether the folkloric, ahistorical customs Bourdieu identified in Berber culture still obtain. Bourdieu himself admitted in conversation with the Berber writer Mouloud Mammeri in 1985 that 'the mythico-ritual structure, the oppositions between the dry and the wet, the masculine and the feminine, no longer operate the way they did', before however asserting that 'they still exist in people's heads, in the language' (cited in Goodman 2009: 107, 108). We might add that these models continue to exist in cinema too. In fact, their erosion in the everyday life of modern Algeria surely contributes to the impera-tive to preserve them in Berber film-making. And this is why Bourdieu's work remains a useful guide to nostalgic constructions of Berber identity, even if he may be said to share this nostalgia himself.

In the 1960s Bourdieu famously noted the many imbrications of gender and space within Kabyle culture, in his essays on the honour code and on the Berber house. The space of the house, the inside, is both sacred and taboo, a secret world (the *haram*) which is contrasted with public space, outside, the masculine realm of *thajma'th*. One key function of Berber architecture in this context is to shield in-terior, feminine space from the eyes of outsider males (see Bourdieu 1972: 47–8). Bourdieu returned to this topic in *Masculine domination* as follows:

> The division of (sexual and other) things and activities, according to the opposition between the male and the female, [. . .] receives its objective and subjective necessity from its insertion into a system of homologous oppositions – up/down, above/below, in front/behind, right/left, straight/ curved (and twisted), dry/wet, spicy/bland, light/dark, outside (public)/ inside (private), etc. (Bourdieu 2001: 7)

As we shall see, such oppositions are mobilised in Berber cinema, above all in the representation of space as gendered. Bourdieu's essays on Berber society and also the celebrations of Kabyle folklore and cultural identity by the Berber Cultural Movement (MCB) have tended to focus on 'gendered images of village or domestic settings [. . .] while bracketing the "Islamic" or "modern" dimensions of Kabyle history

or contemporary life' (Silverstein and Goodman 2009: 43). Berber cinema too tends to demonstrate similar nostalgic constructions and elisions, albeit at times tinged with an awareness of the discontents and tragedies of this folkloric culture – as in the representation of the honour code in *Machaho* (Hadjadj, 1996) – or with the shadowy presence of history, as in the references to the Second World War in *La Colline oubliée* (Bouguermouh, 1996) or to French colonialism in *La Montagne de Baya* (Meddour, 1997). Bourdieu's work also informs the wider question of how minority cultures reproduce themselves culturally – a crucial question for Berber communities in Algeria. Derek Robbins glosses Bourdieu's theorising of reproduction as follows: 'The production and reception of intellectual and cultural artifacts is to be seen as a strategy whereby distinct social groups have sustained their distinction and reproduced themselves' (Robbins 2000: 56). This is at stake in cultural production not just under colonialism but also after independence from colonialism. With regard to Algeria it informs the attempts of Berber communities to sustain their distinction from the Arab majority and to maintain cultural reproduction in the face of repression and restriction by the state. But in an independent Algeria where film production was nationalised, how was this to be achieved?

The anti-colonial, memorialising *cinéma moudjahid* sponsored in the 1960s by the FLN writes Arab-speaking subjects into history but obliterates or forgets others. In Ranjana Khanna's terms, this 'mourning model of nationalism [. . .] seeks to erase differences' (Khanna 2008: 166). The *cinéma moudjahid* is often set in eastern Algeria (where the liberation struggle started on 1 November 1954) but, although the spaces and the images we see are from Berber areas, no Berber language is heard. The Berber communities are rendered mute. Both *Le Vent des Aurès* and *Les Hors-la-loi* (Fares, 1969) are set in the Aurès mountains, a Chaouia-speaking area, but the dialogue is in Arabic and French only. Simlarly, *L'Opium et le bâton* (Rachedi, 1969) is set in Kabylia but there is no Kabyle dialogue. Sound is all the more important in Berber identity formation via cinema since, as we have noted, the Berber languages are traditionally unwritten. Even classics of Berber literature such as Mouloud Mammeri's *La Colline oubliée* (1952) are written in French. Assia Djebar, who writes in French, comments of her lost Berber language that 'I have to recapture the deep song strangled in the throat of my people, finding it again with images', and asks 'how many of us are there who [. . .] feel exiled from

their first writing?' (Djebar 2001: 152). Djebar's *Algerian White* includes a lament for Mammeri and records the words of the poet Tahar Djaout when the state came to mark Mammeri's death in 1989: ' "Your country's television had no footage of you to show us; it had never filmed you, it had never let you speak" ' (Djebar 2000: 144). The filming of Mammeri was in a sense to take place by proxy, in the belated adaptation of his most famous novel in the mid-1990s (see below).

The defeat of the FFS in the wake of independence had significantly weakened Berber separatism in Algeria and 'shifted the locus of Berber political claims' to the expatriate Kabyle community in France (Silverstein and Goodman 2009: 40). Throughout the late 1960s and the 1970s, activists, researchers, publishing ventures and recording artists based in France promoted a dynamic Kabyle culture which included Mammeri and the singer Idir. Mammeri in particular is a crucial figure: the author of novels including *La Colline oubliée*, a founder member in 1969 of the Paris-based Berber Academy for Cultural Exchange and Research, a collaborator with Bourdieu, he was also a renowned scholar on ancient Berber poetry. It was the cancellation by the Algerian government of a proposed lecture by Mammeri in March 1980 at the University of Tizi-Ouzou in Kabylia that was the catalyst for the Berber Spring. Events escalated from a student occupation to riots, a general strike and bloody suppression by troops sent into Kabylia by the new president, Chadli Benjedid. The Berber Spring crystallised Berber identity politics, such that 'Successive waves of contestation to state authority in October 1988, the autumn of 1994, July 1998, and April 2001 have drawn directly on this early moment of confrontation' (Silverstein and Goodman 2009: 42). Although the unrest was violently put down by government forces, with thirty deaths and hundreds of wounded, it signalled the power of Berberism as a form of identity politics and as a challenge to the FLN: 'Henceforth the Berber Spring would be commemorated each year with meetings and protests, an alternative cycle of remembrance that seriously dented the regime's legitimacy' (Evans and Phillips 2007: 123).

The Berber Spring was a product of Kabylia, and was not supported by the Chaouia Berbers of the Aurès, for example. As the novelist Boualem Sansal has noted, the Kabyles are the Berber group most actively engaged in identity struggles (Sansal 2006: 33). The protests of Black October 1988, which were even more brutally suppressed by the state, were in effect national and not Berberist, but were

supported by many activists in Kabylia. In the aftermath of Black October, a series of reforms saw the relaxation of state censorship of the media. In 1991 during this short-lived reformist atmosphere Azzedine Meddour made *La Légende de Tiklat*, a documentary that was screened on Algerian television in both Arabic and Berber versions. Meanwhile the erosion of the state monopoly on the film industry allowed Berber cinema to finally develop (see Baumberger 2004: 213). The feature films *Machaho* and *La Montagne de Baya*, for example, were both reliant for their production on the independent company Imago Films, set up by the directors Belkacem Hadjadj and Azzedine Meddour. However, film-making in Algeria – and particularly in Kabylia – rapidly became a perilous activity. From early 1992 onwards the rise of Islamic fundamentalist terror and state counter-terror resulted in increasing atrocities which eventually claimed up to two hundred thousand lives (see Chapter 7). Among the targets of Islamist terror groups were performers championing Berber identity: the poet Tahar Djaout was killed in 1993, the singer Lounès Matoub in 1994. The filming of all three of our case study films in Kabylia proved problematic and hazardous. Work on *Machaho*, for instance, was delayed when in July 1994, five months into filming, the crew were ambushed. The shoot was subsequently completed only thanks to the local community providing round-the-clock protection. As Hadjadj later asked, 'Qui aurait la folie de tourner en 1994 en Kabylie, en décors naturels, alors que chaque jour apportait son lot de nouvelle tragédies? Qui, sinon des fous mus par l'amour insensé de ce pays et de ce peuple que l'Histoire tourmente?' [Who would have been mad enough to film in 1994 on location in Kabylia, while every day there were new tragedies? Who, apart from the mad, driven by a crazy love for this land and this people tormented by History?] (cited in Baumberger 2004: 214).

La Colline oubliée (Bouguermouh, 1996)

As Hadjadj's comments reveal, the production context for Berber cinema in the 1990s was hazardous, but contributed to a sense of mission that drove the film-makers. The first Berber feature film to be completed in Algeria, Abderrahmane Bouguermouh's *La Colline oubliée* (1996) was hailed by the newspaper *Le Pays* as having been produced not by an individual but by the Berber people. It had in fact taken Bouguermouh almost thirty years to bring Mammeri's well-known novel to the screen; he had submitted the scenario for a film adaptation

as early as 1968 but had seen the project rejected by the state. Bouguermouh had made a *moyen métrage* [mid-length-film] in the Berber language in 1965, *Comme une âme*, but this only resulted in the film being confiscated by the authorities. When finally granted permission to film *La Colline oubliée* in the late 1980s, Bouguermouh found that support from the Centre du cinéma algérien was limited to the provision of technicians and equipment. Hence he was obliged to raise funds from within the Berber community. His eventual success in completing the film in this manner led to the famous declaration by *Le Pays* (see Baumberger 2004: 213). Similar claims about community involvement in producing, acting and filming can also be made for *Machaho* and *La Montagne de Baya*. The release of these three films at the same moment in the late 1990s can be viewed as marking the belated arrival of Berber cinema in Algeria (around five years after its appearance in Morocco).

Mammeri was 'an almost iconic representation of Kabyle tradition' through his writings, knowledge of ancient Berber poetry, and activities in the Berber Cultural Movement (Silverstein and Goodman 2009: 36). He died in a car crash in 1989 so did not see the film adaptation of *La Colline oubliée* nor the coming of age of Berber cinema in Algeria. The novel that the film adapts is an example of Mammeri's detailed historicising of the modern Berber experience – unlike, say, the more ahistorical, eternalising approach to Berber culture evident in many of the writings of his friend and colleague Bourdieu, as well as in other Berber films, notably *Machaho*. As Colonna has noted, Mammeri's novels 'provide invaluable documentation of and testimony to the "adjustments" [. . .] on the part of both men and women that resulted from *local* historical change' (Colonna 2009: 78, italics in original). In the case of *La Colline oubliée*, the local historical change is the impact of the outbreak of the Second World War on the remote village of Tasga in Kabylia. Two male students, Mokrane and Menach, return to the village to await a call-up to the French army. The desire to document the impact of modernity on the Berber community involves challenging tradition (the issue of infertility, desire for a married woman) but there is also a certain celebration, in both image and soundtrack, of Berber identity – location shooting in the mountainous Kabyle landscape, a detailed presentation of the decorative interiors of Berber houses, and a careful attention to the Kabyle language. Moreover, this is not the modernised version of Kabyle spoken by younger generations but a historical, 'impeccable' Kabyle, according

to Bouguermouh (see Brahimi 2009: 183). *La Colline oubliée*, and much Berber cinema generally, hence functions as a curator of folk memory. As Teshome Gabriel asserts, 'folklore attempts to conserve what official histories insist on erasing', so that 'folkloric traditions of popular memory have a rescue mission', with film-makers often serving as 'caretakers' of such memory (Gabriel 1989b: 54–5). In this context it is important to recall the 'erasing' of Berber identity carried out since 1962 by the Algerian state. Although Gabriel sees official histories as being imposed via 'the wilful forgetting of the West' (Gabriel 1989b: 63) rather than of the neo-colonial independent state, as in Algeria, these remarks do illuminate the function of Berber cinema. The distinction between official history and indigenous histories evoked by Gabriel can be mapped directly on to the positions of the FLN and of Berber film-makers, the latter participating in the construction of cinema as a guardian of popular memory: 'Official history tends to arrest the future by means of the past. [. . .] It claims a "centre" which continuously marginalises others. In this way its ideology inhibits people from constructing their own history or histories' (Gabriel 1989b: 53).

The form and style of *La Colline oubliée* suggests however that the Berber history told in the film is largely dependent on a French idiom – rather like Berber novelists such as Mammeri and Djebar using the French language. The idiom here is that of the heritage genre, an often touristic, conventional form that had adapted Balzac, Zola and Pagnol for the screen and proved massively successful at the French box office of the late 1980s and the 1990s (see Austin 2008: 167–98). *La Colline oubliée* follows generic format in its historical setting, privileging of the source text, tableau shots of the landscape and repeated framing devices both visual and verbal (most insistently in the form of window frames and voice-overs). These characteristics are most apparent in the opening scenes, which establish a frame narrative whereby the spectator is introduced to the historical setting. Establishing shots of a carriage travelling though the mountains of Kabylia are followed by a passenger, Menach, revealing that his boyhood friend Mokrane (Mohad Chabane) is dead. In a gesture that indicates the heritage genre's dependence on text, Menach then pulls out Mokrane's journal and begins to read it aloud to his fellow passengers. The film is thus constructed as a flashback, authorised and anchored by the text, to the lost prewar year of 1939 when Mokrane and Menach were young men. The narrative is punctuated by the voice-over from

Mokrane's journal, for instance when new characters are introduced. This reiterates the importance of the source novel and hence the authenticity provided by Mammeri's status in Berber cultural affairs. But it also lends the film a certain heaviness, increased by the fore-knowledge of Mokrane's death, that weighs down this earnest adaptation. The imbrication of Berber identity with history ironically gives *La Colline oubliée* a fixity and a familiarity in terms of genre conventions. While also dealing with matters of gender relations, a sense of belonging and death, Belkacem Hadjaj's *Machaho* is strikingly simple in comparison, ahistorical in setting, but that is the source of its great power.

Machaho (Hadjadj, 1996)

Where *La Colline oubliée* evokes literature and history in the form of its source novel and Second World War context, *Machaho* draws on the ahistorical models of folklore and quest. The plot is a simple cycle, the characters stock types who are best defined by their narrative function: shepherds who help the protagonist, bandits who hinder then help him, men who rescue and are in turn rescued, women who uphold or betray the family honour. The film is at once a perfect illustration of the gendering of space that Bourdieu identifies in Berber culture and a beautifully shot tragedy that has the simplicity, balance and intensity of myth. Moreover, while *Machaho* is a celebration of Kabyle rituals, costumes and songs, it is also tragic precisely because of a key Berber tradition: the honour code or *nif*, the defining principle of masculinity in Berber culture (see Bourdieu 2001: 12).

In a remote wood in Kabylia, coming across a dying stranger in the snow, the peasant Arezki (Belkacem Hadjadj) rescues the young man and takes him home. While convalescing, the stranger, Larbi, has a secret affair with Ferroudja, Arezki's daughter. After Larbi's departure Arezki discovers that Ferroudja is pregnant, and vows not to return home until he has found Larbi and killed him. The majority of the narrative is hence a quest for vengeance in which Arezki slowly nears his quarry while at the same time becoming increasingly alienated from society, abandoning his wife, missing the wedding of Ferroudja and Larbi and the birth of their son, observing social rituals (a harvest, a feast, a funeral) from the edge of the frame, and gradually metamorphosing from a respectable *paterfamilias* into a starving and tormented beggar. A year after the start of the story he wanders close

to his home, collapses in the snow and is rescued by Larbi at the exact point where he once rescued the young man. The inversion is complete when Larbi builds a fire to warm the stranger just as Arezki once did for him. But realising that he has found his quarry at last, Arezki grabs the axe used to chop firewood and murders his son-in-law, before stumbling across his own threshold in a crazed stupor, to leave his wife and daughter calling out for the man he has killed.

The sparse narrative is matched by low-budget shooting, but this is used to great advantage by Hadjadj. Shot in natural light throughout, *Machaho* is magical to look at. Sunlight dazzles, twilight drips with gloomy greys, night sees figures blur across the screen like ghosts. The pastoral activities of Berber life are shown in naturalistic but brilliant colours: green for the olive harvest, gold for the barley harvest. Colour symbolism is also used, with the national palette (the red, white and green of the Algerian flag) apparent throughout the film. But these colours do not function as directly as they do in, say, the characterisation of Madame Algeria from Nadir Mokneche's *Délice Paloma* (2007), or the glimpse of schoolgirls wearing national uniform in Abdelkrim Bahloul's *Le Soleil assassiné* (2003). Here Hadjadj plays on the specifically Kabylian meanings of those colours, hence combining the national and the regional. Thus we see both Larbi and Arezki frequently dressed in white – the colour of masculinity in Berber culture (see Bourdieu 1972: 72). White is worn by the young men in *La Colline oubliée*, too. The snowy setting of *Machaho* also ensures that white is the dominant colour in the two fateful meetings between Arezki and Larbi. Green, associated with spring and fertility, is present in the recurrent images of foliage, the olive harvest and the spring festival, as well as in Ferroudja's headscarf. Red is also worn by Ferroudja (she stands out against the green and gold tableau of the olive harvest) and is matched by the clothes worn by her mother, by her father's hat and cloak, and by the blanket under which Larbi sleeps. The positive cultural associations of red are however twisted in the end so that the fire by which Arezki warms Larbi becomes the site of a murder, and a close-up shows blood on the face of the victim. As we shall see below, sound is also crucial to the evocation of the murder. Sound effects (the fall of the axe, the ominous cawing of crows as Arezki nears home) carry all the more weight since dialogue is minimal in the film. Music plays an important role too, with Idir's lyrical guitar score symbolising the romance between the two lovers, and Ferroudja's singing at key moments acting as a commentary on the action.

Although the setting is vaguely premodern (as much as we can judge from the bandit leader's flintlock pistol), *Machaho* is essentially ahistorical. Its engagement with time is cyclical rather than linear: the repeated precolonial patterns of seasons and rituals (a wedding, a birth, a circumcision, a funeral), exchanges and inversions, misdeeds and settling of scores. The honour code or *nif* is the motor of the narrative and of the tragedy. It is a masculine principle, closely associated with 'physical virility' (Bourdieu 2001: 12). Hence, by killing Larbi at the close of the film, Arezki is demonstrating his own masculinity and he does so against all the odds, that is to say, after having braved the ordeals of solitude, injury, hunger and exhaustion; by still being strong enough and determined enough to carry out this 'honour killing', Arezki proves himself a man. But although Arezki lives by the code, and ultimately enacts the vengeance it demands, at the end of the tale he has destroyed his own daughter's happiness, and returned to a family home ruined by his obsessive desire to protect it according to the *nif*. The simplicity of this quasi-mythical narrative (like that of Oedipus) only concentrates the tragedy. Essential to the plot are two invisible acts: the unseen sex between Larbi and Ferroudja, and the unseen murder of Larbi by Arezki. Their invisibility, and the fact that they are only decoded by the viewer after they have occurred, lend them an almost sacred significance. While the elision of the sex between Ferroudja and Larbi may seem in some ways conventional, the choice not to show the murder scene and to evoke it only by sound is magisterial. It adds a moment of disbelief, when the vacillation in Arezki's mind between duty and forgiveness finds an echo in the spectator's uncertainty about what has actually happened. Arezki's choice to kill becomes a mystery, which cannot be seen and can barely be believed. The blow of an axe is heard but the screen just shows the flames jumping from the fire. Only a few seconds later does a close-up reveal Larbi's corpse. The act of cutting (encoded as masculine in Berber culture) which has previously signified hospitality and generosity (Arezki cutting wood to warm the frozen Larbi, then a reversal of the same) here becomes deadly, just as Hadjadj's cutting (editing) heightens the tragic intensity of the murder.

If the sexual relationship between Ferroudja and Larbi remains off-screen, it is nonetheless indicated by reference to the gender symbolism and the 'mythico-ritualistic' cosmology that Bourdieu has identified as central to Berber culture. Ferroudja removes her head-scarf, revealing her hair (signifying a loosening of the strict control

over her body) when she is alone with Larbi. She also helps him out of bed and down the steps to the 'feminine' part of the house. The mirror taken by Larbi as a keepsake in which he imagines he can see Ferroudja's face while he is away from her recalls the ritualistic function of the mirror in Kabylian rites of masculinity, as signifying a crossing of the threshold between childhood (realm of the mother) and manhood (realm of the father): the young boy looks in the mirror to signify that he has become a man on his first trip to the market (Bourdieu 2001: 26). Larbi's masculinity has been asserted not in a public, authorised ritual like this but in a private, secret and unseen (unshowable) liaison. Symbolism, film style and narrative are synthesised in the central trope of upright masculinity: 'the ethic of male honour can be summed up in a word, [. . .] *qabel*, to face, face up to, and in the upright posture' (Bourdieu 2001: 27). As in *Les Hors-la-loi* (Fares, 1969, see Chapter 3), masculinity is thus associated with height: hence the importance of noon (the height of the day), the masculine symbol of the sun, or mountain-top settings. In *Machaho*, Arezki's pursuit of Larbi involves him climbing hills and mountains, and attempting to scale a cliff (which results in his fall and injury). While Larbi is convalescing in the peasants' house, he sleeps in a chamber placed above the female-coded workspace where Ferroudja caries out her chores, and she has to climb the steps in order to get a glimpse of him. Hadjadj integrates this structuring principle into his camerawork with striking overhead shots, the camera assuming a 'masculine' position looking directly down on the action, and thus evoking a sense both of destiny and of the tragic certainties of the honour code. Both meetings of Larbi and Arezki in the snow (at the start and the end of the film) and the final, longed-for but disastrous arrival of Arezki back home after the murder are shot from above in this way, signalling their importance to the narrative and also evoking a fatalism born of the relentless logic of the *nif*.

Women meanwhile are conventionally placed below men, and are expected to assume stooped or passive positions. When Arezki discovers his daughter's pregnancy, in his patriarchal rage he beats her and then drags her across the floor. The association between women and animality in Berber tradition is evoked when, in the next scene, we see Ferroudja tied up with the cow as punishment for her (apparently animalistic) actions. As in other films set in Berber regions – *Le Vent des Aurès*, *Les Hors-la-loi* and *La Maison jaune* – gender is at stake in framing and in the representation of space (see Chapter 4). Throughout

Machaho, the threshold is presented as a crucial site, and the act of crossing it and entering the world outside is associated with men rather than women. In a prelude to his quest, we first see Arezki crossing outside space, both on horseback and on foot. Meanwhile his wife and daughter remain at home. One of the very few compositions to show both women outside is the almost fantasmagorical sequence when, in desparation, they climb a mountain top to call out for Arezki to return. More frequently, Hadjadj uses a recurrent shot from within the yard of the Berber house, usually from the point of view of a female character, showing the outside world through the gateway at moments when men are setting off on a journey. This composition is used for the departures of Larbi, Arezki and later the two bandits who visit mother and daughter, as well as for Ferroudja's departure to go with Larbi to get married. In the latter case, it is only Larbi's presence as her soon-to-be-husband that authorises Ferroudja's leaving home and her occupying a place on screen so regularly constructed as masculine. The exceptional nature of this scene is reiterated when Ferroudja runs back to embrace her mother once more, thus momentarily abandoning the unfamiliar masculine space beyond the gate.

If these compositions reinforce the conventions governing gender within Berber culture, the film's conclusion sketches a more subtle and unexpected symbolism to evoke the loss that is the cost of such a system. Arezki's return, and the execution of his duty according to the masculine code of the *nif*, is portayed as an empty achievement. The outward signs of celebration that the patriarch has finally come home, and of domestic harmony – cheerful music on the soundtrack, his wife picking oranges from the family tree, wife and daughter then positioned in their rightful place in the yard as seen through the gateway from outside, in a position to welcome back Larbi too – are undercut by the hidden figure in the shot. While Ferroudja and her mother call out for Larbi, the foreground of this final image displays his corpse in symbolic form. A long stone lies on the ground between the two women, just outside the gate to the family home. Like the site of the dead child imagined by Salvador Dalí in his reworking of Jean-François Millet's painting *The Angelus*, this apparently neutral area of ground signifies the dead object that determines the family group. It also signifies the death that lies hidden at the centre of the Kabylian culture that *Machaho* has lovingly recreated. Nostalgia for a timeless Berber identity is thus cut through with violence and a questioning of the sanctity of ancient codes and customs.

La Montagne de Baya (Meddour, 1997)

Recent critiques of Bourdieu's work on Kabylia have observed that he not only tends to dehistoricise Berber practices but also neglects the role of religion in Kabyle communities (see Silverstein and Goodman 2009: 43). To a certain extent, Algerian cinema as a whole shares in this refusal of religion, possibly as a legacy of the officially secular character of the independent nation-state established by the FLN. From the early 1990s onwards, when Islam is evoked it is often problematised via the rise of fundamentalism – witness *Bab El-Oued City*, *Rachida*, *Al-Manara* and *Viva Laldjérie*. Rarely, as in *La Citadelle*, the ancient folk practices of consulting marabouts are depicted. Within the nascent Berber cinema of the 1990s, religion seems at first to be equally marginal. However, Azzedine Meddour's *La Montagne de Baya* (1997) literalises the centrality of folk religion in Berber identity by placing in the centre of the frame Baya (Djamila Amzal), a sacred figure who is both the daughter of a Kabyle saint and the conscience of her community. The film mixes folklore and history, religious ritual and communal work, in an account of a Berber tribe in Kabylia at the height of the colonial period in the late 1800s. After her village is destroyed by the French and her husband killed by a collaborating local *caïd*, Baya and her tribe are driven into the mountains. Refusing to give up to the authorities the blood money that she has been paid, according to the local honour code, for her husband's murder, Baya is hence responsible for her people's poverty at the same time as she is revered as a quasi-saintly figure who may lead them to a safe haven. Ultimately avenging her husband's death by means of her son (who kills the killer), Baya returns the blood money and now that honour has been achieved helps establish a new village on the top of the mountain. She is preparing to marry the outlaw hermit Djendel when the French attack again, killing Djendel and destroying the new village as they did the old.

La Montagne de Baya historicises Berber struggle by placing it in the context of French colonial oppression and more specifically as a reaction to the confiscation of land from rebel tribes. Although no precise date is given, the setting is the general aftermath of the last major Kabyle revolts in 1871 (see Brahimi 2009: 90). The villagers' regular refrain 'Our land! Our land!' equates territory with life. The narrative both begins and ends with French soldiers attacking Baya's tribe and driving them from their homes. But between these two

attacks, there is an attention to cylical patterns such as seasons, work and religious rituals. In a largely circular narrative so characteristic of Berber cinema, the film iterates a pattern of return: not just the comings and goings of Baya and Djendel, the return of each at various points to the haven of the mountain, but more crucially the return of religion, and of the *nif* or honour code, to a community where modern history, imposed by the French, had threatened their continuation. At one point Djendel warns Baya that the old laws no longer hold, since the imperative is now (that is to say, under colonialism) simply survival. But Baya adheres to the eternal values that the colonial encounter is jeopardising. She personifies both the *nif* and the folk religion of the Kabyles. She stands to some extent outside history – unlike her husband and Djendel, she is not killed by the enemy, and she alone is seen at the end of the film having survived the latest French raid. If the reappearance of the French in the final sequence symbolises the return of history, then Baya alone transcends it, because she embodies an eternal Berber identity. She makes use of her knowledge of the Berber house when, confronted by her husband's murderer who wishes to seduce her, she runs into the animals' stall and rubs dung on her face and arms – thus recasting Ferroudja's punishment in *Machaho* as an act of resistance. But she is more than human, as is implied in the rain ritual when she is dressed in a net to help catch the rain-god Anzar. Her practical wisdom in choosing the mountain site and advising the tribe on how to make it fertile is matched by miraculous powers, as when a dead tree she was tied to overnight magically blooms again.

A number of contrasts are mobilised throughout the film in order to dramatise the choices facing Baya and her tribe. However, although we can detect a certain functioning here of the gendered contrasts essential to Bourdieu's vision of Kabylia – as in the segregation of genders in the cave or in village tasks – many of the binaries in the film relate to the colonial context rather than to the internal, eternal spaces of the Berber community. Colour symbolism opposes the Berber villagers, dressed in white and red, with the black-clad French soldiers. The plains – where the *caïd* collaborates with the colonial occupiers – are constructed as a site of deception, corruption and betrayal, as against the mountains associated with purity, freedom and an escape from the oppressor. This spatial dichotomy recalls such films on the national liberation struggle as *La Bataille d'Alger* and *Les Hors-la-loi*, where distinct spaces are identified with the occupiers and the resistance.

The other crucial opposition in *La Montagne de Baya* is between the individual and the collective, epitomised in the tension between Baya's personal interpretation of the honour code and the material needs of her village. Hence the recurrent conflict between her desire to keep the blood money until she has avenged her husband's death, and the tribe's desire to give it to the occupiers in the form of a tax that will allow them to escape further persecution. At its most violent, this tension results in Baya being tied up and whipped by her own tribe. Although she appears to privilege her own feelings over the economic needs of the clan, in fact Baya is motivated above all by the *nif*, the honour code, and her revenge is not purely personal: it restores order and fulfils the requirements of the code. But it does unsettle to some degree the anti-individualism or negation of the self that Bourdieu reads in Berber culture:

> ce précepte fondamental de la morale sociale qui interdit de se singular-
> iser, qui demande d'abolir, autant qu'il peut, la personnalité profonde,
> dans son unicité et sa particularité [. . .]. Il n'y a que le diable (*Chitan*)
> qui dit moi [this fundamental precept of social morality which forbids
> calling attention to oneself, which demands, as far as possible, the aboli-
> tion of the intimate self in its singularity and its uniqueness. Only the
> devil (*Chitan*) says 'me']. (Bourdieu 1972: 39)

Baya is not the devil: she is a saint. Her individuality, her uniqueness, is in fact the key to her tribe's survival, since she alone has not abandoned the ancient customs. It is thanks to her wisdom that the mountain flourishes. But for all that, the tribe are massacred and the village destroyed by the French. *La Montagne de Baya* thus presents, as does *Machaho* (and to a lesser extent *La Colline oubliée*), an ultimately ambivalent picture of Kabyle culture, a culture that some (Bourdieu included) may read as eternal but which in these films is under attack from history or from the violent intransigeance of its own codes.

Conclusion

Teshome Gabriel's taxonomy of 'Third World' cinema includes as the 'combative phase' or third cinema, 'a cinema of mass participation, one enacted by members of communities speaking indigenous languages', in short a cinema 'for and by the people' (Gabriel 1989a: 33). If the *cinéma moudjahid* of the 1960s and early 1970s falls short of this ideal, then the Berber cinema that finally appeared in Algeria

in the 1990s seems to achieve it. For Gabriel, monolithic power is associated with the West rather than the postcolonial state: 'Official history [. . .] claims a "centre" which continuously marginalises others. In this way its ideology inhibits people from constructing their own history or histories' (Gabriel 1989b: 53). But the Algerian nation-state established in 1962 created a new 'centre', the FLN's autocratic rule legitimised by its reference back to a mythologised liberation struggle. Against this 'centre' is positioned Berber cinema which is close to the folklore Gabriel compares to film in its curatorial function and use of popular discourse: 'folklore attempts to conserve what official histories insist on erasing' (Gabriel 1989b: 54). It is folklore and popular memory which feed Berber cinema, speaking to its audience about themselves. By mobilising neglected languages, Berber cinema goes beyond the monolingual Arabisation policy of the FLN: 'The view of the nation as unitary muffles the "polyphony" of social and ethnic voices within heteroglot cultures' (Shohat and Stam 1994: 286). Berber cinema allows some of those muffled voices to be heard. Shohat and Stam's observation on the status of Arabic in European cinema might also be applied to the status of Tamizight (the Berber languages) in post-independence neo-colonial Algerian cinema: 'Arabic exists as only a background murmur, an incomprehensible babble' (Shohat and Stam 1994: 252). In fact, as we have seen, Kabyle and Chaouia are not even murmured in the *cinéma moudjahid* – they are silenced. The 'linguistic and cultural dignity' that Shohat and Stam see Pontecorvo granting the Algerian protagonists in *La Bataille d'Alger* was withheld from their Berber comrades over the next thirty years of Algerian film.

In the last decade, Berber film-making in Algeria has continued. Recent films have presented a variety of genres. These include documentary – *Algérie, la vie quand même* (Djamila Sahraoui, 1998, see Chapter 7) and *La Chine est encore loin* (Malek Bensmaïl, 2008); folktale – *Mimezrane, la fille aux tresses* (Ali Mouzaoi, 2008); road movie – *La Maison jaune* (Amor Hakkar, 2007, see Chapter 8); and historical dramas – *Si Mohand U M'hand, l'insoumis* (Liazid Khoja and Rachid Benallal, 2004) and *Arezki l'indigène* (Djamel Bendeddouche, 2008). But the relation between Berber regions – Kabylia in particular – and the Algerian state remains problematic. In 2001 Kabyle unrest was sparked by police brutality and repression after marches to mark twenty years since the Berber Spring. The state response was to increase violent suppression to unprecedented levels, inluding the use

of snipers and snatch squads. By the end of June 2001, 'the "black spring" had left an estimated two hundred dead and five thousand injured'. The disenfranchisement and despair of the Kabyle rioters was expressed by their infamous slogan 'You cannot kill us, we are already dead' (Evans and Phillips 2007: 277). A continuing sense of dislocation from national politics was apparent in the September 2005 referendum on an amnesty following the civil war of the 1990s. The proposal was passed with an apparent 97.43 per cent in favour, on a national turnout of 80 per cent, but this result obscured the fact that in Tizi-Ouzou, capital of Kabylia, only 11.4 per cent had voted (see Khanna 2008: 248).

A key trope in the struggle for recognition of Berber identity is erasure or obliteration (of local, marginal, plural languages and histories). Khanna observes that, in contemporary Algeria, Arabic 'is achieving the status that French once had in the region; it is becoming the language of power designed to obliterate local cultures' (Khanna 2008). Erasure is also a central image in the recent documentary by Malek Bensmaïl, *La Chine est encore loin*, set in the Aurès village where the liberation struggle began in 1954. This documentary reveals the continuation of the clash between classical Arabic and Berber (in this instance, Chaouia). And it does so in the context of schooling which, Bourdieu states, is a prime site for symbolic violence: 'All *pedagogic action* (PA) is, objectively, symbolic violence insofar as it is the imposition of a cultural arbitrary by an arbitrary power' (Bourdieu cited in Robbins 2000: 59). *La Chine est encore loin* shows boys who can barely speak it or understand it being taught classical Arabic. The attempt to communicate the nationalist vision (predicated as ever on the legitimising effects of the liberation struggle) confronts the boys with the 'cultural arbitrary' of FLN history expressed in a language they can barely follow. While their teacher perpetuates the discourse of the FLN ('martyrs', the 'revolution' and so on), his pupils mutter curses under their breath. When called upon to answer with an example of martyrdom from his own family, one boy – Lakhdar – mistakenly talks of a relative's imprisonment by the French in a *mosque* rather than a *prison*. The accidental confusion of *mosque* and *prison* (caused by a misunderstanding of classical Arabic) is resonant since in the village mosque as well in the school (both spaces as claustrophobic as prisons), and in the totalising visions offered by both forms of pedagogic action, these Berber children are imprisoned in a language other than their own.

The film also shows that a combination of Berber codes and the influence of patriarchal, fundamentalist Islam have ensured that only one woman in the community will agree to be filmed and interviewed. Even then she is reluctant to be filmed outside. Her name is Rachida, she is a Chaouia Berber like all the villagers, and she works as a cleaner at the (Arabophone) school. It is instructive to compare her experience with a fictional character also called Rachida. The Arabic-language feature film *Rachida* ends with a young schoolteacher, undeterred by an Islamist massacre, writing 'today's lesson' in Arabic on a blackboard and hence confronting a future where she has a function and a place. *La Chine est encore loin* shows Rachida, the old woman who cleans up at the village school, erasing from a blackboard the words (in Arabic) 'Mon histoire avec le temps' [My history/story with time]. One Rachida is young, mobile, defiant, forward-looking and associated with writing (she is a teacher, she is seen writing, she has a place in a written culture – Arabic – and in history, as a resister against terrorist violence). The other is old, seen only indoors, despairing, and unwritten (she is outside written culture, outside the language of the school where she works, excluded from public space, and also apparently excluded from history, since she occupies the ahistorical, naturalised space of women within a traditional, patriarchal culture). She embodies the erasure or obliteration of Berber identity that has often been threatened within Algeria.

References

Abu-Haidar, Farida, 'Arabisation in Algeria', *International Journal of Francophone Studies*, 3:3 (2000), pp. 151–63.

Austin, Guy, *Contemporary French Cinema: An Introduction* (second edition, Manchester: Manchester University Press, 2008).

Baumberger, Jeanne, 'La "permance berbère"', *CinémAction*, 111 (2004), pp. 212–15.

Bourdieu, Pierre, *Trois études d'ethnologie kabyle / Esquisse d'une théorie de la pratique* (Paris: Editions du Seuil, 1972).

Bourdieu, Pierre, *Masculine Domination* (translated by Richard Nice) (Cambridge: Polity Press, 2001).

Brahimi, Denise, *50 ans de cinéma maghrébin* (Paris: Minerve, 2009).

Brett, Michael, and Elizabeth Fentress, *The Berbers* (Oxford: Blackwell, 1996).

Colonna, Fanny, 'The phantom of dispossession: from *The Uprooting* to *The Weight of the World*', in Jane E. Goodman and Paul A. Silverstein (eds),

Bourdieu in Algeria: Colonial Politics, Ethnographic Practices, Theoretical Developments (Lincoln, NE: University of Nebraska Press, 2009), pp. 63–93.

Djebar, Assia, *Algerian White* (translated by David Kelley and Marjolijn de Jager) (New York and London: Seven Stories, 2000).

Djebar, Assia, *So Vast the Prison* (translated by Betsy Wing) (New York and London: Seven Stories Press, 2001).

Evans, Martin, and John Phillips, *Algeria: Anger of the Dispossessed* (New Haven and London: Yale University Press, 2007).

Gabriel, Teshome, 'Towards a critical theory of Third World films', in Jim Pines and Paul Willemen (eds), *Questions of Third Cinema* (London: BFI Publishing 1989a), pp. 30–52.

Gabriel, Teshome, 'Third cinema as guardian of popular memory: towards a third aesthetics', in Jim Pines and Paul Willemen (eds), *Questions of Third Cinema* (London: BFI Publishing 1989b), pp. 53–64.

Goodman, Jane E., 'The proverbial Bourdieu: *habitus* and the politics of representation in the ethnography of Kabylia', in Jane E. Goodman and Paul A. Silverstein (eds), *Bourdieu in Algeria: Colonial Politics, Ethnographic Practices, Theoretical Developments* (Lincoln, NE: University of Nebraska Press, 2009), pp. 94–132.

Jenkins, Richard, *Pierre Bourdieu* (revised edition, New York and London: Routledge, 2002).

Khanna, Ranjana, *Algeria Cuts: Women and Representation, 1830 to the Present*, (Stanford, CA: Stanford University Press, 2008).

Messaoudi, Khalida, *Une Algérienne debout: entretiens avec Elisabeth Schemla* (Paris: Flammarion, 1995).

Robbins, Derek, *Bourdieu and Culture* (London: Sage, 2000).

Sansal, Boualem, *Poste restante: Alger. Lettre de colère et d'espoir à mes compatriotes* (Paris: Gallimard, 2006).

Shohat, Ella, and Robert Stam, *Unthinking Eurocentrism: Multiculturalism and the Media* (Routledge: London and New York, 1994).

Silverstein, Paul A., 'Of rooting and uprooting: Kabyle *habitus*, domesticity, and structural nostalgia', in Jane E. Goodman and Paul A. Silverstein (eds), *Bourdieu in Algeria: Colonial Politics, Ethnographic Practices, Theoretical Developments* (Lincoln, NE: University of Nebraska Press, 2009), pp. 164–98.

Silverstein, Paul A., and Jane E. Goodman, 'Introduction: Bourdieu in Algeria', in Jane E. Goodman and Paul A. Silverstein (eds), *Bourdieu in Algeria: Colonial Politics, Ethnographic Practices, Theoretical Developments* (Lincoln, NE: University of Nebraska Press, 2009), pp. 1–62.

6

After 'Black October': mourning and melancholia

Case studies: *Youcef* (Mohamed Chouikh, 1993), *Bab El-Oued City* (Merzak Allouache, 1994), *Rome plutôt que vous* (Tariq Teguia, 2006).

The events of October 1988 form a watershed in recent Algerian history. Known as Black October, this was the moment when popular trust in the state, eroded for years, finally collapsed. Alienated by state corruption and secrecy, frustrated with massive unemployment and failing economic policies, thousands of young demonstrators took to the streets to protest. The army responded by firing on the people. By the end of the month, five hundred demonstrators had been shot dead and the relation between people and government had altered irrevocably. October 1988 has been described as 'the climax of a rupture between state and society' (Evans and Phillips 2007: 105). This rupture was particularly felt by the vast youth element of Algeria's population, which had increased enormously since independence: 'Between 1966 and 1987 the population nearly doubled to 23 million, two thirds of whom were under twenty-five, and it was this post-independence generation that bore the brunt of the 1980s crisis' (Evans and Phillips 2007: 106). This vast demographic group felt a sense of betrayal at being left behind by the money-making of the 1980s (much of it based on Algeria's energy wealth). If the presidency of Boumediene (1965–78) had been characterised by an emphasis on education, under his successor, Chadli Benjedid, corruption had increased and the populace felt increasingly disempowered. Hence, 'October 1988 must be understood not as a bread riot, still less an act of mindless vandalism, however much the regime tried to portray it as such. Instead, the rioters' actions were structured by a sense of moral and political economy, a desire to return to the certainties of

the 1970s' (Evans and Phillips 2007: 103–4). In the aftermath of Black October, Chadli introduced immediate reforms, and the end of the one-party state was approved by a national referendum in November 1988 (with a 92.3 per cent vote in favour). But despite the reforms that followed (characterised by increased freedoms of expression for the press, and of production and distribution for film-makers), the FLN was to remain in power and the seeds of civil war were sown. Black October was in effect 'the bleeding white of the future' (Djebar 2000: 229), a moment of rupture that fed resentment against the state and facilitated the rise of the FIS (Front islamique du salut), culminating in the suspended elections of December 1991 that triggered civil conflict (see Chapter 7).

Algerian cinema has often measured the state of the nation against the ideals of the independence struggle. Memories of the revolution serve in particular as a yardstick to gauge the depths of the alienation experienced by the 1988 generation. Although not all reflections back to the Algerian revolution are entirely nostalgic, on the whole this period of history – before the amnesia or hypermnesia overseen by the FLN – stands as a lost ideal, in Freudian terms a lost object. One might say that recent Algerian cinema mourns this ideal, since mourning is a reaction to 'the loss of a loved person, or to the loss of some abstraction which has taken the place of one, such as one's country, liberty, an ideal, and so on' (Freud 1984: 253). When mourning becomes pathological, that is to say, according to Freud, obsessive and repetitive, a fixation rather than a normalised phenomenon that can be worked through, it crosses over into melancholia. Freud's description of this moment, when revolt at a great loss has become obsessive but impotent, is as follows: 'the reactions expressed [. . .] proceed from a mental constellation of revolt, which has then, by a certain process, passed over into the crushed state of melancholia' (Freud 1984: 257). This bears close comparison with the 'crushed', alienated state of Algerian youth in the years after the abortive revolt of Black October. But this melancholia, as glossed by Ranjana Khanna, may also offer a hope of agency, of 'a critical resistance to imperial rule and to state nationalism' whereby, 'Unable to achieve representation in the language of the state, it nonetheless interrupts through insurgency, through representational breakdown, through a critical agency always in search of justice' (Khanna 2008: 60, 59). Michael Rothberg sees memory as the crucial means whereby this can be achieved: 'When the state instrumentalizes the law of mourning, claims of justice must

emerge from "outlaw" agents of memory and postmemory' (Rothberg 2009: 308). This pursuit of justice, this insurgency, this outlaw agent of memory is encapsulated in the allegorical figure of Youcef, from the first of our case studies on the theme of melancholia after 1988.

Youcef (Chouikh, 1993)

For the dispossessed majority of the Algerian population, the regime of President Chadli Benjedid (1979–92) was rotten with corruption. As Evans and Phillips explain, by the late 1980s 'Money was equated with dishonesty and exploitation', while resentment at the state generated a series of 'archetypal hate figures – the lazy bureaucrat, the corrupt politician, the grasping capitalist, the vindictive police officer – all part of the same system leeching off the people' (Evans and Philips 2007: 110). It is precisely these archetypes that appear in Mohamed Chouikh's tragic allegory *Youcef* (1993), as we shall see shortly. But they are also present in a comic form in the last of the popular *Hassan* films, *Hassan Niya* (Bendeddouche, 1988). Initiated by Mohamed Lakhdar Hamina with *Hassan Terro* in 1968, the comedy series included *L'Évasion de Hassan Terro* (1974), the TV series *Hassan Terro au maquis* (1978) and *Hassan Taxi* (1982). The lead character was played as a comic everyman by the actor Rouiched, whose own play was adapted for the original film. The series charted the state of the nation for a popular audience, shifting from the arena of conflict to economic survival. By the late 1980s and *Hassan Niya*, the hero is confronted from first to last by a series of (male) authority figures whom he has to outwit while remaining loyal to his (female) family: his sister and his fiancée. Although the film lacks the bitterness and despair of the younger generation (since Hassan is a lovable middle-aged rogue who has no problem finding work), it does launch a sustained comic assault on the state and its avatars. Hassan is stopped by the police five times in the film, and ends up (mistakenly) gaoled by a vindictive officer who promises him death by hanging and the guillotine. 'Both at once?' asks Hassan. At one point working for his sister, Hassan exemplifies the importance of kin networks, family structures that were of increasing necessity in the 1980s in order to secure employment or to access other forms of political and social capital. His other boss, Si Lounes, is a corrupt entrepreneur on the make, who runs a restaurant while also smuggling drugs, building an illegal villa and dealing in bribes and forged documents. In the

film's climax, Hassan is released and Si Lounes gaoled in his place. But this conclusion is undercut by the car accident that follows, apparently killing off the hero. There is moreover no real acceptance of official authority. At regular points throughout the narrative Hassan clearly defines himself against the state. He tells a friend that working for a state-owned company 'is worse than hell'. The film begins with him threatened with eviction from his dilapidated home, raging against the authorities and telling a cheering crowd of (significantly young) supporters, 'For the house of my ancestors, I will die a martyr'. He follows this up by identifying with the national hero commemorated in *La Bataille d'Alger* (Pontecorvo, 1965), shouting 'Blow up the house and me with it, like Ali la Pointe!' By invoking the war of liberation he manages to invert official FLN ideology and cast the Algerian state as the new occupier, the new enemy of the people, as in *Youcef*, whose protagonist cannot believe that the French are still not in control, such is the nation's suffering.

In the brief Algerian Spring of 1989–91 that followed Black October, the press grabbed with relish new freedoms, and began excavating the national past that had been memorialised mythologised and monopolised by the ruling FLN: 'For journalists [. . .] who revelled in the new atmosphere of investigative freedom, one issue mattered above all others: the recovery of their country's history' (Evans and Phillips 2007: 145). This questioning of the past and investigation of national identity is the backdrop for *Youcef*, in which an amnesiac war veteran escapes from an asylum in the desert and wanders through 1990s Algeria under the impression that the war against the French is still going on. By the time Chouikh began filming *Youcef* in 1992, the Algerian Spring was over. A state of emergency had been declared following the rise of Islamist militancy, the suspension of elections and the assassination of President Boudiaf (see Chapter 7). As Chouikh explains, however, the casting of radio stars associated with the Algerian Spring (Mohamed Ali Allalou, Youcef Benadouda) was an attempt to extend the sense of freedom that had been glimpsed under the short-lived reforms (see Taboulay 1997: 53).

The full title of Chouikh's film is *Youcef: La légende du septième dormant*, and the narrative derives from a myth (found in both Islamic and Christian tradition) according to which seven young men, persecuted for their religion, fall asleep in a cave and awake 372 years later to find their nemesis long dead and the world entirely changed for the better. In Chouikh's version, the premise is twisted so that when the

sleeper awakes he finds himself in an alien world, but one where corruption reigns, and where the ideals of the cause for which he fought (the Algerian revolution) have been entirely lost. Youcef (Allalou) thus embodies the dislocation of a country that has lost its memory and its connection with the values of the independence struggle. The film mourns the loss of those ideals while painting a despairing view of the present. Youcef witnesses suffering and abuse, including the burning of an 'impure' woman's house and child – an atrocity he associates with the French occupiers but which it transpires is perpetrated by Islamists. When he attempts to pay for a night in a hotel his money is rejected, symbolising that his old ideas have no currency in the new Algeria (see Brahimi 2004: 158). He also observes a street demonstration which seems to invoke the memory of Black October, and is ultimately presented with a list of grievances by the suffering Algerian people, who see him as their only representative. Making reference to his lead actor's status as a popular radio host during the Algerian Spring, Chouikh has Youcef attempt to broadcast his findings on an old military wireless. Youcef suffers hallucinations of the liberation struggle, the cinematic trope of the flashback here identifying traumatic experience as simultaneously past and present. Both *Youcef* and *Bab El-Oued City* – along with more recent works like *Barakat!* (Sahraoui, 2006) – also figure the war against the French by means of the female veteran, a character that assumes a political resonance in the 1990s (women veterans were regular targets of the FIS) as well as a Freudian resonance (the mother of early infancy as lost object).

Youcef centres on the trope of the lunatic who is more sane than the society he finds himself in. At a key moment, when told what has happened during his long incarceration, Youcef asks where independence is: he cannot see any evidence of it around him. Instead, he witnesses the abuse and marginalisation of women, political corruption, poverty, fear and despair. 'Did we fight them to become like them?' he asks a former FLN comrade who now lives in the same villa and exercises the same form of power that the French colonial enemy did. Similar observations have been made by Bourdieu, who comments on the appearance of neo-colonialism in the independent Algeria, resulting in 'une sorte d'imitation servile de l'Etat à la française' [a sort of servile imitation of the state in its French form] (Bourdieu 1997: 24). The fact that the neo-colonial Algeria has (despite official mythologising) actually forgotten the war of liberation is realised in the sequence

where Youcef, coming across the scene of a past battle with the French, finds the bodies of his comrades in a cave, forgotten skeletons. The setting of the cave both here and later in the film also functions as a figure for forgotten elements of Algerian history, recalling as it does the cave of Dahra in Assia Djebar's account of female resistance, *La Nouba des femmes du Mont Chenoua* (1978, see Chapter 4) and the mysterious site of the father's murder in Kateb Yacine's novel *Nedjma* (Yacine 1996). Significantly Youcef's death is brought about via a state-sponsored public ritual that seeks to co-opt him into the official commemoration of the war. Youcef represents the truth about why the independence struggle was fought, a truth that exists outside the FLN's amnesia/hypermnesia. In his return from exile and in his death he also stands as an avatar of President Boudiaf, another war veteran exiled in the desert and murdered on his return to the centre of Algerian society. Boudiaf was assassinated in June 1992 after only five months in power, an event that only hastened the country's descent into conflict and trauma. In *Youcef*, thirty years of independence have created a dysfunctional state on the brink of civil war. For Chouikh, Algeria had fallen into 'un coma de trente ans' [a thirty-year coma] (in Taboulay 1997: 58). During the filming, Chouikh heard of the murder by Islamists of the Kabyle poet Tahar Djaout, the first of many writers to be targeted during the years that followed. Djaout had been on the official panel that approved financial aid for the making of *Youcef*. He had also been the subject of a fatwa since 1987. The completed film was dedicated to his memory.

Homi Bhabha has written that 'the problem of the cultural emerges only at the significatory boundaries of cultures, where meanings and values are (mis)read or signs are misappropriated' (Bhabha 1989: 127). Black October 1988 marks one such 'significatory boundary'. It is a moment of historical, ideological and cultural transition, the watershed between Algeria as postcolonial state and Algeria as neo-colonial state. In the aftermath of Black October we might expect to see the misreading or misappropriation of signs that Bhabha speaks of. And we find it throughout *Youcef*, as the protagonist misreads the signs around him to conclude that Algeria cannot yet be independent of colonial rule. The process of misreading or translation is more precisely directed by the film at another film, the dominant reference in Algerian cinema, *La Bataille d'Alger* (referenced also, as we saw above, in *Hassan Niya*). What is made clear in *Youcef*'s key allegorical sequence is the process of rehistoricisation that allows the meaning

of *La Bataille d'Alger* to be inverted, as in a mirror – thus repeating the transformation that Pontecorvo operated on Delacroix in his own film (see Chapter 4). If 'the meaning and symbols of culture have no primordial unity or fixity' and therefore 'even the same signs can be appropriated, translated, rehistoricised, and read anew' (Bhabha 1989: 130), *Youcef* reads *La Bataille d'Alger* anew by juxtaposing the latter's idealisation of independence with the reality of 1990s Algeria. This juxtaposition is magically dramatised when *La Bataille d'Alger* is screened for Youcef on the wall of his cave.

According to Bhabha, 'In the moment of liberatory struggle, the Algerian people destroy the continuities and constancies of the "nationalist" tradition. They are now free to negotiate and translate their cultural identities in a discontinuous intertextual temporality of cultural difference' (Bhabha 1989: 130). This utopian view might have once applied to the young Algeria and to *La Bataille d'Alger*, but after Black October it rings hollow. *La Bataille d'Alger* has become simply a piece of nationalist discourse, a stone in the edifice of power built by the FLN, an example of how the Algerian revolution has been used to legitimise the one-party state. *La Bataille d'Alger* has become a fiction of liberation, not an index of it. This is made ironically apparent when Lyes, one of Youcef's former comrades, declares 'independence is real: there are films!' and proceeds to screen the film on the wall of the cave. The setting here deliberately evokes the cave from Plato's *Republic*, with *La Bataille d'Alger* (and, by extension, the liberation rhetoric of the FLN) reduced to the flickering of an illusion. Youcef himself, who has seen the reality of the independent Algeria with innocent eyes, is Plato's lone philosopher, whose message from the real world is unlikely to be welcomed by those under the sway of the glowing images on the cave wall. In Plato's epistemological space of transition 'between representation and reality' (Khanna 2008: 13), Youcef sees the reality, and *La Bataille d'Alger* is merely an idealising representation. Sitting in the cave before the film is shown, Youcef hears from his former comrade Fatima how after 1962 she lost her struggle for emancipation as a woman. Meanwhile, Lyes urges him to exploit his resistance connections, to become a good capitalist, and to use his training as an architect to design monuments for the martyrs of the revolution (an ironic allusion to Makam al-Shahid). The sequence we see shown in the cave is in fact the ending of *La Bataille d'Alger*, when a female protestor with a national flag incarnates Algerian independence. Rehistoricised by Chouikh after Black October

(and after the Family Code – see Chapter 4), this image becomes a lie. There is no such thing as Algerian liberation, least of all for women.

What *Youcef* does, then, is to transform the meaning not just of *La Bataille d'Alger* but of the postcolonial. For Bhabha, in 'the "hybrid" moment of political change', a 'transformational value' is to be found in 'the re-articulation, or translation of elements that are *neither the One* [. . .] *nor the Other* [. . .] *but something else besides* which contests the terms and territories of both' (Bhabha 1989: 120, italics in original). *Youcef* contests the terms and territories of the colonial and the postcolonial by in fact collapsing the one into the other and demonstrating that Algeria has become *something else besides*: the neo-colonial. What is more, the film's transformative rehistoricising of signs reveals that, in the hybrid moment of Algeria after Black October, the colonial and the postcolonial are not opposite terms, but identical.

Bab El-Oued City (Allouache, 1994)

By the summer of 1993, when Merzak Allouache was filming *Bab El-Oued City* in secretive circumstances in Algiers, the electoral process had been discontinued, and Algeria was under a state of emergency (see Chapter 7). Logistically difficult and highly dangerous, film-making in Algeria all but disappeared. In the words of Benjamin Stora, 'Dans ce contexte, les rares films de réalisateurs algériens ont quelque chose de proprement "héroïque"' [In this context, the few films made by Algerian directors have something 'heroic' about them] (Stora 2001: 88). Even more 'heroic', one might say, was the attempt by Allouache to address the rise of the hardline fundamentalist FIS, charting the slippage from moderate Islam to an increasingly intolerant and violent militancy. *Bab El-Oued City* was filmed in Algiers and Kabylia, often using hidden cameras, and in the face of recurrent difficulties such as when four actors in turn quit the role of the imam (eventually taken up by Ahmed Benaïssa). The film was ultimately screened at Cannes in 1994, but was not given an Algerian release.

Bab El-Oued City is set in the aftermath of October 1988, in early 1989, at the moment when the FIS is on the rise but has not yet been criminalised, and the country has yet to collapse into civil conflict. The film centres on Boualem (Hassan Abdou), a young baker who steals one of the local mosque's loudspeakers in an effort to silence fundamentalist propaganda. Subsequently persecuted by a gang led

by Saïd, Boualem is forced to abandon the girl he wants to marry (Yamina, Saïd's sister) and flee to France. The narrative is framed by Yamina's voce-over, as she waits (in the early 1990s, we assume from newspaper headlines) for Boualem to return. The plot involving the theft of the Islamists' loudspeaker provides an intertextual reference back to the days of the Algerian revolution, recalling Little Omar's stealing of the French microphone in *La Bataille d'Alger*. As in *Youcef*, so too in *Bab El-Oued City* the revolution is evoked as a time of certainty and solidarity which is now lost. The gulf between myth and reality is less devastating in *Bab El-Oued City* than in *Youcef*, but it is still apparent. Like Chouikh, Allouache includes the figure of the female war veteran in order to personify the lost ideals of the resistance struggle, and in particular to demonstrate the post-independence disempowerment of the former *moudjahidat* and of Algerian women generally. An additional dichotomy established in *Bab El-Oued City* is in the domain of religion, between the moderate imam who recalls the revolution and the radical Islamists who take power into their own hands. Both the female veteran and the imam recall when Algeria was a young country, and the former equates the loss of the idealised Algeria with the loss of her fiancé in the war of liberation. Shut up in her room for fear of abuse by the Islamists, she has no links with the present apart from Boualem, who secretly brings her bottles of wine. Notably the militants themselves are of the younger generation, and are led by the powerful figure of Saïd, a veteran of the Black October riots. October 1988 is a key reference in the film, and, rather like Yasmina Khadra in his novel *A quoi rêvent les loups*, Allouache demonstrates how Black October was a crucial factor in the radicalisation of Algerian youth and hence in the rapid growth of the FIS and subsequently of fundamentalist terrorism during the early 1990s (see Khadra 1999).

Like the more recent films considered below, Allouache's narrative is circular, held within the frame of Yamina's agonised commentary. This structure 'pose le problème de la perte de l'origine et met en exergue la difficulté d'être dans un pays en pleine crise d'identité' [poses the problem of the loss of origins and highlights the difficulty of existence in a country that is suffering from an identity crisis] (Crouzière-Ingenthron 2004: 181). But although in *Bab El-Oued City* both Yamina and, by extension, Algeria itself are left to suffer the 'black decade' with no hope of respite or escape, Boualem's disappearance can be read as a gesture of survival, if only in flight, and as an

allusion to the exile of the writers and artists who managed to flee Algeria in the 1990s, and hence to Allouache himself, several of whose subsequent films were made in France. In the city that Boualem leaves behind, a couple of French tourists wander around Algiers sightseeing, in a *hommage* to the cult film *Tahia ya didou* (Zinet, 1971) and to the energy of the new Algeria evoked in that work. But the blindness of Mohamed (the torture victim played by Zinet) in *Tahia ya didou* is now transferred to the aged French woman who is being shown around Algiers by her nephew. In opposition to this comic representation of the French visitors, who seem to be clinging to an obsolete *pied-noir* memory of French Algeria, blind to its current reality, is the menacing image of a car repeatedly driven through the streets of Algiers. The car belongs to a mysterious *eminence grise* who is apparently manipulating Saïd and encouraging the rising violence. In this cryptic figure, who provides Saïd with a gun, Allouache seems to be implicating the Algerian elite as *agents provocateurs* in the instability of the 1990s. It was also noted at the time that the fundamentalist 'movement that attracts impoverished young people also finds acceptance among older and richer groups' (Lazreg 1994: 213). At the end of *Bab El-Oued City* this movement is depicted as leading the country from light into darkness – the darkness of the so-called 'black decade' (see Chapter 7). The sunshine and bright colours that dominate the early sequences, the bleached white stones of the cemetery where Boualem meets Yamina (and which evoke in turn the white cemeteries of *Tahia ya didou* and Allouache's 1976 debut, *Omar Gatlato*) are replaced in the film's conclusion by gathering gloom. The obscurity (both literal and figurative) of the final sequence – Saïd firing a gun in the dusk – suggests the violence of the black decade that is beginning. This enveloping dark is observed also by Assia Djebar, who says of the city in the 1980s, 'the heart of Algiers was given over to terror, in the sticky darkness', and who sees the traditional image of *Alger la blanche* becoming a 'black city' of anxiety and menace (Djebar 2000: 182, 41). A similar play of darkness and light, closer to Djebar than to Georges Bataille (see Chapter 3), evocative of what has been lost in Algeria since the 1960s, is reflected in Tariq Teguia's superb *Rome plutôt que vous* (2006).

Rome plutôt que vous (Teguia, 2006)

The 'crushed state' of melancholia after October 1988 is perhaps best expressed in recent Algerian cinema by *Rome plutôt que vous*. Although

filmed over a decade after *Youcef* and *Bab El-Oued City*, Teguia's debut is also set in the 1990s and engages even more directly with the alienation of Algeria's vast youth population, exploring their disempowerment and their dreams of leaving. An escape to Europe such as Boualem's in *Bab El-Oued City* is however a fantasy rather than a project with any realistic hope of fulfilment. As Boualem Sansal was to describe it in his polemical essay of the same year, Algerians have become reduced to solitude and incarceration: 'Nous voilà seuls, à tourner en rond' [Here we are alone, going round in circles] (Sansal 2006: 12). In *Rome plutôt que vous* the Beckettian plot (waiting for a people-smuggler who never turns up) and long repetitive scenes (as when the central couple drive round and round, lost in a new housing development at La Madrague) posit the Algeria of the 1990s as a society in suspension. In terms of genre, this is a road movie where no one goes anywhere – thus contrasting with the more successful journeys of *Le Clandestin* (Bakhti, 1991), *Barakat!* (Sahraoui, 2006) and *La Maison jaune* (Hakkar, 2007). *Rome plutôt que vous* depicts an Algeria where state powers appear arbitrary and subject to misuse, where Islamic fundamentalism is powerful and where authority is always elsewhere, off-screen, invisible and inaccessible. The narrative concerns the attempt of the central couple to secure false papers in order to leave Algeria, a goal that is represented as recurrently impeded by a power that remains perpetually hidden, off-screen.

Initially the images of this society are fragmented and disparate: cryptic early scenes include a long slow tracking shot along an empty costal road, a passport photo session, the docks in Algiers at night, two young workers in a garage. These images are unmediated by dialogue or music, and hence the characters seem isolated from each other and from any unifying story-line. However, after five minutes, Teguia presents the central protagonist Zina (Samira Kaddour), and anchors her in Algiers with a situating shot from her balcony above the port. A long scene of her preparing coffee and talking with her mother appears to conform to the gendering of space whereby the private, domestic realm of the home is coded as feminine, while the public domain of the street is coded as masculine (see Chapter 4). When Zina descends to the street she passes numerous men and is accosted by Kamel (Rachid Amrani), who wants to take her to Italy with him. What accosts the spectator during this street scene is the blazingly vibrant soundtrack and the energetic tracking shot which follows Zina and Kamel as they move in and out of focus, in and out of

earshot, and in and out of the white pillars that are the visible remnants of French colonial rule. Moreover the reds and greens of the clothing here, in combination with the white architecture, create a glimpse of the Algerian national colours. A sense of urgency and desire for escape is expressed by the movement of protagonists and the camera, especially since the right-to-left direction in this sequence evokes progression from past to future, as in other Arabophone films – for example, the endings of *L'Arche du désert* (Chouikh, 1997) and *Rachida* (Bachir Chouikh, 2002). The dynamism is not just visual: the soundtrack explodes with the exhilarating chaos of Afro-American jazz musician Archie Shepp's 'Brotherhood at Ketchaoua'. What is significant about the music used is that, even while the image track drives energetically forwards, the sound-track evokes a relation with history, a glance back at the golden age of the newly independent Algeria. Shepp's performance was recorded live in 1969 with Tuareg musicians at the first Pan-African festival, the acme of Algerian cultural influence, and in a sense the highest achievement of the new nation, only seven years after the end of the war of liberation. The 1969 festival has been described as 'a remarkable display of the new African identity', with Shepp's concert a key reason why the event 'has lived on in Algerian folklore' as the symbol of 'an optimistic time when the population felt self-confident about the future because Algeria, as a beacon of African and Third World militancy, was strong and stood for something' (Evans and Phillips 2007: 97–8). A gulf between past and present is therefore expressed succinctly but poignantly by Teguia's choice of music. Where the Algerian revolution is the lost object in *Youcef* and *Bab El-Oued City*, in *Rome plutôt que vous* it is the cultural flowering derived from the revolution that is mourned as lost, in this brief echo of 1969.

Rome plutôt que vous is also embedded in contemporary social realities. Its title refers to a football song from the terraces of the Algiers team USM Alger (see Zahzah 2007). The cast are nearly all non-professional actors, including Rachid Amrani who was spotted in the street before joining the cast, recalling the practices of neo-realism and the provenance of Brahim Haggiag as Ali La Pointe in *La Bataille d'Alger*. Teguia's film style is however far from neorealism. Deeply influenced by Jean-Luc Godard, notably his 1960s work such as *Pierrot le fou* (France, 1965), Teguia employs loud ambient sound, metatextual placards, interviews to camera, repeated tracking shots, literary allusions, symbolic colour and long interior takes in order to express the frustration of living in Algeria in the 1990s. (Precise

temporal references are very rare, but we see Kamel reading a newspaper with a headline about the massacre in Raïs – which took place in 1997.) At one point a young Islamist declaims a tract he is writing about the need for Jihad. In a to-camera interview an unidentified character, attempting a clandestine escape from Algeria, declares 'I want a change of life. I've got nothing.' There is a consistent engagement here with the dispossessed, as in Djamila Sahraoui's documentary *L'Algérie, la vie quand même* (made in 1998 for French television channel Arte), devoted to the young unemployed men of her home town in Kabylia, and offering them the space to tell their stories of poverty, boredom and despair. By the mid-1980s, 72 per cent of the unemployed in Algeria were under twenty-five: 'Commonly referred to as *hittistes*, derived from the Arabic word *heta* meaning walls and a comment on how they congregated around the walls of their local neighbourhoods, these unemployed young men defined 1980s Algeria' (Evans and Phillips 2007: 107). The young *hittistes* of Sahraoui's documentary describe themselves as the living dead, perpetually on their knees, humiliated by the state, unable to move freely, suspected of terrorism, but never offered an alternative. 'This country', they say, 'is a dog that eats its young'. Sahraoui recounts how in 1988 the Algerian flag flying above the war veterans' cemetery was replaced by an empty grain sack, to signify (according to the director's voice-over) that 'ils en ont assez de la culte des morts' since 'les vivants ont faim' [they've had enough of the cult of the dead, the living are hungry]. In a realisation of the myth of the seven sleepers from *Youcef*, one of the *hittistes* wishes he could be injected so that he could fall asleep and wake up in a better future.

Like Sahraoui's film, *Rome plutôt que vous* concerns the impotence that follows a failed revolt (Black October), the 'crushed state' of melancholia. Algiers is a building site, but the post-'88 society being built has no place for the young, disenfranchised protagonists. Slowly, and with a reliance on imagery over (Arabic) dialogue, Teguia connects the disparate strands of the narrative until it becomes clear that Kamel is trying to track down 'the Bosco', alias 'Ferhat the sailor', an enigmatic figure who can provide him with the forged papers necessary to leave the country. He persuades Zina to accompany him on his quest for this 'merchant of hope'. Action and movement are however persistently aborted or reversed throughout the film. The exceptions are stolen moments such as the early street sequence analysed above, the football game played on the beach or the dancing to a tape of

Cheb Azzedine, singing 'Eteins la lumière et allume-toi' [turn out the light and turn yourself on]. Music is however symbolically silenced in the scene where a man sleeps cradling his mute ghetto blaster, an image that recalls Omar with his treasured tape-recorder in an earlier evocation of fixity and circularity, *Omar Gatlato* (see Chapter 4). The silencing of music is symbolically the silencing of the voice of protest. As the protagonist is told in Yasmina Khadra's novel *A quoi rêvent les loups*, there is now only one right in Algeria, the right to remain silent (Khadra 1999: 82). Failing to find 'the Bosco' in the huge, silent new development at La Madrague, Kamel is obliged to reverse his car back out of the complex. Later, he and Zina are arrested by the police before being released without charge. Waiting is the principal activity of the film, a summation of the limbo in which Algerian youth finds itself. Action remains predominantly off-screen. Thus the central event of the narrative – the murder of 'the Bosco' – is elided, having already taken place off-screen by the time, near the end of the film, that Kamel and Zina find his body.

Power exists only as a disembodied voice, an authority that is off-screen and therefore inaccessible. In Zina's home it is the voice of the unseen father, asking where she is going when she leaves the house. At the clinic where she works it is again a male, patriarchal voice, the voice of the clinic's director, telling the women to get on with their tasks. A hand appears as if from behind the camera, a gesture of authority and control (directing the female workers), but power has no visible body. Similarly, the voice of an unseen sheikh is heard on the radio giving advice on correct forms of marriage arrangements and of bodily ablutions: the voice of Islamist power conveyed, as in *Bab El-Oued City*, as a disembodied presence that polices the neighbourhood. As Benjamin Stora has written of Algeria in the 1990s, 'Le pouvoir existe toujours dans la distance et l'invisibilité' [power always exists as distant and invisible] (Stora 2001: 46). This renders the narrative of *Rome plutôt que vous* Kafkaesque. (It is no coincidence that Kafka's *America* is referred to by Kamel early in the film.) The closer Kamel tries to gets to the unseen site of power, the further away he is from his goal. He and Zina are often shown incarcerated in a car, driving but making no progress, overshadowed by the dark mass of trees on the road to La Madrague or going round in circles in the labrynthine twilight of the half-built development. A growing darkness on the image track in the later stages of the film literalises the obscurity and secrecy that enfolds power structures in

Algeria, evoking what Stora terms 'l'opacité dont s'entourent de longue date les plus hautes sphères du pouvoir algérien' [the impenetrability that has for years hidden the higher reaches of Algerian power] (Stora 2001: 41).

Assia Djebar's novel *Algerian White* traces the disappearance of numerous Algerian writers, notably during the black decade in which *Rome plutôt que vous* is set. A contrast runs through the text between darkness (associated with betrayal, with Islamist terror and state counter-terror) and the white light of the dying writers, who 'flicker out, like lamps' (Djebar 2000: 131). Djebar repeatedly compares Algeria to a place of 'shadow and darkness', a torture chamber of 'sticky darkness', a 'dark kingdom' where 'half of the land' has been seized by 'hideous shadows', plunging the country into 'an Algerian night' that can no longer be dismissed as simply colonial (Djebar 2000: 119, 182, 138, 217, 221). The traditional epithet for Algiers (*Alger la blanche* [White Algiers]) is stained by blood, becoming 'this black city' (Djebar 2000: 41). The military coup of 1965 in which Boumediene removed Ben Bella is described by Djebar as 'Algiers empitied of its utopia' (Djebar 2000: 161). Against the dark is posited the white of hope, of 1962's 'sullied dawn', of the men and women who continued to write and who thus illuminated Algeria, such as Jean Sénac who signed his poems with the symbol of a sun and lived 'in dazzlement', Mouloud Mammeri whom Djebar meets 'face to face in the morning sun' or Anna Gréki who 'was to be buried one sunny day' (Djebar 2000: 230, 129, 139, 168). We can observe a similar dichotomy of darkness and light throughout *Rome plutôt que vous*. Daylight sequences (the street, the beach) show white walls, pale sand, the glare of the sun, but Kamel and Zina's movements are increasingly cast in gloomy darkness as they search for 'the Bosco' at La Madrague, culminating in a night spent partly in police custody. When they finally manage to enter his house, where they find his corpse, it is daylight again. The hope of a future away from Algeria is evoked as a blinding white light that saturates a map on the wall, erasing its contours so that it is simply a glow of hope at which Kamel points a finger saying 'We would like to be there'. The closing moments of the film are also flooded with white light. Kamel is shot by unknown gunmen and as Zina drives away from the house a white glare of sunlight bursts on the car windows, like a reflection of the glow of martyrdom that marks Ali La Pointe's death in *La Bataille d'Alger* (see Chapter 3). But the white light of *Rome plutôt que vous* is no state-led idealisation of the

'one million dead', no official mourning. It is closer to the tone of personal melancholy that arises from the protagonist's death in *Youcef*, or the lament for dead friends in *Algerian White*. As Djebar's novel reclaims the colour white, 'Not the white of oblivion', of dust, of official burials and state ceremonies, 'a whiteness which insidiously effaces', but as the 'brilliance' and 'unalterable white' of the dead writers' presence (Djebar 2000: 51, 53), so too Teguia's film reclaims the sunlight of Algiers as shining on the struggles of the dispossessed.

A sense of impossibility hangs over Zina and Kamel's dreams of escape. Although the murder of 'the Bosco' presents them with a chance of flight – they find two passports in the smuggler's house – Teguia's compositions do not suggest they are likely to escape together. Here he places the couple on either side of the frame, with a vertical axis separating them, and very rarely do they actually look at each other. When Kamel is shot the imminence of his death is figured by the sudden silence or 'suspension' on the sound track (see Chion 1990: 111–13) and the stunning white glare on the image track. Sound and colour gradually bleed back into the film as Kamel begins to whisper in delirium. Like Djebar continuing to hear the voices of beloved writers after their death (see Djebar 2000: 52), Kamel insists 'I can hear Hasni'. There is no music on the soundtrack as the film ends, but these dying words establish a connection with the victims of Islamist violence in the 1990s, since the singer Cheb Hasni was killed by Islamists in 1994, and 'Nobody had done more than Hasni to give voice to the frustrations, hopes and needs of his generation' (Evans and Phillips 2007: 194). The final image is of Zina at the wheel, looking directly at the camera. The couple are still incarcerated in their vehicle, and the hope of escape has receded once more. As with the gaze at the camera which closes Yamina Bachir Chouikh's film *Rachida* (see Chapter 7), this image addresses the spectator, asking if they can see a way out. In *Rachida* the potential for movement, for continuity, for a working through of trauma is evoked by the narrative (school starting up again after the massacre) and by the camerawork (purposive right to left tracking shots). At the end of *Rome plutôt que vous* there is no such suggestion.

But we should not let our reading of the film become overly teleological. Despite the fatalistic ending, despite the recurrent sense of stasis evoked by Teguia's frequent use of static camera, there is something more at issue here. As with the emergence of the young teacher and the schoolchildren at the end of *Rachida*, there is a moment in *Rome*

plutôt que vous when the subaltern emerges from the edges of the frame. In a brief scene early in the film a young cigarette seller, marginalised by his black market activity, marginalised too in the narrative (this is his only scene), marginalised in the frame by his position on the very edge while Kamel occupies the middle foreground, runs up to the camera and presents his own placard, handwritten in Arabic on cardboard: 'I AM ALIVE: AM I SEEN?' This crucial moment represents more than a 'crushed state' of Freudian melancholia, a state of defeat and fixity which broadly coincides with the circular narrative and claustrophobic atmosphere of the film as a whole. The moment of interruption signalled by the cigarette seller's emergence from the corner of the frame to the centre, and by his scrawled message, recalls Ranjana Khanna's conceptualisation of postcolonial melancholia as 'subaltern interruptions', as 'moments of spontaneous insurgency' and as 'representational breakdown' via 'a critical agency always in search of justice' (Khanna 2008: 61, 59). The means by which normative (filmic) representation is here broken down is by the sudden darting run of the youth from the background and the far left-hand corner of the composition, by his spontaneous grabbing of the camera's attention and his desperate scribbled message. His position socially, narratively, and formally (in the frame) marks him out as subaltern, hence as a supplement that nonetheless can challenge, resist or damage the centre (as did the insurgencies of 1988 and since that inform the background to Teguia's film). As Khanna puts it, 'If one exists at the margins of society, it is as a frame that causes damage to the interior' (Khanna 2008: 56). Grabbing an instant of interruption in the interior and the foreground of the film's frame, cutting across from the very edge, the youth in this emblematic scene posits a melancholic resistance that goes beyond the Freudian 'crushed state' of the Algerian masses to express Khanna's critical melancholia, a call for justice that 'emerges from marginalization, repression and exclusion from community' (Khanna 2008: 56).

Conclusion

Youcef, Bab El-Oued City and *Rome plutôt que vous* present differing visions of how a Freudian melancholia in the shadow of a crushed revolt might relate to Algerian experience after Black October. All three films also signal to some extent the possibilities of what Khanna calls postcolonial melancholia, a critical agency manifest as subaltern

interruptions or insurgency against the neo-colonial state. This possibility is rapidly foreclosed in *Bab El-Oued City*, where Boualem's theft of the loudspeaker (an interruption of Islamist rhetoric) results in his abandonment of Yamina and his flight from Algeria. Insurgency is more sustained in *Youcef*, although ultimately recuperated in the climactic ceremony where Youcef is killed and hence incorporated into the body of the state as just another martyr from the war, feeding what Khanna calls 'the mourning model of nationalism that seeks to erase all differences', according to which the state 'seeks to assimilate, indeed to mourn, thus making all subjects into figures who are always already national subjects' (Khanna 2008: 166). The place of the subaltern at the margins of the state is most brilliantly represented in the cigarette seller's interruption of *Rome plutôt que vous*, a moment of insurgency that demands to be seen and heard even while it is deliberately marginal to the narrative of Kamel and Zina's dream of escape.

Emigration and exile are represented in these films as means of escaping the monumental stasis of Algeria, a place of fixity and death. But only in *Bab El-Oued City* is escape achieved, and this at the price of leaving the female subaltern (Yamina) behind. In *Youcef*, a return from exile is terminated by murder, in a devastating reference to the fate of Mohamed Boudiaf, who had been seen as a president willing to break the power of the military elite, to listen to subaltern voices and to lead Algeria out of its impasse. That impasse is detailed in the enclosed, circular narrative of *Rome plutôt que vous*, and its abortive dreams of flight – or of being simply seen and heard by *le pouvoir* [the powers that be]. The concept of *harga* – clandestine escape – is again explored in an hour-long *moyen métrage* [mid-length film] by Samir Dellal, *Visa de la mort* (2008). Stylistically the films are very different (one Godardian, the other closer to the aesthetics of the rap video). The cultural allusions of *Rome plutôt que vous* are literary, those of *Visa de la mort* belong to the world of hip-hop. But both narratives end with the protagonist badly injured (one shot, the other half drowned) and hence, ironically, since they each dream of movement and flight, immobilised (Kamel bleeding in the passenger seat of the car, Kouider on a drip in a hospital bed). Escape from Algeria is aborted, impossible. In *Rome plutôt que vous* the journeys of Ferhat the sailor (like those of Mal-de-mer in *Omar Gatlato*) remain fantastical, quasi-imaginary, off-screen. Even in those very few Algerian films that represent a successful departure from the country – the passenger ferries of *Bab El-Oued City* and *Le Soleil assassiné* (Bahloul, 2003),

the rowing boat of *Délice Paloma* (Nadir Mokneche, 2007) – arrival elsewhere is not shown. The fate of Boualem in *Bab El-Oued City*, of Belkacem in *Le Soleil assassiné* and of Riyad and Rachida in *Délice Paloma* is a mystery. Like Kouider's fellow escapees in *Visa de la mort*, they are missing, absent from the Algerian screen. Merzak Allouache's *Harragas* (2009), the latest addition to the cycle of *harga* films, sees the clandestine emigrants' desperation summarised in the phrase, echoing the murdered poet Tahar Djaout, from Omar's suicide note: 'Si je pars, je meurs; si je ne pars pas je meurs. Donc je pars, et je meurs' [If I leave, I'll die; if I stay, I'll die; so I will leave, and die]. Insurgency has become a defiant attempt to leave Algeria and die, rather than staying and dying in the neo-colonial state.

References

Bhabha, Homi, 'The commitment to theory', in Jim Pines and Paul Willemen (eds), *Questions of Third Cinema* (London: BFI Publishing, 1989), pp. 111–32.

Bourdieu, Pierre, 'Dévoiler et divulguer le refoulé', in Joseph Jurt (ed.), *Algérie – France – Islam* (Paris: L'Harmattan, 1997), pp. 21–7.

Brahimi, Denise, 'Images, symboles et paraboles dans le cinéma de Mohamed Chouikh', *CinémAction*, 111 (2004), pp. 154–9.

Chion, Michel, *L'Audio-vision: Son et image au cinéma* (Paris: Nathan, 1990).

Crouzière-Ingenthron, Armelle, 'Merzak Allouache, ou le nouveau cinéma algérien', *CinémAction*, 111 (2004), pp. 177–83.

Djebar, Assia, *Algerian White* (translated by David Kelley and Marjolijn de Jager) (New York and London: Seven Stories, 2000).

Evans, Martin, and John Phillips, *Algeria: Anger of the Dispossessed* (New Haven and London: Yale University Press, 2007).

Freud, Sigmund, 'Mourning and melancholia', *Pelican Freud Library, Volume 11: On Metapsychology* (London: Penguin, 1984), pp. 245–68.

Khadra, Yasmina, *A quoi rêvent les loups* (Paris: Julliard, 1999).

Khanna, Ranjana, *Algeria Cuts: Women and Representation, 1830 to the Present* (Stanford, CA: Stanford University Press, 2008).

Lazreg, Marnia, *The Eloquence of Silence: Algerian Women in Question* (New York and London: Routledge, 1994).

Rothberg, Michael, *Multidirectional Memory: Remembering the Holocaust in the Age of Decolonization* (Satnford, CA: Stanford University Press, 2009).

Sansal, Boualem, *Poste restante: Alger. Lettre de colère et d'espoir à mes compatriotes* (Paris: Gallimard, 2006).

Stora, Benjamin, *La Guerre invisible: Algérie, années 90* (Paris: Presses de Sciences Po, 2001).

Taboulay, Camille, *Le Cinéma métaphorique de Mohamed Chouikh* (Paris: K Films Editions, 1997).

Yacine, Kateb, *Nedjma* (Paris: Editions du Seuil/Points, 1996).

Zahzah, Abdenour, '*Roma Wella N'Touma* de Tariq Teguia: un film sensitif', *El Watan*, 26 July 2007, at http://elwatan.com/Film-Roma-Wella-N-Touma-de-Tariq, unpaginated, accessed 2 July 2010.

7

Screening the 'invisible war'

Case studies: *L'Arche du désert* (Mohamed Chouikh, 1997), *Rachida* (Yamina Bachir Chouikh, 2002), *Barakat!* (Djamila Sahraoui, 2006)

In Algeria the 1990s are known as 'the black decade', a period of widespread terror and trauma. Ostensibly this was a civil war, fought between the forces of the state and various fundamentalist Islamic groups, most notably the armed wing of the FIS (Front islamique du salut) and the notorious GIA (Groupe islamique armé). But it has more accurately been described as not 'une guerre civile' [a civil war] so much as 'une guerre contre les civils' [a war against civilians] (Stora 2001: 15). Jacques Derrida signalled the gendered nature of the violence by calling it 'une guerre *virile*' (see Khanna 2008: xiii). Fed by the reservoir of resentment that had been manifest in the events of October 1988 (see Chapter 6), the FIS won the first round of elections in late 1991, with 188 of the 231 seats available; the FLN secured a derisory 15. It seemed certain that, with 199 seats to be decided in the second round, the FIS were heading for a decisive majority in the National Assembly. At this point the military stepped in, directing what was 'clearly a putsch' (Evans and Phillips 2007: 171). On 11 January 1992 President Chadli resigned. Elections were suspended, and in early February a state of emergency declared. Mohamed Boudiaf returned from exile to head up the emergency government, and began to target corruption and nepotism. Boudiaf's reforms (including an attempt to break the power of the hated army generals) were initially popular and began to defuse the tension, despite the anger of FIS supporters. But the reforms were short-lived. He was assassinated in suspicious circumstances on 29 June 1992, to be ultimately replaced by President Zeroual. The result was increasing

violence, the establishment of curfews, a wave of murders perpetrated by fundamentalists against writers and intellectuals, and a spiral into the atrocities of the mid-1990s, perhaps the most terrible of which was the massacre at Bentalha in 1997 which left 417 victims, and raised questions about the complicity of state counter-terror units. Viewed in France and elsewhere as a 'second Algerian war', the conflict claimed between one and two hundred thousand lives by the end of the decade.

The desperation of Algerians attempting to flee the country was exacerbated by French immigration policy. In 1989, before the civil war, France had granted 800,000 visas to Algerians. By 1994, as the conflict worsened, this figure had been reduced to fewer than 100,000. The policy was described by Bourdieu and others as 'une quasi-fermeture de la frontière entre les deux pays' [practically closing the border between the two countries] and condemned as the (French) crime of 'non-assistance à une personne en danger' (see Bourdieu and Leca 1995: 319; Bourdieu, Derrida and Naïr 1994: 315). The scale of the terror during the black decade can be gauged by a joke from the late 1990s which ran: 'If you did not study during Boumediene's time [1965–78] then you will never study. If you did not make money during Chadli's time [1979–92] then you will never make money. If you did not die during Zeroual's time [1994–99] then you will never die' (Evans and Phillips 2007: 215). The year 1999 is generally seen as the beginning of the end of the conflict, with the AIS (Armée islamique du salut) ceasing its activities, and a series of amnesty laws rushed in by the new president, Abdelaziz Bouteflika, whose election has been described as the 'first step' along the path to resolution (Le Sueur 2010: 8). The amnesty process was not unproblematic however, since the state seemed, characteristically, to be foreclosing the discussion of controversial issues, such as the role of the army in certain atrocities, or the practice of mass rape by the Islamic militants. The civil concord of January 2000 initiated by Bouteflika 'led to an amnesty whereby six thousand militants from the AIS [and other groups] were pardoned'. As Evans and Phillips have observed,

> Theoretically this amnesty was only extended to those not guilty of rape, murder or terrorism but in reality few questions were asked and there was little way of verifying the official figures. The whole process was deliberately opaque, partly, many suspected, because this allowed any double agents to disappear into obscurity. (Evans and Phillips 2007: 264)

After Bouteflika's controversial re-election in 2004, censorship increased, as did efforts to pass a peace charter pertaining to the civil war. In September 2005 the charter was passed despite dissent and protest, and on 1 November (the much-mythologised date of the insurrection against French rule in 1954), Bouteflika ordered that 6,778 prisoners be amnestied (see Evans and Phillips 2007: 290).

The cultural historian Benjamin Stora has called the black decade a war without images, 'an invisible war' fought within a 'culture of silence'. It is for this reason, he contends, that the 1997 photograph of a grieving Algerian woman became such a famous visual index of the conflict, winning the World Press Photo prize and being circulated around the world. The visibility of this image screened the absence of any others (see Stora 2001: 7). Similarly, the novelist Boualem Sansal has written of a generation 'brought up in a culture of lies, taught the discipline of forgetting' (Sansal 2010: 178). Consequently, in an effort to evade state-censored representations, and the state monopoly of Algerian TV, 'Disgusted by the media silence about their everyday life, Algerians have turned in massive numbers to satellite television programming' (Hadj-Moussa 2009: 121). During the 1990s the culture of silence in Algeria was fuelled by fear of reprisals at the hands of the Islamists. Throughout the late 1980s and the 1990s, those who spoke out against the FIS risked death. The Kabyle poet Tahar Djaout, the subject of a fatwa issued in 1987, famously declared: 'le silence c'est la mort et toi si tu te tais, tu meurs, et si tu parles tu meurs, alors dis et meurs' [silence is death and if you're silent you'll die, and if you speak you'll die, so speak and die]. Murdered by Islamists in 1993, Djaout remained an inspiration for others, including the film-maker Mohamed Chouikh, who dedicated *Youcef* to his memory (see Chapter 6), and the Algerian rap group MBS (Le Micro Brise le Silence), whose 1999 debut album bore his words on the cover. But the culture of silence was also a product of Algeria's history – notably the legacy of colonialism and the underground struggle against the French, but also its more recent history since independence, dominated by FLN ideology, run as a one-party state, controlled by the army as much as by politicians. There had been a brief relaxation of censorship in the so-called Algiers Spring that followed October 1988, but this was rapidly reversed after the declaration of a state of emergency in 1992. A ministerial decree was issued by the Ministry of the Interior on 7 June 1994, limiting the Algerian media to the simple reproduction of official communiqués about the conflict; selection panels were

established to oversee the printing of all Algiers's major newspapers (see Bourdieu et al. 1998: 430). Between January 1992 and January 1997, there were fifty-eight seizures, banning orders or similar censorship measures against the news media (Stora 2001: 25). Hence the Algerian conflict was the opposite of a mediatised modern war such as Vietnam. Images of the atrocities were extremely rare. According to Stora, Algeria's suffering was rendered invisible by a host of factors, including the departure of external agencies, fearful of mounting violence; by internal policies (from massive censorship to Bouteflika's amnesty laws at the end of the conflict); by confusion around the goals of the state and the fundamentalist rebels; by an ignorance of the historical origins of the Algerian crisis; by the traumatising effects of colonialism; even perhaps by an Islamic tradition that disapproves of the visual and favours text over image. The result is a war without a history. Playing on the opacity of French terminology for the Algerian war, Stora concludes: 'A la "guerre sans nom" s'ajoute la "guerre sans visage" ' [The war without a name is followed by the war without a face] (Stora 2001: 46).

Stora is however very careful not to fall into the trap of calling this 'the second Algerian war'. Others were not so judicious, particularly in France. With its catalogue of terror and counter-terror, torture and trauma, the conflict was viewed by many French commentators as a repeat of the 'events' of 1954–62. Bourdieu shared this perception, declaring in 1997, 'on a l'impression que la guerre d'Algérie se rejoue [. . .] qu'il s'agit d'une répétition avec les mêmes phobies, les mêmes automatismes barbares, les mêmes réflexes primitives de la barbarie militaire' [it seems that the Algerian war is being replayed, with a repetition of the same phobias, the same barbaric reflexes, the same brutal reactions of military savagery] (Bourdieu 1997: 24). Assia Djebar too noted that the anti-intellectualism prevalent within the FLN in 1958 was again manifest in the black nineties: 'they are killing journalists, doctors, teachers, female professors and nurses, they are killing anyone with "degrees" even though they have no power' (Djebar 2000: 200). Stora has claimed that a tendency to see the black decade as a repeat of the earlier conflict fed the revival of French interest in the Algerian war during the 1990s – an interest evident in numerous press features, memoirs, TV broadcasts, and films about the French in Algeria (see Austin 2009). But he has also warned against the simplifications this entails: 'Tout se passe comme si l'histoire algérienne s'était arrêtée en 1962 [. . .] et reprenait son cours en 1992, à nouveau

marquée par la violence' [Everything is happening as if Algerian history stopped in 1962 and then started up again in 1992, once more marked by violence] (Stora 2002: 58). As I hope to have shown in my account of Algerian cinema thus far, Algerian history, and Algerian cultural production, did not cease in 1962 only to resume thirty years later with the start of another conflict.

The black decade obviously damaged Algeria's film industry. Coming after a decade of terror and conflict, 2000 was in effect Algerian cinema's year zero: 'zéro production, zéro salle, zéro distributeur, zéro billet vendu' [zero production, zero theatres, zero distribution, zero ticket sales] (Tesson 2003: 38). This in comparison with the zenith reached in 1975, the year of Lakhdar Hamina's Palme d'or for *Chronique des années de braise*, when 45 million film tickets were sold nationally, to a population of 30 million (see Chapter 2). Attempts to kick-start Algerian film production at the end of the 1990s were not initially successful. The launch of a millennium film project in 1999 had yet to bear fruit three years later. As recently as 2003/4 (in a book published in 2005), Roy Armes could write: 'Algerian cinema continues to be virtually non-existent, with no sign of production and distribution structures being restored' (Armes 2005: 74). But two caveats are required. Firstly, despite the massive difficulties of filming in Algeria during the conflict, a very small number of films had been made during the black decade. Some of these works represent an escape from contemporary suffering, as in the historical and ahistorical spaces of Berber cinema from the late 1990s (see Chapter 5). Others allude to the tensions that were to develop into civil war, including two examples we explored in Chapter 6, *Youcef* (Chouikh, 1993) and *Bab El-Oued City* (Allouache, 1994). Secondly, in the last decade, and in part thanks to initiatives like the French Ministry of Culture's 'year of Algeria' in 2002/3 and Algiers's role as the 2007 Arab capital of culture, Algerian film production has recently increased. (For debates on the extent to which current Algerian film production is compromised by French involvement, see Chapter 9).

A key concern of the films made after the end of the 'invisible war' is to make it visible. This is achieved by engaging with the trauma and its victims, but also by showing protagonists who survive to tell the tale. Narrativising suffering is one way of coping with it, since 'the narratives of trauma told by victims and survivors are not simply about facts. They are primarily about the impact of those facts on victims' lives, and about the painful continuities created by violence

in their lives' (Kaplan 2005: 42). Initially most striking in the Algerian context are those films that present realistic and often harrowing portrayals of the conflict, such as Yamina Bachir Chouikh's *Rachida* (2002), Belkacem Hadjadj's *Al-Manara* (2004) and Djamila Sahraoui's *Barakat!* (2006). To these we might add Mohamed Chouikh's allegory *L'Arche du désert* (1997). All of these examples explore the trauma of the civil war, to focus ultimately on the survival of protagonists at the close of the narrative. Both collectively (as much as one can talk about a collective response, when the number of films is so small) and within each film, the suffering of the 1990s is remembered and worked through. As trauma theory has it, `It is through the very process of rehearsing and re-enacting a drama of mental survival that the trauma narrative effects psychological catharsis' (Henke 1998: xix). Formally, survival is often evoked in these films by the use of the right-to-left tracking shot, which in an Arabophone culture denotes progress towards the future (it mimics the direction of reading, just like a left-to-right tracking shot in Western culture). Young adults or child protagonists also function as symbols of survival beyond trauma. In *L'Arche du désert*, for example, a young boy flees an oasis where the villagers have been massacred to walk, right-to-left, into the desert. And in *Rachida* a young female teacher is determined to teach again after an attack on her village: both she and her few surviving pupils are tracked walking right-to-left through the rubble to the school in the final sequence. Finally, in *Barakat!*, the closing image of the Mediterranean Sea – rather like the desert and the sky at the end of *L'Arche du désert* – evokes an eternal space, whose existence allows one to think beyond the temporal frame of the conflict. We will now look at these three films in greater detail.

L'Arche du désert (Chouikh, 1997)

Confronting the issue of the civil war, Mohamed Chouikh does not vary from the allegorical approach that we can also observe in his treatment of gender and the Family Code in *La Citadelle* (1988, see Chapter 4) or of memory and history in *Youcef* (1993, see Chapter 6). Again in *L'Arche du désert* Chouikh engages with the state of the nation by employing a form close to the parable, along with references to myth – in this case, the story of Noah's ark. Shot at Timimoun in the Saharan south of Algeria, the film concerns the disruption of an idyllic and timeless way of life in an oasis community. The apparently

illicit love between Myriam and Amin (Myriam Aouffen and Hacen Abdou) sparks a series of schisms whereby he is exiled, she is incarcerated and the community is divided in two, with barriers set up between each half of the village. Forced into an arranged marriage, Myriam kills the groom and flees into exile to be reunited with Amin. The film closes with them returning to the oasis only to discover that the villagers have been massacred. The only surviving witness, a little boy named Salim, sets off into the desert, declaring that the adults have gone mad.

At first glance the relation between *L'Arche du désert* and the events of the black decade does not appear obvious. This is partly a question of setting, since most narratives of the civil war are predominantly urban (such as Rachid Boudjedra's novel *Les Funérailles*) or divide their focus between Algiers and the rural communities of northern Algeria (*Rachida, Al-Manara*, Yasmina Khadra's novel *A quoi rêvent les loups*). The desert, although often a place of political exile, was also a refuge from the worst violence of the 1990s. Chouikh observes that during the shoot he met 'en plein désert, des intellectuels en exil qui fuyaient la violence du Nord et sa vague d'attentats' [exiled intellectuals in the desert, fleeing the violence of the North and the wave of attacks] (in Taboulay 1997: 65). The oasis community functions nonetheless as a very clear allegory of Algeria's internal conflict. By removing the competing political discourses of the FIS and the state and replacing them with the basic antagonism of two social groups (one identified by green flags, the other by blue), Chouikh reveals that the essential motor of the violence is intolerance and that the endpoint is the massacre of civilians. Moreover, it is not clear who is responsible for the massacre. This ambiguity – like that surrounding the death of Saïd and the identity of the BMW-driving *éminence grise* in *Bab El-Oued City* – captures the disempowering sense of confusion that characterised the black decade, and that saw conspiracy theories proliferate in response to massacres like that at Bentalha (see Evans and Phillips 2007: 238-42).

The brutality of adult society is emphasised by contrast with children (especially Salim, who acts as a witness to the trauma) and animals. In a scene that recalls the flock of sheep in Luis Buñuel's *The Exterminating Angel* (Mexico, 1962), Chouikh shows goats running through the streets of the village, pushing aside the green and blue barriers as they do so. A natural, animal existence has no need of the social distinctions erected by humans. Once Myriam has been

imprisoned, a beautiful and simple sequence shows a tortoise with a candle placed on its back making its way slowly into her cell. If these moments seem at one remove from the trauma of the 'invisible war', they belong to a nexus of imagery in the film around Noah's ark, which comes to a head in the final sequence, after the massacre. As Salim walks into the desert he passes the exiled wise man El Moutanabi standing in a boat – the ark of the film's title – surrounded by sand. Again one thinks of Buñuel and the ridiculous hermit in *Simon of the Desert* (Mexico, 1965). Another intertext here is Lakhdar Hamina's epic *Chronique des années de braise*, where the crazed hermit Miloud is a more positive figure, a holy fool and a surrogate father to the protagonist's young son. But where the young boy towards the conclusion of *Chronique* searches for the dying Miloud, in *L'Arche du désert* childen have been completely betrayed by the adult world, and Salim deliberately walks away from the old man. The boat and the hermit have specific national connotations here. An Algerian flag is glimpsed on the ark, while El Moutanabi, recalling Miloud, speaks of the 'flood of blood and tears' that has engulfed the land. In response, Salim walks alone into the desert, declaring 'I'm leaving to find another land, where they don't kill children and burn houses'. If there is despair in this ending, there is also, in the purposive right-to-left tracking shot and the beauty of the sunset over the desert landscape, a sense that survival, continuation and the ability to live at peace in the eternal space of land and sky may still remain.

Chouikh's choice of a child as witness and survivor in *L'Arche du désert* is significant not just because of the association between children and hope but also because of the perceived infantilisation of the Algerian public by the FLN's one-party state. According to Chouikh, the shift from independence to alienation, from 1962 to October 1988, can be explained according to an Oedipal model: 'les dirigeants sont devenus les "pères" de la nation [. . .]. Les enfants se sont sentis coupables de n'avoir pas participé à la guerre, ils sont infantilisés par des discours en langue de bois. Ils ont découvert le mensonge du "père" et se sont révoltés' [the leaders became the 'fathers'of the nation. The children, feeling guilty because they were not involved in the war, were infantilised by political rhetoric. They discovered that the 'father' had lied, and so they rebelled] (in Taboulay 1997: 49). Thus the child is a powerful figuration of the Algerian people as a whole, notably in their problematic relation with the 'fathers' of the nation-state. Even after October 1988, Algerian youth remained disempowered,

humiliated, reduced to the status of dependants, as recounted in Djamila Sahraoui's documentary, *Algérie, la vie quand même* (see Chapter 6). But the figure of the child is not just a metaphor. The atrocities of the 'invisible war' by no means spared children, and the child as victim of particularly brutal violence is a recurrent figure in Rachid Boudjedra's novel *Les Funérailles* (Boudjedra 2005). More positive images of Algerian children as recipients of a cultural memory passed down by older generations are presented in *Viva Laldjérie* (Mokneche, 2004) and *La Maison jaune* (Hakkar, 2007), while children function as both symbols of the future and survivors of trauma in our next case study, *Rachida*.

Rachida (Bachir Chouikh, 2002)

Rachida and *Barakat!* (see below) present the trauma of the black decade as a story of women. Father figures (even deluded ones, like the hermit of *L'Arche du désert*) are absent from both films. The husband whose kidnap sparks the narrative in *Barakat!* is spoken of, but never shown on screen. In *Rachida*, meanwhile, the protagonist's fiancé remains an equally marginal figure. The terrorists in either case are of course male, but remain minor characters. Both films are made by women, and the gender balance here also reflects the reality of Algeria during the 1990s. As Stora puts it, 'dans le conflit d'aujourd'hui, l'Algérie a fait l'expérience d'une société "désertée" en partie par ses hommes (partis en migration, dans les combats et dans les prisons) et prise en main par ses femmes' [in today's conflict, Algeria has experienced the partial abandonment of society by men (lost to emigration, war, prison) and has been taken in hand by women] (Stora 2001: 104). This 'taking in hand' of traumatised Algeria by women can be seen in female resistance to patriarchal Islamist discourse, in novels and memoirs by writers such as Assia Djebar, and in films by directors such as Hafsa Zinaï Koudil, Yamina Bachir Chouikh, Djamila Sahraoui and Habiba Djahnine. And this in a context of sustained violence against women, in the form of rape and murder. Stora concludes that against all the odds Algeria in the 1990s saw 'la *sortie des femmes, leur dispersion dans l'espace public*' [women *going out* into public space], with significant political, managerial and cultural roles being filled by women (see Stora 2001: 99, italics in original).

Rachida concerns a young teacher (Ibtissème Djouadi) who is forced to flee Algiers after she is shot and wounded by terrorists when refusing

to carry a bomb for them. She and her mother are driven to the countryside by Rachida's headmistress, and Rachida begins to work in the local school. The film concludes, like *L'Arche du désert*, with the massacre of the village and a scene evoking survival: Rachida and what remains of her class gather in the ruined school for a new lesson. Bachir Chouikh says of her choice of protagonist, 'J'ai choisi [. . .] une des victimes "préférées": une femme, une jeune enseignante' [I chose one of the 'favoured' targets: a woman, a young teacher] (Bachir Chouikh 2004: 2). *Rachida* is in many ways a commemoration of the victims of the terror. It addresses the targeting of women, of teachers, and of schools (for example by the GIA in their massacres of summer 1994), while reference is also made to the murder of Catholic monks from Tibehrine in 1997 and to the kidnapping and rape of women by fundamentalist groups throughout the 1990s (hence the kidnap of both Aunt Zohra and the young bride in the film). Finally, the soundtrack pays homage to the music of Cheb Hasni, the popular *raï* singer who was assassinated during the black decade, and whose death is also referred to in the closing scene of Tariq Teguia's *Rome plutôt que vous* (2006, see Chapter 6).

The representation of women in the film, while varied (showing both Westernised and traditional avatars) is essentially defiant of fundamentalist codes. Both at the start and the end of the film, and despite the terror that she suffers and witnesses in between, Rachida refuses the veil, dressing in 'Western' style. The film opens with a close-up of her applying lipstick, and concludes with her wearing a walkman (both symbols of what the FIS might term Western decadence). While women are frequently portrayed as victims of violence in the narrative, they are also figures of solidarity, personified by Yasmina the headteacher and by Rachida's mother. When male patriarchal codes entail the rejection of Zohra, the rape victim, it is the women of the village who drape her in their coloured scarves (thus covering her injured and half-naked body while uncovering their own heads) and invite her to the bath house to wash with them before the wedding scene. Rachida herself occupies an ambiguous space: both teacher and victim, she is represented as part adult and part child. The trauma of her wounding and of the subsequent murders she witnesses in the village infantilises her: a recurrent image in the film (also present on the posters and DVD box) shows her curled up, rocking backwards and forwards. But as we have noted, in the final sequence she walks through the ruins of the village to continue teaching the surviving children.

Given the subject of the film, it is notable how restrained Bachir Chouikh's mise en scène is. *Rachida* is her first film as director, although she had already edited numerous works including her husband's *L'Arche du désert* (see above). The atrocities in *Rachida* are generally de-dramatised, often shot in near-silence and with gentle camerawork, in order to convey the fact that such events are part of an everyday reality. We are in fact far from the hallucinatory, fragmented mise en scène that is often associated with the cinema of trauma (see Chapter 3). The only time disjointed editing and hand-held camera are used, for example, is to film Zohra's escape from her kidnappers. More usually, Bachir Chouikh's film style is gentle, one might say classical, but effective. After the massacre, she reveals a line of corpses laid out on the ground with a slow tracking shot from left to right. The camera movement here – the opposite of the direction of reading in Arabic culture – subtly suggests an inversion, a movement in the wrong sense, towards death. This is contrasted by the closing scene which uses a purposive right-to-left tracking shot to reveal Rachida walking towards the ruined school. Here, progression from the present towards a potential future is evoked by the movement of character and camera, thus reinforcing the fragile hope of the ending: Rachida has not stopped teaching, some of her class have survived, there is still a kind of future for Algeria. The identification between camera and writing here – both sharing the same movement, both also functioning as ways of telling the story of trauma – is reinforced by the fact that Rachida writes on the blackboard (in Arabic, right to left) once she has entered the school. The film closes with a question. Recalling François Truffaut's famous use of freeze-frame at the end of *Les 400 Coups* (France, 1958), which caught Antoine Doinel balanced between past and future, pessimism and optimism, Bachir Chouikh has Rachida stare directly into the camera, as the blackboard behind her displays the heading: 'TODAY'S LESSON'.

Rachida is a realist attempt to portray the suffering of the 'invisible war'. Making that suffering visible is the film's raison d'être, and this theme is hinted at in the opening scenes at Rachida's school in Algiers, where class photos are taken in a mood of defiance against the fear of terrorism, the photographer murmuring, 'It's not an execution'. A close-up on the eye of the camera fills the screen, as if to fill up the absence, the 'void' that characterised Algerian visual culture in the nineties (see Stora 2001: 7). *Rachida*, like Amor Hakkar's *La Maison jaune*, addresses the need to preserve images, to use visual culture as

a means of remembering the past and recording the traumatised present. Whereas in *La Maison jaune* the images concerned are on videotape (see Chapter 8), in *Rachida* they are photos, notably the class photos taken in Algiers, but also those of her fiancé and her estranged father. In both films, of course, the images are also those of cinema itself, providing the beginnings of a visualisation of the black decade and its aftermath. In *Rachida* this means images of the dead and wounded, certainly, but it means above all images of children: the pupils in the village school blowing bubbles together, or a little boy (Salim) telling a little girl (Kalima) about his aunt's rape while his hands move uncontrollably in distress, squeezing dry the orange Kalima has given him. The symbolism of such scenes might seem conventional, but it is deeply felt. More cryptic, more troubling, are the images of Zohra, enclosed in silence, pregnant with the child of her rape, the child of Algeria's trauma.

Barakat! (Sahraoui, 2006)

If *Rachida* explores female solidarity in the face of terror, so too does *Barakat!*, but with a narrower focus (a couple rather than a village) and with added generational tensions. The film works with the conventional generic models of the road movie and the odd couple, although naturally enough the register is tragic not comic. The odd couple are two women, whose journey in some ways evokes the 1960s classic *Le Vent des Aurès* (Lakhdar Hamina, 1966). Where the latter is the story of a mother seeking her son, arrested by the French, *Barakat!* follows Amel (Rachida Brakni) and Khadidja (Fettouma Bouamari), in search of Amel's husband who has been kidnapped by fundamentalists. The two women are presented as opposites in many ways, but also as internally contradictory (hence resistant to stereotypes). Amel is young and tall, wears Western dress but hates cigarettes and pills. Khadidja is older, smaller, more prepared to wear the veil and to assume traditional customs, but also a veteran of the war of liberation and an inveterate smoker and pill-popper. Their drama is a quest narrative on two levels: to find Mourad, Amel's missing husband, and also to define their own identities in relation to each other and to the generations (and the conflicts) that they embody.

The centrality of the female duo is manifest throughout the film. Amel, Khadidja, or the two together, are present in practically every scene. Sahraoui makes frequent use of facial close-ups on her two

lead actresses, often without dialogue, filming their expressions and their moments of fear, anger, trust and antagonism. The characterisation of Khadidja in particular is thrilling: an independent, middle-aged woman who carries a small silver pistol, but on whose face the stress of the black decade is etched, and who has to continually smoke and take tranquillisers to calm her nerves. When their friendship does break down, it is because of generational conflict: young Algeria, suffering the 'invisible war' of the 1990s, does not trust old Algeria, and cannot understand the importance accorded to the war of liberation. Thus, when they have been captured by a group of relatively moderate Islamists, one of whom, the jeweller Slimane, fought with Khadidja against the French, the 'buddy' pairing is split. While Khadidja tries to connect with Slimane (the camera circling round them as if to evoke the loss of bearings since the more certain days of the 1960s), Amel feels betrayed and abandoned. Once they have been freed by the Islamists, the two argue about the meaning of the war against the French and decide to go their separate ways. Sahraoui's use of composition and colour here expresses their division: Amel sits in blue on one side of the frame while Khadidja stands in pink on the opposite side, the barrier of a fruit tree separating them. Landscape is also used symbolically to represent their *dépaysement* and uncertainty (about the whereabouts of Maroud, about their own roles): the Islamists steal their car and turn them loose without shoes, so that the two women have to make their way painfully and slowly through the unfamiliar landscape. Nonetheless, when they are more reconciled, and descend the hillside together, Sahraoui films the couple in *contre-jour* [against the light], their silhouettes on the mountain recalling the mythic silhouetted compositions of the heroic mother journeying across Algeria in *Le Vent des Aurès* (see Chapter 3).

Meanwhile for the most part men are absent from the narrative, or held at its margins. They are either invisible (Amel's father and husband), shadowy and menacing (the fundamentalists), passive (the taxi drivers who refuse to take the women home) or duplicitous (the mechanic who lies about Mourad's whereabouts). Slimane is a minor character of some interest, but at the end of the film we hear that he has been killed by the GIA. The one exception is the old peasant widower that the women meet and who drives them in his donkey cart across country and back to their home village. The old man personifies loss (his wife is dead, his sons have disappeared in the 'invisible war'), and also the traditional peasant way of life – which

Khadidja in particular accepts, symbolically making bread (again, like the peasant mother in *Le Vent des Aurès*) once they are welcomed into his house. If Khadidja is Amel's surrogate mother (Amel calls her 'petite mère' at one point), the old man is a grandfather figure, whose connection with the land and also with a time before even the 'first' war, makes him the personification of an eternal Algeria. While Khadidja transmits historical memory to the younger generation – like the female veterans in *Youcef* and *Bab El-Oued City* (see Chapter 6), or the characters played by Biyouna in the films of Nadir Mokneche (see Chapter 8) – the widower transmits a more ageless wisdom to the two women, warning them against hatred and revenge. In the final scene, once Amel has been reunited (off-screen) with Mourad, the old man takes Khadidja's pistol and throws it into the sea, declaring 'barakat!' [enough] – an image reminiscent of *Viva Laldjérie* (Mokneche, 2004) where a young woman symbolically rejects violence by dropping a pistol in a drain. Khadidja echoes him, repeating 'barakat!', and the film ends with the two of them walking in the crashing waves of the sea. The symbolism of cleansing is obvious; where at the end of *L'Arche du désert* the 'flood of blood and tears' threatened to engulf the land, ten years later in *Barakat!* there is a sense of trauma coming to an end, of bloodshed being washed away and of life being restored.

Conclusion

The postcolonial, neo-colonial Algerian state has embraced the process of nation formation dependent on Ernest Renan's concept of 'remembering to forget'. Evans and Phillips explain:

> Renan, in a lecture given in 1882, famously argued: 'forgetting, even getting history wrong, is an essential factor in the formation the nation, which is why the progress of historical studies is often a danger to nationality'. Nowhere has this adage been more true than in post-independence Algeria. (Evans and Phillips 2007: 9)

In the desperate, suspicion-racked atmosphere of the late 1990s, 'remembering to forget' meant deflecting attention away from the black decade, forgetting the army's role in recent atrocities for example, by turning attention once more to the war of liberation. Whereas the internecine bloodletting of the Algerian revolution had for years been erased from history by the FLN – the film *Les Sacrifiés* (Touita, 1982) on the MNA was immediately banned – now was an opportune

moment for these issues to be revived, as a screen memory to obscure memories of more recent state violence. President Bouteflika 'sought to efface this immediate history by facing up to taboo aspects' of the war against the French (Evans and Phillips 2007: 266). Hence on 5 July 1999, the anniversary of independence, he named four key airports after revolutionary leaders killed or exiled by the FLN: Messali Hadj, Abane Ramdane, Krim Belkacem and Mohammed Khider (on the assassinations of the first three, see Djebar 2000). In sum, 'For the sake of peace Bouteflika was determined to bury the 1990s' (Evans and Phillips 2007: 266). Or as Khanna puts it, 'Bouteflika has run on a ticket for amnesty ever since he first campaigned for office in 1999', and in power 'he has simply agreed to forget – performing thereby the amnesia that informs all amnesty laws' (Khanna 2008: 248). Organised forgetting continued with the amnesty referendum of 29 September 2005, described by Boualem Sansal as a falsified result, the people's desire to move on from the black decade being co-opted into a vote of thanks and allegiance to Bouteflika: 'nous avons voté quoi à 98 per cent sous couvert de reconciliation et de paix? L'amnistie des terroristes et [. . .] des commanditaires, n'est-ce pas? [. . .] nos urnes ont servi de machine à laver le linge sale des clans au pouvoir' [what did 98 per cent of us vote for under the guise of peace and reconciliation? Amnesty for terrorists and hidden killers. Our ballot boxes became a washing machine to clean the dirty laundry of the clans in power] (Sansal 2006: 27, 49).

Cinema however, as in the examples we have discussed above, attempted to record and remember the 'invisible war'. In 2004, the year of Bouteflika's first controversial re-election, Belkacem Hadjadj's film *Al-Manara* was made. Like *Rachida* and *Barakat!*, *Al-Manara* places a female protagonist at the centre of an account of the black decade. The film takes the form of a flashback narrated by Asma (Samia Meziane) from self-imposed exile in France, after her kidnapping and rape by Islamists during the 1990s. The key setting is however the Algerian town of Cherchell, where an ancient religious ritual (Al-Manara) joins Asma and her two male friends in a celebration deemed heretical by fundamentalist Islam. *Al-Manara* therefore consciously reflects the imperative to remain tolerant, but also to remember the divisions of the black decade, symbolised by the story of the three friends' divergent paths through the terror and away from each other. Like all Algerian films addressing the 'invisible war', *Al-Manara* reflects above all the need to create images of Algeria to fill the space evacuated

initially by colonialism, then later by the one-party state, the civil conflict and the culture of invisibility epitomised by Bouteflika's amnesty laws. As Hadjadj has stated,

> Le cinéma est un miroir, qui permet aux Algériens de se regarder. Les Algériens ne se regardent pas. [. . .] Malheureusement on a simplement remplacé le modèle colonial par un autre modèle, au détriment des valeurs culturelles locales. Et ça continue. Dans ces conditions, comment voulez-vous que les Algériens aient plaisir à se voir? [Cinema is a mirror, which allows Algerians to look at themselves. Algerians are not looking at themselves. Unfortunately we have simply replaced the colonial model with another model, to the detriment of local cultural values. And it goes on. In these conditions, how can Algerians take pleasure in seeing themselves?]. (Hadjadj 2003: 71)

We will address the answer to this question in our next chapter, where the ambivalent pleasures of origins and memories are at stake.

References

Armes, Roy, *Postcolonial Images: Studies in North African Film* (Bloomington: Indiana University Press, 2005).

Austin, Guy, ' "Seeing and listening from the site of trauma": the Algerian war in contemporary French cinema', *Yale French Studies*, 115 (2009), pp. 115–25.

Bachir Chouikh, Yamina, 'Entretien avec Yamina Bachir Chouikh', Limited edition DVD booklet (Les Films du Paradoxe, 2004).

Boudjedra, Rachid, *Les Funérailles* (Paris: Livre de Poche, 2005).

Bourdieu, Pierre, 'Dévoiler et divulguer le refoulé', in Joseph Jurt (ed.), *Algérie – France – Islam* (Paris: L'Harmattan, 1997), pp. 21–7.

Bourdieu, Pierre, Jacques Derrida and Sami Naïr, 'Non-assistance à une personne en danger' (1994), in Bourdieu, *Interventions, 1961–2001: Science sociale & action politique* (Paris: Agone, 2002), pp. 315–16.

Bourdieu, Pierre and Jean Leca, 'Non à la ghettoïsation de l'Algérie' (1995), in Bourdieu, *Interventions, 1961–2001: Science sociale & action politique* (Paris: Agone, 2002), pp. 319–20.

Bourdieu, Pierre, Majid Benchikh, Tassadit Yassine et al., 'Lettre ouverte aux members de la mission de l'ONU en Algérie' (1998), in Bourdieu, *Interventions, 1961–2001: Science sociale & action politique* (Paris: Agone, 2002), pp. 429–32.

Caruth, Cathy (ed.), *Trauma: Explorations in Memory* (Baltimore: Johns Hopkins University Press, 1995).

Djebar, Assia, *Algerian White* (translated by David Kelley and Marjolijn de Jager) (New York and London: Seven Stories Press, 2000).

Evans, Martin and John Phillips, *Algeria: Anger of the Dispossessed* (New Haven and London: Yale University Press, 2007).

Hadjadj, Belkacem, in *Cahiers du cinéma*, Spécial Algérie (February 2003), cited at www.trusiad.fr/coordination/mascarades/index.html, acessed 15 April 2011.

Hadj-Moussa, Ratiba, 'The undecidable and the irreversible: satellite television in the Algerian public arena', in Chris Berry, Soyoung Kim and Lynn Spigel (eds), *Electronic Elsewheres: Media, Technology, and the Experience of Social Space* (Minneapolis: University of Minnesota Press, 2009), pp. 117–36.

Henke, Suzette, *Shattered Subjects: Trauma and Testimony in Women's Life Writing* (London: Macmillan, 1998).

Kaplan, E. Ann, *Trauma Culture: The Politics of Terror and Loss in Media and Literature* (New Brunswick and London: Rutgers University Press, 2005).

Khanna, Ranjana, *Algeria Cuts: Women and Representation, 1830 to the Present* (Stanford, CA: Stanford University Press, 2008).

Le Sueur, James, *Algeria since 1989: Between Terror and Democracy* (London and New York: Zed Books, 2010).

Sansal, Boualem, *Poste restante: Alger. Lettre de colère et d'espoir à mes compatriotes* (Paris: Gallimard, 2006).

Sansal, Boualem, *An Unfinished Business* (translated by Frank Wynne) (London: Bloomsbury, 2010).

Stora, Benjamin, *La Guerre invisible: Algérie, années 90* (Paris: Presses de Sciences Po, 2001).

Stora, Benjamin, 'L'Algérie d'une guerre à l'autre', in D. Borne, J.-L. Nembrini and J.-P. Rioux (eds), *Apprendre et enseigner la guerre d'Algérie et le Maghreb contemporain* (Versailles: Ministère de l'Education nationale, 2002), pp. 89–100.

Taboulay, Camille, *Le Cinéma métaphorique de Mohamed Chouikh* (Paris: K Films Editions, 1997).

Tesson, Charles, 'Boujemaa Karèche' [interview], *Cahiers du cinéma*, Hors-série: Où va le cinéma algérien? (2003), pp. 36–41.

8

Memory and identity: from lost sites to reclaimed images

Case studies: *Viva Laldjérie* (Nadir Mokneche, 2004), *Délice Paloma* (Nadir Mokneche, 2007), *La Maison jaune* (Amor Hakkar, 2007)

A loss of identity and a sense of dispossession are two related and painful threads that run through modern Algerian history. They can be observed in the violent dispossession enacted by the civil war or the 'black decade' (see Chapter 7), the political dispossession effected by the one-party system, the economic dispossession of the 1980s, and perhaps above all the forced dispossession of rights, identity and culture under French colonial rule. It has been observed that between 1860 and 1918 more than a million hectares of Algerian land passed from Muslim to European hands. The result was a loss of land but also a loss of self via acculturation (see Stora 2001: 36). As Pierre Bourdieu explained at the time, the massive cultural shift brought about by the colonial encounter was exacerbated by the 1954–62 conflict, and notably by the large-scale displacement and urbanisation that saw around two million Algerians

> arrachés à leur univers familier, à leur terre, à leurs maisons, à leurs coutumes, à leurs croyances, à tout ce qui les aidait à vivre [. . .]. Bref, la guerre et ses séquelles ne font que précipiter le mouvement de désagrégation culturelle que le contact des civilizations et la politique coloniale avait déclenché [torn from their familiar world, their land, their homes, their customs and beliefs, from everything that helped them to live. In short, the war and its consequences are only accelerating the cultural disintegration that had been unleashed by the contact between civilisations and by the colonial project]. (Bourdieu 1961: 25)

It is in this light that Belkacem Hadjadj's question from our previous chapter – how can Algerians look at themselves? – needs to be addressed.

Another related question comes from Frantz Fanon. As Fanon puts it, embedding the issue of national identity in a colonial context, 'colonialism forces the people it dominates to ask themselves the question constantly: "In reality, who am I?"' (Fanon 2001: 200).

One way to answer these questions and to regain a sense of identity is to have recourse to memory, particularly the memory of origins. In independent Algeria, official memory has remained fixated on the war against the French. This makes it all the more important to look beyond the anti-colonial struggle and the FLN's mythologising of the Algerian revolution as the founding moment of national identity. While history seems to begin in 1954 for the FLN, the pre-colonial epoch may be excavated for a sense of origins outside official discourse. Kateb Yacine's 1956 novel *Nedjma* returns repeatedly to a perception of ancient history informing the present: 'ce sont des âmes d'ancêtres qui nous occupent' [it's the souls of our ancestors living in us]; 'qui d'entre nous n'a vu se brouiller son origine comme un cours d'eau ensablé, n'a fermé l'oreille au galop souterrain des ancêtres' [who among us hasn't seen his origins hidden like a silted-up water-course, and hasn't closed his ears to the underground gallop of our ancestors?] (Yacine 1996: 105, 106). The uncovering of these lost origins can seem a way of understanding Algeria's traumatic present. For Bourdieu, speaking in the 1990s, 'c'est à condition de remonter très loin que l'on peut saisir les racines les plus cachées du problème algérien' [it is only by going far back that one can grasp the most hidden roots of the Algerian problem] (Bourdieu 1997: 21). Current Algerian cinema is a vehicle for this exploration of origins. As recently as in 2003, Stora asserted that Algeria had evaporated, the absence of images during the 1990s contributing to the existence of a fantasy country (see Stora 2003). But since 2003, Algerian film has gradually taken on the role of a vector of memory. Here memory is presented as regional, personal, gendered – rather than uniform and monolithic as under FLN ideology. In particular, stories of Berber culture (the films of Amor Hakkar) and of the gendered body (the films of Nadir Mokneche) recall the past in order to grasp a sense of identity in the present. Communities marginalised by FLN policies (the Berbers, women) or by FIS ideology (again, women) are a key focus for these new Algerian auteurs. Mokneche and Hakkar both address the need to transmit memory from one generation to the next, whether in the form of video images (*La Maison jaune*, Hakkar, 2007) or of female performance (*Viva Laldjérie*, Mokneche, 2004). These directors also

engage with the memory of historical origins, via a symbolism that identifies initially rootless modern-day characters with the legacy of the ancient past.

Viva Laldjérie (Mokneche, 2004)

During the black decade of the 1990s, images of the Algerian experience became increasingly rare and hence increasingly important (see Chapter 7). The image is central to memory in the films made after the end of the civil war, even if it is not overtly the trauma of the conflict itself which is at stake. Images in these films help to secure the memory of the lost loved one and of lost origins. The figure of the lost relative or friend reminds the audience in turn of 'les disparus', the disappeared of the 'invisible war', of whom Stora writes: 'Les disparus de cette guerre sont les symboles de cette opacité. [. . .] Disparition d'acteurs ou de témoins gênants, disparition des corps, disparition de la mort' [The disappeared of this war are the symbols of an impenetrable darkness. Awkward witnesses or participants, bodies, death itself – all have disappeared] (Stora 2001: 112). Both Hakkar's *La Maison jaune* and Mokneche's *Viva Laldjérie* confront the 'disappearance of death' by showing the protagonists' desperate attempt to find and collect the body of a missing person. The need to recuperate the body is a way of taking hold of the memory of the dead, similar in function to the preservation of the dead in the form of the image. In *La Maison jaune*, it is the video image which keeps alive the memory of the dead son (see below), while in *Viva Laldjérie* the still photographic image is all that remains of the prostitute Fifi once she has been abducted and her apartment emptied of every trace of her existence. The photo here is associated strongly with death, as it is in the theories of Raymond Bellour (see Bellour 1991). It is precisely at the moment when Goucem presents the police with a photo of the missing Fifi that she is told her friend is dead. Similarly in *Délice Paloma* the fate of the 'disappeared' of the black decade is succinctly expressed by the photo of her missing son that one of Madame Algeria's clients carries with her. By adding these photographic images to the apparently unique press photo of the 'invisible war', the films of Mokneche and Hakkar challenge the culture of silence and secrecy that engulfed the 1990s (see Chapter 7).

Viva Laldjérie presents the struggle of both Papicha (Biyouna) and Goucem (Lubna Azabal) to reach a form of individuation that

acknowledges but moves on from the past. In the case of Goucem, this means letting go of the delusion that her lover Aniss will leave his wife to marry her. That she is imprisoned in this belief and this affair is indicated explicitly when a composition shows her behind bars (actually the rungs of a ladder) on a visit to the wise woman who she hopes will confirm that she and Aniss have a future together. Goucem is also strongly identified with the photographic image and the need to represent the present, since she works at a photo studio. Family photos surround her at work, and a red bulb lit up at the studio indicates that contemporary reality is being recorded, thus illuminating the purpose of Mokneche's film itself. *Viva Laldjérie* is punctuated with a dozen mirror compositions, mostly of Goucem and/or her mother Papicha. The effect of these repeated mirror images is to suggest that each woman has multiple selves, and to evoke the possibility that a potential new self may be accessed. A key means of access to the potential self is performance and the spectacle of the female body, especially as regards Papicha. Initially such spectacle is represented as mournful and despairing – Papicha's drunken singing and dancing to the music of Cheba Djanet after visiting her husband's grave. But performance is also represented very powerfully in the film as a means of passing on memory down the generations, and of securing one's own identity despite loss (see below). And in Papicha's case, her past identity – as a dancer – is again captured by means of the image, in posters of her former incarnation. Meanwhile Goucem's rage at her situation (comparable to the rage of Algerian youth in the 1990s, but expressed here in the register of romance rather than politics) is symbolised when she steals a gun from one of Fifi's clients, possibly with the intention of threatening Aniss. (The phallic power represented by the gun is made explicit when she hides it between her legs, under the mattress she is sitting on.) However, when she learns that Aniss has left his wife to marry someone else, Goucem is freed from her imprisonment. In a scene that mirrors the ending of *Barakat!* (see Chapter 7), she throws away the gun and is hence freed into the future. She mourns the death of Fifi (demanding to see her body at the hospital and ignoring Aniss in the process) and of her father (visiting the cemetery without her mother for once). And then she is ready, at the end of the film, to finally reach out to Samir, the young man who has been trying to date her from the opening scene.

If the two scenes of mourning that Goucem undertakes near the close of the film hint at a need to engage with the past before moving

on, the narrative involving Papicha is more overtly concerned with the need to return to one's origins in order to secure a sense of identity. Historical sites are the source for a projected new life for Papicha as for the matriarch Madame Algeria (also played by Biyouna) in Mokneche's subsequent film, *Délice Paloma* (see below). The Roman baths of *Délice Paloma* and the Copacabana nightclub of *Viva Laldjérie* share this function with the ruins of Timgad in Hakkar's documentary about Berber and Roman ruins (see below). It is via a return to the traces of the past that the peasant farmer of *Timgad* or the mother figures in Mokneche's films seek a sense of self. What is particularly strong in *Viva Laldjérie* is the desire to regain a female identity realised via the body, performance, and corporeal memory. To this end the casting of national icon Biyouna, a very popular performer in Algeria, is extremely effective. Biyouna began belly dancing in Algiers at the age of fourteen, developing a successful television and music career and appearing in Mokneche's first film, *Le Harem de Madame Osmane* (2000). Her presence in *Viva Laldjérie* ensures a sense of historical continuity, since for an Algerian audience it evokes memories of her performances from the 1970s onwards. This is particularly poignant at the time of the film's release, in the aftermath of the black decade, since the rise of Islamic fundamentalism in the 1990s had called into question the display of the female body, and since the rape and murder of women, as well as increased constraints on their movement, activity and dress, had characterised the civil war. As the feminist campaigner and politician Khalida Messaoudi – herself condemned to death by the FIS (Front islamique du salut) – explained in the mid-1990s,

> Les intégristes [. . .] veulent avoir une mainmise absolue sur la société et ils ont parfaitement compris que cela se passe d'abord par le contrôle de de la sexualité des femmes, [. . .] visible sur leur corps. Voilà pourquoi les islamistes tiennent à le cacher, à le voiler, à faire disparaître la différence biologique dans ses signes extérieurs [The fundamentalists want complete domination over society and they have understood perfectly that this is achieved first and foremost by controlling women's sexuality, which is visible on their bodies. This is why the Islamists insist on hiding women's bodies, veiling them, making the external signs of biological difference disappear]. (Messaoudi 1995: 161)

In such a context, Papicha's desire to revisit her past life as a belly dancer, and her plan to buy the Copacabana cabaret where she used to perform, become acts of defiance. The club has been closed down

and is in the process of being turned into a mosque, indicative of the exclusion of female bodies from sight under hard-line Islamic ideology. Although Papicha's attempt to buy the club and return it to its original function fails (like Madame Algeria's attempt to buy the Roman baths in *Délice Paloma*), she manages to reclaim her performative past self. While seeking the owner of the site, she discovers the Rouge-Gorge cabaret-restaurant, where old posters of her belly-dancing days adorn the walls. Moreover, she now embarks on a new but related role as a singer. The final sequence of the film cross-cuts between Goucem's visit to her father's grave and Papicha's triumphant opening performance at the Rouge-Gorge. During this performance, the black mourning shawl that Papicha wears in an earlier, drunken dance where she mourns her husband's death is now draped casually around her arms. She is ready to cast off mourning since she has reconnected with a past characterised by agency rather than loss.

Equally significant is the development of the relationship between Papicha and the concierge's young daughter Tiziri, to whom she is a surrogate grandmother. It is Tiziri who brings the records of the past (a pile of old newspapers) to Papicha and who helps her to look for reports on the Copacabana. And it is to Tiziri that Papicha demonstrates both the site of the club and the art of belly dancing. In the latter scene, Papicha appears for the first time in her dancer's costume, and, in another mirror composition, teaches the girl to dance. Cultural memory, as performance, is thus passed down from one generation to the next – just as in *Le Harem de Madame Osmane* the mother teaches the younger generation the tradition of the 'youyou' or wailing, whereby women express codified inner emotions in a public space. Despite the absence of strong male characters in the film, and the warm rapport between Papicha and Tiziri, or between Goucem and Fifi, there is not a comprehensive sense of female solidarity in *Viva Laldjérie*. The concierge's wife disapproves of Fifi's trade, while Goucem disapproves of Papicha's belly-dancing antics. There is a clear distance between mother and daughter, explicable perhaps by the fact that Goucem represents the lost generation of Black October and of the black decade. Unlike Papicha (or indeed the middle-aged female veterans of *Barakat!*, *Bab El-Oued City* and *Le Harem de Madame Osmane*), Goucem is of a generation that has no golden age to look back on or to reclaim. Hence she can only dream of a fantasy exit into a new future, like the unemployed young men known as *hittistes* in Djamila Sahraoui's *Algérie, la vie quand même* (1998). Indeed, the

potential future relationship glimpsed in her rapprochement with Samir at the end of the film recalls the revelation at the end of Sahraoui's documentary that one of the *hittistes*, at least, has managed to get married and thus leave behind the 'zombie' existence of a perpetual present.

Mokneche's deployment of colour symbolism questions the place of Islam in national identity. Supposedly one of the pillars of Algerian identity (for example in the 1930s credo of Sheikh Ben Badis, or in the 1984 Family Code), Islam – signified by the colour green – is clearly missing from the red-and-white pillars that frame Goucem's workplace at the start of the film. Indeed, red and white dominate the film's colour scheme, with green often relegated or absent. The national tricolour of red, white and green is for once manifest in the painting of St George and the dragon purchased by Fifi, but green is the colour of the dragon: a monster killed by the saint who wears all three colours. This medieval image connects Fifi, an incarnation of contemporary Algerian discourses around the sexualised (female) body, with an ancient myth of (masculine) sainthood, since both Fifi and St George are looking straight at the camera, challenging the spectator to trace the link between the medieval knight and the modern-day prostitute. The connection is further symbolised by the fact that both figures, saint and prostitute, have brown curly hair emerging from a yellow halo and from a white robe and veil. Of all the major female characters in the film, only Fifi does not dance. This is ironic because in Algerian constructions of femininity, dancing and prostitution have often been associated. The association of belly dancing with prostitution has been identified as a legacy of colonialism. Precolonial dance by women was increasingly eroticised and commodified by the French, generating 'a loss of status [for] the dancers among their immediate community as well as the larger society' (Lazreg 1994: 32). For Assia Djebar the belly dancer is half-way between the veiled woman and the 'fatal' nightmare (in the patriarchal imagination) of the entirely sexualised, fully exposed woman (see Djebar 1980: 152). Djebar locates a paranoid policing of the female body, as well as a breakdown in communication between generations and between genders, in the dispossession enacted by the colonial period (Djebar 1980: 153). We can see the control of women's bodies as heightened further in the fundamentalist terror of the 1990s. Against this, *Viva Laldjérie* celebrates female dance performance as almost ubiquitous (the night-club dancer, Papicha, Goucem and Tiziri all dance) and reconnects with a

tradition that is both precolonial and also, in the context of the black decade, a form of defiance against fundamentalist Islamist strictures on the veiling of the female body.

The dialogue in *Viva Laldjérie* refers at times to terror attacks, road blocks and murders, but the film is not 'about' these things. The constrictions and conflicts of the black decade in fact provide a series of alibis for certain characters, enabling them to deceive others: Goucem lies to her boss about a terror attack (excusing her absence from work), Aniss lies to Goucem about having to treat victims in Oran and being held up by a road block in Algiers (while he is in fact with another mistress). Like the robes and veils that Goucem and Fifi wear over their revealing 'Western' clothes, these remarks take the discourse and drama of the times and use them as disguise. (The same can be said of Madame Algeria's use of the veil in *Délice Paloma*.) The meaning of the war is thus renegotiated by its potential victims, as part of the currency of everyday life. Nonetheless Mokneche does make a very powerful allusion to the abduction and murder of the primary victims of the 1990s conflict: women. When Fifi is kidnapped and then killed by a client who happens to be a member of the security service, her death stands as a symbol of the fate of thousands of women in Algeria during the black decade (primarily, it must be said, at the hands of Islamist terror groups such as the GIA – see Chapter 7). The threat of fundamentalism against women's bodies is expressed through Papicha's fear of 'les barbus' (Islamist militants) and above all by the status of female performance in the film. Defiance against such threats energises the film's representation of the sexualised body: prostitution, sex, full-frontal nudity, homosexuality. If Biyouna as Papicha embodies female performance and corporeal memory in the film, Azabal's portrayal of Goucem embodies female desire and a more intimate form of corporeal display: we see her having sex with various lovers, sitting naked on the bed smoking a post-coital cigarette and washing herself between the legs after sex with a stranger. Once the latter act is completed, she remarks cheerfully to her mother (gently ridiculing notions of sexuality and cleanliness), 'Je suis propre maintenant, tu peux dormir' [I'm clean now, you can go to sleep]. In a similar fashion, Mokneche's film mocks the demonisation of the female body, and celebrates its exuberant presence whether in private space (Goucem, Fifi, the universe of sex) or in public display (Papicha, Tiziri, the world of song and dance), in past tradition or in present transmission.

Délice Paloma (Mokneche, 2007)

Mokneche's comedy-drama *Délice Paloma* is in some ways a sequel to *Viva Laldjérie*, especially in its treatment of femininity and spectacle. The female body is again on display in belly-dancing and night-club scenes (with the MC urging the crowd to applaud Rachida's body), there are comic twists on the performance of Islamic femininity (the veil as a means of farcical disguise), the film as a whole offers an allegorical commentary on the state of the nation, and the central performance once more comes from the renowned actress and singer Biyouna. Again cast as a matriarch, Biyouna is here even more explicitly identified with the nation. Assuming the name Madame Algeria, she dresses in national colours, declares herself a national benefactor and attempts to meet the needs of her citizens (using blackmail and dirty tricks, and for a large profit). The film is not limited to a satire on the corruption of the state, however. Madame Algeria, like the family group gathered round her (a son, Riyad, who has never met his Italian father, a surrogate daughter, Rachida, who has left her native village to work in Algiers and who ends up a belly-dancing star), is in search of reassurance about origins and hence identity. In Madame Algeria's case, such reassurance can come only from a connection with the past, both her own (childhood memories) and that of her country (its Roman heritage). Hence her plan to buy and renovate the Roman baths outside Algiers she used to visit as a child, and which are now abandoned and in disrepair, a metaphor for Algeria's neglect of its own history. *Délice Paloma* is constructed as a series of flashbacks after the failure of this scheme, with the form of the narrative thus emphasising the interrelation between past and present, memory and history (see Turim 1989). Remembering is central to the film's plot and to its retelling (in voiceover) by Madame Algeria herself. She incarnates a nation that is no longer subject to amnesia or indeed hypermnesia (there are no references to the war of liberation in the film). A slow pan across the shelves of her apartment reveals artefacts and objects that speak of the past: books, prints, statuettes – recalling the posters of the young Papicha in *Viva Laldjérie*.

When we first see Madame Algeria (leaving prison after a three-year term) she is dressed in the green, white and red tracksuit of the national team. This symbolism on the level of mise en scène is maintained throughout much of the film. Green, white and red figure subtly in the decor of several scenes. Riyad's room features a football poster

complete with Italian flag, the national colours echoing those of Algeria and providing a crystallisation of his identity crisis. When Madame Algeria first visits the Roman baths, the green, blue and gold of her clothes deliberately mirrors the colours of the landscape behind her, the blue of the sea, green of the trees and gold of the beach. She is the very embodiment of the land and has returned to claim it. A similar composition in the first scene of the comedy *Hassan Niya* (Bendeddouche, 1988) matches Hassan's blue jacket (a traditional fisherman's outfit) and yellow scarf with the blue Mediterranean and the yellow buildings of Algiers, establishing him as the embodiment of the city and in a sense as Monsieur Algeria. As with *Délice Paloma* the colour symbolism is reinforced by the casting: Rouiched is the comic star and writer of the Hassan series, and is a national icon to compare with Biyouna. In the case of *Délice Paloma*, there is another connection at work – a nexus of symbolism that links the Mediterranean, notions of maternity and Arab identity. The Tunisian film-maker Ferid Boughedir has noted that in Arabic the word for mother, *Oum*, is very close to the word for nation, *Oumma*. He concludes that 'pour les Arabes, totalement méditerranéens en cela, la mère signifie toujours CE QU'IL Y A DE PLUS IMPORTANT' [for Arabs, who are to this extent entirely Mediterranean, the mother always signifies WHAT IS MOST IMPORTANT] (Boughedir 2004: 105, emphasis in original). Biyouna's role both as a figurative mother to the nation and as a literal mother to her son cements this connection, to which one might also add the asociation, for French speakers, between *la mer* (sea) and *la mère* (mother).

For Stora, *Délice Paloma* explores Algeria's intermediary status in the new millennium, caught between tradition and modernity (Stora 2008). It is characteristic of Mokneche to represent this juncture via a female protagonist, as in *Le Harem de Madame Osmane* and *Viva Laldjérie*. More generally in Algerian culture women often function as an embodiment of 'the distance that separates the "old" from the "new"' (Lazreg 1994: 172; see also Chapter 4). In *Délice Paloma*, social themes relating to gender and to modernity are treated with a mixture of comedy and pathos. References are made to the oppression of women under the Family Code, the plight of relatives seeking 'the disappeared' of the civil war and the arrival of Chinese investment. The primary theme of dispossession is handled by Mokneche with a light touch, but with a very sure grasp of Algeria's past. Madame Algeria declares that she has not visited the Roman baths since 1965

– a key date in Algeria's history and in the rewriting of that history, since it marks the military coup that saw President Ben Bella replaced, and in effect erased from official history, by Houari Boumediene. The baths were, we are told, nationalised by Boumediene and their slow collapse into disuse reflects the gradual collapse of revolutionary idealism under the rule of the FLN (particularly since Boumediene's death in 1978).

As in Assia Djebar's *La Nouba des femmes du Mont Chenoua* (1978) and Amor Hakkar's TV documentary *Timgad* (2000) – both of which also feature Roman ruins – Mokneche suggests that one way out of the impasse of contemporary Algeria is to reconnect with the past. At the baths, Madame Algeria declares her dream is 'le retour aux sources' [a return to origins], and she literally embraces the past in the form of the Roman statue of the baths' founder. One of her colleagues, meanwhile, meets and marries a modern-day Algerian who appears to be a double of the bearded figure in a Roman mural at the site. The narrative ends, however, on a darker note with an admission that the recovery of lost heritage is not as unproblematic as it seems to be in *Viva Laldjérie* or in *Timgad* (see below). Madame Algeria is arrested for fraud, while Riyad and Rachida, like a more successful version of Kamel and Zina in *Rome plutôt que vous* (Teguia, 2006), escape from Algeria by boat and attempt to row all the way to Italy. The mother is thus not the only character to seek a sense of self in a return to origins. History and narrative form a spiral, with the son departing in search of his father to the very country which gave Algeria its Roman heritage and Madame Algeria her childhood experiences at the baths. The film concludes with Madame Algeria, alone after her release from prison, wandering down the streets of Algiers, drunk and alone.

Despite this down-beat ending, the film – powered by Biyouna's performance – maintains that it is possible, indeed vital, for Algeria to develop a new sense of identity by recognising the diversity of its past and the complexity of its present. Madame Algeria tells her son that he can be whatever he wants to be, and the narrative demonstrates that this entails an acknowledgement of his origins. Like *Viva Laldjérie* or Hakkar's *La Maison jaune* (see below), this is a film with a memory. Characterisation (Madame Algeria), narrative structure (flashbacks) and theme (history as always present) all point to that. Even those who have no memory of the past can seek it out and engage with it. In this regard, Riyad's search for his father echoes the

search for traces of the Berbero-Roman past in Hakkar's documentary *Timgad*. In 2003 Stora asserted that in the black decade Algeria had ceased to exist, thanks to an absence of images, and was replaced by an imaginary country: 'l'Algérie, pays qui s'est évaporé, devient abstrait, incompréhensible [. . .]. Cette absence construit une Algérie fantasmée qui n'existe pas' [Algeria, a country that has evaporated, becomes abstract and incomprehensible. This absence creates a fantasy Algeria that does not exist] (Stora 2003: 8). The Algeria of Mokneche and Hakkar's cinema fills this absence, creating a country rooted in history, engaged on a search for identity.

La Maison jaune (Hakkar, 2007)

The history of Algeria is not just one of occupation by, and independence from, France. Its ancient and premodern past – the legacy of Roman, Arab and Ottoman invasions, for example – also informs its present: 'Algerian history, like all history, is a palimpsest. [. . .] A landscape which encouraged resistance to central authority, religion, Ottoman structures: the cumulative impact of these different layers is permanently present' (Evans and Phillips 2007: 25). What is significant here for our case study is the role of what Evans and Phillips call Algeria's 'dissident landscape'. This is most apparent in the divide between mountains in Kabylia or in the Aurès (both home to very long-established Berber communities) and the site of central power (be it Ottoman, French or FLN) in Algiers. Landscape has facilitated the expression of dissent and maintained a physical barrier between central power and the mountain communities:

> The mountains functioned as natural obstacles where the power of the plain stopped abruptly and the end result was a Berber society that was fiercely independent. The Arabs made a fundamental divide between *Bled el Makhzen*, 'the lands of government', and *Bled es Siba*, 'the lands of dissidence', and each colonizing power in turn found it difficult to subdue the mountain populations. (Evans and Phillips 2007: 25)

We should also mention that the vast majority of Algerian territory is in fact the Sahara desert, very sparsely inhabited but with a tiny, nomadic Tuareg population. The 'South', as it is called, was historically beyond the pale, a region outside central control, although it was policed to an extent by the French Foreign Legion. After independence it became the site of internal exile for dissidents, and in the 1990s

of internment camps for Islamic militants. The representation of the desert in Algerian cinema is relatively limited, but can be seen in films by Mohamed Lakhdar Hamina (*Vent de sable*, 1982), Mohamed Chouikh (*L'Arche du désert*, 1993) and Tariq Teguia (*Inland*, 2008). The mountains are a more sustained presence, notably in the evocation of Berber identity (see Chapter 5). Amor Hakkar's work can be seen as deriving from this Berber cinema celebrating 'dissident landscape', but also as a search for an inclusive sense of national identity based on an engagement with the past.

In his television documentary *Timgad* (made for French TV in 2000), Hakkar attempts to rescue the Aurès region's Berber-Roman past from neglect and amnesia, following the work of Ali, a local archaeologist, and constructing a meeting between him and a peasant farmer, Mahmoud, an everyman who is presented as ignorant of the heritage on his doorstep. As the opening voice-over tells us, the transmission of collective memory is not easy but is essential for the local people to understand their history and hence their identity. There is an echo here of the sequence in *La Nouba des femmes du Mont Chenoua* where Lila visits an ancient tomb as a means of engaging with her tribe's past. After a section explaining Ali's efforts to maintain the vast Roman site at Timgad, Hakkar shows Mahmoud developing an interest in local history and visiting Roman baths plus the tomb of a Berber king. The final sequence concerns Mahmoud's trip to Timgad itself: when he arrives late in the evening he finds that the site is shut, symbolising that the gates of history are closed to the Algerian public. In a highly theatrical ending, the gates to Timgad are then opened and Mahmoud is granted a nocturnal tour, a return to his ancient historical heritage – as a Berber but also as an Algerian.

Bourdieu revealed in his studies of Kabylia that memory is of great importance in Berber culture: '"L'homme d'oubli, dit le proverbe, n'est pas un homme." Il oublie et s'oublie lui-même [. . .]; on dit encore: "Il mange sa moustache"; il oublie ses ancêtres et le respect qu'il leur doit' [The man who forgets, says the proverb, is not a man. He forgets, and so forgets himself. They also say: 'He eats his moustache'; he forgets his ancestors and the respect he owes them] (Bourdieu 1972: 38). This theme might be said to inform both *Timgad* and Hakkar's full-length fiction film, *La Maison jaune*. But *La Maison jaune* is also a reaction to personal loss (the death of Hakkar's father), to national loss (the thousands who died in the black decade of the 1990s) and to the loss of an Algerian national cinema during the

1990s too – what Stora has called an absence of images which made Algeria disappear (see Stora 2003 and above). What makes *La Maison jaune* such an important film is not just its warm and at times gently comic representation of a Berber community, nor its evocation of grief, but its insistence on the role of the filmed image in the representation and the overcoming of Algeria's loss. One could say that *La Maison jaune* is a film about the moving image – in both senses of the term.

At the core of the film is a video-cassette. Described repeatedly as a 'white box', it is one of the possessions left behind by a soldier, Boualem, who dies in a car accident. The narrative is structured around two quests in reponse to this death: the first shows Boualem's father Mouloud (Amor Hakkar) bringing his son's body back from Batna to the mountains; the second shows Mouloud, helped by his eldest daughter Alya (Aya Hamdi), trying to access the contents of the mysterious cassette. The box that contains Boualem's body is thus mirrored by the box that contains his image. The first half of the film is in effect a road movie featuring a slow-moving tractor, hence reminiscent of David Lynch's *The Straight Story* (USA, 1999). Mouloud drives to Batna on his tractor, recovers his son's corpse, and drives the coffin home for burial. The second half of the film concerns attempts to view Boualem's testimony. In the final sequence the whole family are able to watch Boualem's video message, gathered in their home as he speaks to them from beyond the grave. Although there is no direct reference to the traumas of the civil war, Boualem's death is a synecdochic representation of all the deaths that Algeria suffered in the nineties. Because of the setting (the Aurès region) and the device of the father's journey, *La Maison jaune* also recalls the mother's search for her missing son in *Le Vent des Aurès* (Lakhdar Hamina, 1966), and, via that intertext, the losses suffered in the war against the French. But *La Maison jaune* is not by any means as bleak a film as *Le Vent des Aurès*, or the narratives of loss to come out of the black decade (see Chapter 7). In many ways it is more optimistic than a comedy such as *Hassan Niya* (Bendeddouche, 1988). Whereas in *Hassan Niya* the protagonist's journey is complicated by lies, misunderstandings, conspiracies and arrests, with authority figures in particlar proving officious and unhelpful, in *La Maison jaune* Mouloud is helped every step of the way by each person he meets, including those in authority: the policeman gives him a lamp, the taxi driver a tow, the imam a blessing, the pharmacist advice, and the police chief a connection to

the national grid. The film thereby paints a picture of a consensual, kindly Algeria, even while it focuses on a story of loss and grief. One might even compare the narrative to a fairy tale, since each obstacle is overcome through a series of helpers met on the road, with Alya (if not the youngest daughter, than certainly a child hero confronting the realities of life and death, symbolised by a wedding and a funeral) proving to be her father's greatest helper.

Mouloud tells the pharmacist, 'I am looking for medicine to treat sorrow'. The pharmacist advises him to paint his house yellow in order to cheer up his grieving wife. But the solution is to be found in the white box and the video message that Boualem recorded before his death, while in a wider sense the solution to Algeria's sorrow is to be found in the resurgence of a visual culture able to record and broadcast images of the nation's sorrow itself. Both on the literal and the figurative level, then, *La Maison jaune* proposes images of the past as a way into the future. This is far from the state-sponsored, monolithic hypermnesia of *cinéma moudjahid*, however (see Chapter 3). *La Maison jaune* is a very personal film, depicting a single family, a remote region and an often marginalised culture, expressed in the Berber language and soundtracked by an intimate, spare accompaniment of voice and guitar. In its moving conclusion, however, it also symbolises the importance of the film image in the restoration of Algerian identity after the silent, amnesiac years of the 1990s, when film production all but ceased and the nation could no longer see itself. Seeing oneself in the image of the dead loved one is a simple but powerful expression of the role of cinema in Algeria after the black decade. Hakkar captures this in the film's brilliant final scene, as Mouloud, his wife Fatima and their three daughters watch Boualem's message. The composition here is apparently simple, but massively symbolic. A red curtain to the side of the television set refers us to the theatricality of cinema screenings, while the image of the family itself (the Algerian audience) is clearly reflected on the screen even as Boualem's video plays. Hence both departed son and surviving family occupy the same space, literally the same screen, as Boualem tells them 'I'm glad to be coming home. I miss my mountains. I miss you very very much . . .' If the still image in cinema means death (see Bellour 1991), the moving image rescues the lost, the absent, the diappeared from death and makes them live again. Unlike the photo of the dead Fifi in *Viva Laldjérie* or the photo of the missing son in *Délice Paloma*, this video image makes the invisible visible, makes the loss apparent but allows it to be shared and puts

an end to the sense of a nation without a memory, without a history, without an identity.

Conclusion

Dispossessed in a variety of ways, predominantly uprooted from rural communities in the massive urbanisation that followed independence, Algerian audiences are offered a return to the land, to memory and to history by the cinema of Hakkar and Mokneche. Both film-makers use the attempt to record or capture the past as a means of answering Stora's question about Algeria after the millenium: 'C'est un pays qui fonctionne sans arrêt dans la rupture, en situation de table rase. Comment le cinéma peut anticiper cela?' [This is a country that is always in breakdown, facing a *tabula rasa*. How can cinema anticipate that?] (Stora 2003: 12). Colonial discourse often presented Algeria as a *tabula rasa*, an empty site which was ready to be mastered (see Fanon 2001). In 1960 Bourdieu and Sayad described the French disciplining of space as also relating to time, 'a decisive way of making *tabula rasa* of the past by imposing a new framework of existence' (cited in Gilsenen 1992: 150). An exception was made for Roman ruins, the existence of which allowed a Eurocentric connection to be established between the Roman and French presences in North Africa (see Haddour 2000). But as reinterpreted in *Timgad* and *Délice Paloma*, as well as in the Berber tomb sequence from *La Nouba des femmes du Mont Chenoua*, the ruins of the ancient past can stimulate a re-engagement with identities beyond the colonial and the neo-colonial. In Djebar's terms, a return to hear the stories of the past can result in a new agency in the present and the future: 'This introspective, backward-looking gaze could make it possible to search the present, a future on the doorstep' (Djebar 2001: 306).

Djebar's reference here to 'the future on the doorstep' connects with the theorisation of an Algerian future in Ranjana Khanna's work. For Khanna, influenced in particular by Antonio Gramsci and Jacques Derrida, Algeria is a test case, where the sovereignty of the neo-colonial, postcolonial state can only be contested or resisted ('cut' in Khanna's terms) by the insurgency of the subaltern. A future for Algeria might therefore be found in moments of resistance, in a critical agency that Khanna describes as postcolonial melancholia: 'the work of melancholia, critically attesting to the fact of the lie that is intrinsic to modern notions of sovereignty, is the only hope for the

future' (Khanna 2008: 27). The representation of women is central to Khanna's thesis: 'A critical melancholia emerges from these representations of women. It is in the attempt to listen to this melancholia that a critical politics can be perceived. It emerges from marginalization, repression, and exclusion from community' (Khanna 2008: 56). Habiba Djahnine's recent documentary *Lettre à ma soeur* (2008) engages with precisely these elements and listens to the voices of those violently excluded from Algerian society: women and feminists targeted in the 1990s. The film sees Habiba return from France to her home region of Kabylia in order to uncover how her sister Nabila, an activist for women's rights, was murdered during a protest march in Tizi-Ouzou in 1995. Although the GIA (Groupe islamique armé) claimed responsibility for the killing, the film is not a criminal inquiry and maintains a sense of suspicion around the respective roles of the Islamists and the state. Instead it offers a careful listening to the voices of Nabila's colleagues and friends, especially the local women who worked with her, were educated by her and were traumatised by her murder. Above all, then, *Lettre à ma soeur* listens to the voices of the subaltern.

A key theme in the interviews throughout the film is a sense of re-emergence that follows the initial insurgency of Nabila's activism, the trauma of her killing and the subsequent years of silence and self-imposed incarceration. One of Nabila's former colleagues, who after the murder did not leave the house for three years, has begun teaching girls again, and declares that 'Il faut transmettre' [we have to transmit]. This beautifully resonant phrase can also be applied to the role of cinema in Algeria currently, and to the work of films like *La Maison jaune*, *Viva Laldjérie* and *Délice Paloma*, transmitting filmic images to fill the void in Algerian cultural identity after the end of the black decade. It is the transmission in particular of repressed voices, of 'subaltern interruptions' (Khanna 2008: 61) that *Lettre à ma soeur* captures. Glimpses of insurgency and interruption punctuate the film, including the apparently miraculous emergence, from outside the frame, of a handful of flowers on a mountain top. As with the 2001 unrest also addressed in the film, 'subalterns manifest themselves in moments of spontaneous insurgency' (Khanna 2008: 57). The film concludes with a final emergence of the subaltern when the interviews and landscapes of the present are interrupted by footage of Nabila – speaking as it were from beyond the grave, as in the video message of the dead son from *La Maison jaune*. The screen first goes black and

then from beyond this blackness, from beyond death, emerges Nabila herself. In a video interview, Nabila addresses the struggles against the government in the years following October 1988, the 'battles' to defend women's rights, the murder of Tahar Djaout, the existence of so-called 'honour crimes'. Noting that violence against women has always existed in Algeria, she concludes that 'on tue tout ce qui dérange' [everyone that gets in the way is killed]. Death is then a recurrent trope in *Lettre à ma soeur*, from the opening shot of a cemetery, via the chilling statement 'Tizi will always smell of death', to the final words of Nabila speaking as if from beyond death. As with *Viva Laldjérie*, *Délice Paloma* and *La Maison jaune*, death is related to the photographic and the audiovisual. The 'disappeared' are re-presented in the form of photos (in the films of Mokneche) or videos (in the films of Hakkar and Djahnine). In a culture that Stora has associated with silence and secrecy, where the mass deaths of the civil war are represented by a single photograph, and the mass deaths of the liberation struggle remain uncounted and consigned to the 'garbage bin of national history' (Khanna 2008: 18), the role of cinema as a listening and a seeing that re-presents the bodies of Algeria's subaltern masses is therefore an urgent one.

References

Bellour, Raymond, 'The film, stilled', *Camera Obscura*, xxiv (September 1991), pp. 98–123.

Boughedir, Ferid, 'La victime et la matronne: les deux images de la femme dans le cinéma tunisien', *CinémAction*, 111 (2004), pp. 103–12.

Bourdieu, Pierre, 'Révolution dans la révolution' (1961), in Bourdieu, *Interventions, 1961–2001: Science sociale & action politique* (Paris: Agone, 2002), pp. 21–8.

Bourdieu, Pierre, *Trois études d'ethnologie kabyle / Esquisse d'une théorie de la pratique* (Paris: Editions du Seuil, 1972).

Bourdieu, Pierre, 'Dévoiler et divulguer le refoulé', in Joseph Jurt (ed.), *Algérie – France – Islam* (Paris: L'Harmattan, 1997), pp. 21–7.

Djebar, Assia, *Femmes d'Alger dans leur appartement* (Paris: Des Femmes, 1980).

Djebar, Assia, *So Vast the Prison* (translated by Betsy Wing) (New York and London: Seven Stories Press, 2001).

Evans, Martin and John Phillips, *Algeria: Anger of the Dispossessed* (New Haven and London: Yale University Press, 2007).

Fanon, Frantz, *The Wretched of the Earth* (translated by Constance Farrington) (London: Penguin Classics, 2001).

Gilsenen, Michael, *Recognizing Islam: Religion and Society in the Modern Middle East* (London and New York: I.B. Tauris, 1992).

Haddour, Azzedine, *Colonial Myths: History and Narrative* (Manchester: Manchester University Press, 2000).

Khanna, Ranjana, *Algeria Cuts: Women and Representation, 1830 to the Present* (Stanford, CA: Stanford University Press, 2008).

Lazreg, Marnia, *The Eloquence of Silence: Algerian Women in Question* (New York and London: Routledge, 1994).

Messaoudi, Khalida, *Une Algérienne debout: entretiens avec Elisabeth Schemla* (Paris: Flammarion, 1995).

Stora, Benjamin, *La Guerre invisible: Algérie, années 90* (Paris: Presses de Sciences Po, 2001).

Stora, Benjamin, 'L'absence d'images déréalise l'Algérie', *Cahiers du cinéma*, Spécial Algérie (February 2003), pp. 6–13.

Stora, Benjamin, 'Entretiens', DVD bonus in Nadir Mokneche, *Délice Paloma* (Editions Vidéo France Télévisions Distribution, 2008).

Turim, Maureen, *Flashbacks in Film: Memory and History* (New York and London: Routledge, 1989).

Yacine, Kateb, *Nedjma* [1956] (Paris: Editions du Seuil/Points, 1996).

9

Conclusion: Algerian national cinemas

Currently, Algerian cinema is starting to reconfigure itself after two decades of attrition and collapse. The nationalised film industry of the Boumediene era is long gone, but there are signs that a national film industry might be under (re)construction. Those signs are small-scale. It was taken as significant that the comedy *Mascarades* (Salem, 2007) was released on as many as eleven screens (Chabani 2008). The 'perceptible change' that the French magazine *Cahiers du cinéma* detected in Algerian film during 2008 was evidenced in part by the renovation of just eight cinema screens, the emergence of three directors (Tariq Teguia, Malek Bensmaïl and Lyès Salem), and promises of enhanced future funding from the Ministry of Culture (Chikhaoui 2009). Volume of production, which was reduced to zero in the year 2000, has certainly increased. In 2007 over sixty films of one kind or another (fiction and documentary, features and shorts, for cinema and for television) were granted 20 per cent of their budget under the programme of Algiers, capital of Arab culture. Late 2008 also saw a new co-operation agreement signed with France, covering co-production, distribution, training and film archives (see Chikhaoui 2009). Since Algeria has no indigenous film school (one was set up in 1984 but closed three years later), training in France and elsewhere remains a necessity. But co-production raises questions around the national identity of the films themselves. The dependence on finance from France in particular is clearly problematic given the colonial past. How to 'combattre les multinationales de la production symbolique' [combat the multinationals of symbolic production] (Bourdieu 1997: 26), if one relies on finance from those very sources? Malek Bensmaïl has declared that only when Algeria is able to regularly raise 70 per cent of a film's production costs will Algerian cinema have really returned (see Anon. 2010: 10).

Regarding French involvement in the cinema of North Africa, Roy Armes writes of 'a particular type of transnational cinema in the Maghreb which is dependent on the initiatives of a foreign state' (Armes 2005: 183). France may no longer be an automatic historical and political reference point as it was in the Algerian *cinéma moudjahid* of the 1960s and 1970s. It is not even the dominant destination in fantasies of escape from Algeria; that function is filled by Italy in *Rome plutôt que vous* (Teguia, 2006) and *Délice Paloma* (Mokneche, 2007), and by Spain in *Harragas* (Allouache, 2009). But France is a vital financial partner in the continuation of Algerian film-making. The very small number of Algerian screens means that domestic films need this kind of external support (and market) to find an audience outside Algeria and hence to cover costs. There can be gains, not just financial (production and box office), for directors working with international partners: 'The European market offers film-makers and producers alternative financial and spiritual spaces, which help them to face the pressure of domestic censorship' (Shafik 2007: 35). For example sex (including nudity and homosexuality) is represented more explicitly in Nadir Mokneche's Algerian-French-Belgian co-production *Viva Laldjérie* (2004) than in most Algerian cinema. Bensmaïl's documentary on the 2004 Algerian elections, *Le Grand Jeu*, is banned in Algeria but has been screened at festivals in France. Yet a film critical of the status quo and despairing for the future of Algerian youth, Teguia's *Rome plutôt que vous* (2006), was exclusively screened at the Algiers Cinémathèque before it was distributed in France. In a review of the film (an Algerian-French-German co-production), the newspaper *El Watan* described Teguia, Mokneche and others as a new generation of Algerian film-makers and declared that the official state-controlled cinema was dead (Zahzah 2007). It is a matter of debate, therefore, whether international co-productions lessen the cultural specificity of Algerian cinema or allow an escape from monolithic state control and censorship, while expressing minoritarian positions (be they social, cultural or linguistic). For Shafik, although European money has helped to maintain Arab film-making generally, 'co-produced films have succeeded in representing Arab cinema abroad while marginalizing Arab mainstream cinema', for example favouring auteur cinema over genre cinema. She concludes: 'In this way, Western hegemony over regional productions has been reinforced on the financial and ideological levels' (Shafik 2007: 42).

If the audiences for Algerian films include diasporic communities, notably in France, a significant number of directors working within

Algerian cinema are also based there. Among these are Merzak Allouache, Amor Hakkar, Abdelkrim Bahloul, Djamila Sahraoui and Habiba Djahnine. A sense of nostalgia or of ambivalence about a return to their 'home' country of Algeria can be detected in their work. This may be informed by the death of a loved one, as in Hakkar's decision to film *La Maison jaune* in the Aurès after attending his father's funeral there, or Djahnine's investigation into her sister's murder in Kabylia, *Lettre à ma soeur* (2008). The role of family and of local territory is hence important in these films and their motivations. In terms of trauma theory, Cathy Caruth has stressed the importance of 'a seeing and a listening *from the site of trauma*' (Caruth 2006: 214, italics in original). For film-makers based outside Algeria, the return to the land of their childhood or their extended family is a crucial gesture, as is the physical act of filming in what may be difficult or dangerous environments. This is all the more important in the context of the 'black decade' and its aftermath, with tensions still evident in the recent shooting of *Inland* (Teguia, 2008) for example. While certain directors risked continuing to work in Algeria during the civil war (see for example Allouache filming on the streets of Algiers, or Berber cinema in the mountains of Kabylia), other films such as Mokneche's *Le Harem de Madame Osmane* (2000) were shot in Morocco for security reasons, a tendency that has continued with Morocco standing in for Algeria in *Indigènes* (Bouchareb, 2006). If in the year 2000 not a single film image was shot in Algeria (Tesson 2003: 38), then a return to film-making from the site of trauma can signal solidarity with the vast majority of Algerians who still occupy that site (Algeria itself) and were unable to leave during the terror of the black decade. Sahraoui's documentary *Algérie, la vie quand même* (1998) enacts a return to Kabylia and involves giving the camera to her cousin to allow him to tell the story of disenfranchised Kabyle youths. And again, *Lettre à ma soeur* also returns to Kabylia, to uncover the story of Nabila Djahnine's life and death, and to interview the traumatiased colleagues who worked alongside her. A return to Algeria from France is also explicitly enacted in *Sous les pieds des femmes* (Krim, 1997) and *Bled Number One* (Ameur-Zaïmeche, 2006). These examples, and others by Merzak Allouache, Yamina Benguigi, Nadir Mokneche and Tariq Teguia, have been described in the Algerian press as 'Franco-Algerian'. According to Teguia, this was a comment aimed not so much at his identity (he has Algerian nationality) as at his legitimacy as a film-maker (see Frodon 2009: 13). Yamina Bachir Chouikh's

Rachida (2002) was a particular case for debate since its funding came entirely from France. To what extent, then, was the film 'Algerian'? Teguia insists, however, that this is the wrong question. A fixation on definitions of national identity can risk ignoring the real issue at stake in film-making that takes place in Algeria, which is how far it engages with contemporary Algerian realities, hence 'de quoi témoigne-t-on?' [what is being testified to?] (Teguia in Frodon 2009: 13).

Language and national identity

Significant too is the language in which this testimony is framed. Although entirely funded by French money, *Rachida* is filmed in Arabic. The choice of language here works as a signifier of national identity, in so far as Algeria is defined linguistically, both in the early independence movement, as in Sheikh Ben Badis's famous 1936 assertion 'Islam is my religion, Arabic is my language and Algeria is my country' (cited in Evans and Phillips 2007: 44), and after independence by the Arabisation policies of the FLN. We might compare Algeria as conceived by the FLN with Stalin's concept of the nation: 'A nation is a historically constituted, stable community of people, formed on the basis of a common language, territory, economic life, and psychological make-up manifested in a common culture' (cited in Chatterjee 1986: 34, n.45). Attempts were made within cinema, and in particular within the *cinéma moudjahid*, to maintain this monocultural and monolingual orthodoxy. The novelist Boualem Sansal sees the state's mismanagement of the language question as having produced a balkanisation in Algeria, a split between Arabophone, Berberophone and Francophone elements. As regards Arabic, Sansal reveals the absurdity of state education in classical Arabic when the Arabophone population uses regional dialects (Sansal 2006: 38–9). The language of the Algerian revolution, and of the 1 November 1954 declaration, was French. Sansal cites Kateb Yacine's assertion 'Le français est à nous, c'est un butin de guerre' [French belongs to us, it's one of the spoils of war], and yet notes how ambivalent its status has been in Algeria ever since independence (Sansal 2006: 41).

Like Algerian literature, Algerian cinema is 'inscribed in a linguistic triangle' between French, Arabic and Berber (Djebar 2000: 227). Of these, Berber (or Tamazight) and its local variants such as the Kabyle and Chaoui languages, is the oldest. After the Arab invasion of the seventh century, Arabic became the dominant language in

Algeria, except for the more remote regions where Berber languages remained. Occupation by France imposed the French language, with for example a 1938 law 'making Arabic a "foreign" language in Algeria' (Abu-Haidar 2000: 152). This in turn was followed by the Arabisation policies of the newly independent Algerian state, with its first president, Ben Bella, declaring on 1 November 1962, 'Notre langue nationale, l'arabe, va retrouver sa place' [Arabic, our national language, will regain its place] (cited in Abu-Haidar 2000: 154). His successors sought to promulgate Arabic (excluding the Berber languages while maintaining an ambiguous stance towards French) throughout the 1970s and 1980s. Despite the continuation of Arabisation policies in the 1990s under Zeroual, and the violence by fundamentalist groups against singers, poets and novelists working in French and Tamazight (most infamously the murder of Tahar Djaout in 1993), both languages were used by writers and film-makers, albeit often in exile. As we saw in Chapter 5, Berber cinema came of age in the mid-1990s with films shot in Kabyle, where earlier Algerian films set in Berber-speaking regions had been required to use Arabic. The opening-up of national identity to plural, multilingual possibilities was initially signalled in a speech by President Boudiaf in April 1992:

> In reality Algeria is suffering from [. . .] an identity crisis. For thirty years our people have been torn between socialism and capitalism [. . .] between East and West, between the French and Arabic languages, between Arab and Berber, between tradition and modernity. (cited in Evans and Phillips 2007: 175)

Boudiaf's assassination may have delayed this realisation from inflecting state policy. But more recently, in 1999, Bouteflika was quoted as recognising the Arabic, Berber and French facets of the country's culture (see Abu-Haidar 2000: 162). One might view Algeria therefore as illustrating Benedict Anderson's assertion that 'nations can now be imagined without linguistic community' (Anderson 1983: 123).

A recent critique of Anderson has noted that 'In the aesthetics of "unisonance" there is always a hierarchy of responses and a mechanism of exclusion' (Carroll 2000: 124). This can be seen at work in the FLN's language policies, which excluded Berber-speakers plus also paradoxically those Arabic-speakers who were unable to access Francophone education, the latter a source of cultural and social

capital even under the FLN. David Carroll contrasts Anderson's concept of unisonance with Edouard Glissant's poetics of creolisation, 'a politics of resistance to "the imperialism of monolingualism"'. He continues: 'This resistance is proclaimed in the name not of one people or language, or unisonance, but of multilinguism, [. . .] "to confront the massive levelling force of language continuously imposed by the West [. . .] with a multiplicity of languages"' (Carroll 2000: 136). Algerian cinema, despite the constraints and contradictions of state policy, is clearly an example of multilinguism, and of resistance against the imperialism of the monolingual, initially in the Arabic-language films of the *cinéma moudjahid*, contesting the colonial imposition of French, then later in the Berber cinema of the nineties, contesting the imposition of Arabic. Arabisation policies and the politically expedient repression of the French language are dramatised in Abdelkrim Bahloul's *Le Soleil assassiné* (2003), with the poet Jean Sénac's 1970s ordeal also reflecting the ordeals of Francophone intellectuals and writers in the 'black decade' of the 1990s. Bahloul employs the recurrent trope of openings (the throwing open of doors and windows, the 'ouverture d'un espace/des esprits' [opening of spaces and of minds] achieved by Sénac's radio broadcasts) to figure freedom of expression. The film also asserts the plurality of Algerian national identity, with the *pied-noir* poet defiantly telling the police chief that Algeria is not simply an Islamic Arab state, but also a diverse Mediterranean nation. Hence the frequent images of the Mediterranean Sea, which function not just as a means of escape (for the young actor Belkacem, who flees to France) but also as a symbol for openness, contact and exchange with the wider world.

We should also note the largely Francophone experiments that resisted Arabisation policies in the 1970s, such as *Tahia ya didou* (Zinet, 1971) and *La Nouba des femmes du Mont Chenoua* (Djebar, 1978). Moreover, different languages regularly co-exist on screen (certainly after the 1960s). As with Bhabha and Gabriel, however, so too with Glissant, the case of Algerian cinema reminds us that the focus on 'the West' as imperial, hegemonic power in cultural theory risks ignoring the role of the post-colonial, neo-colonial state in replicating monolithic, monolingual power structures and policies. It is a measure of the plurality and richness of Algerian cinema that it has managed to create a polyphony despite the one-party post-1962 state and the reductive conception of Algerian identity promulgated by the FLN.

Nationalism and gender

As we have seen in Chapters 2 and 3, the nationalist project was at the heart of Algerian cinema for at least its first decade, when it was entirely state-sponsored and controlled, the project being usually articulated via the commemoration of the independence struggle (*cinéma moudjahid*). Cinema became the guardian of memory and hence of national identity, legitimated by the perception that 'In (re) constructing the postcolonial nation, the maintenance and recovery of historical memory is crucial' (Murphy and Williams 2007: 15). This imperative resulted in what Teshome Gabriel has called 'an urgent, activist cinema – in a word, Third Cinema' (Gabriel 1989a: 63). Throughout the 1960s, Algerian films sought a militant, memorialising form of third cinema. But the results were often monolithic and eventually proved alienating for their domestic audience. The FLN, defining itself as the nation (and funding cinema as the representation of the nation) had marginalised other pro-independence groups (such as the MNA) and assumed rigid control of the national imaginary. Algeria thus entered the problematic of post-colonial nationalism identified by Partha Chatterjee:

> All politics is now [. . .] subsumed under the overwhelming require-
> ments of the state-representing-the-nation. [. . .] Any movement which
> questions this presumed identity between the people-nation and the
> state-representing-the-nation is denied the status of legitimate politics.
> (Chatterjee 1986: 168)

This monolithic, autocratic vision of national identity cannot however fully erase from representation minoritarian identities, such as the Berbers in Algeria:

> Modern statecraft and the application of technology cannot effectively
> suppress the very real tensions which remain unresolved. They are
> apparent in the political life of every post-colonial nationalist regime in
> the world. In numerous cases they appear as separatist movements based
> on ethnic identities, proofs of the incomplete resolution of 'the national
> question'. (Chatterjee 1986: 169)

Chatterjee even appears to predict the clash between the FIS (Front islamique du salut) and the state which so marked Algeria in the 1990s when he adds:

> [the tensions] often appear as fervently anti-modern, anti-Western
> strands of politics, rejecting capitalism too for its association with

modernism and the west and preaching either a fundamentalist cultural
revival or a utopian millennialism. (Chatterjee 1986: 169)

Unresolved nationalism can thus be seen to have haunted independent
Algeria.

While subaltern studies historians such as Chatterjee have stressed
the importance of communal and class identities within anti-colonial
insurgency, they tend to neglect questions of gender. In her critique
of Chatterjee, Gayatri Spivak notes that 'a feminist historian of the
subaltern must raise the question of woman as a structural rather
than marginal issue' (Spivak 1996: 230). This is in a sense what
Ranjana Khanna does in writing about Algeria (see Khanna 2008).
If I have used Pierre Bourdieu alongside Khanna to emphasise the
ubiquity of gendered representations in Algerian culture, it is in order
to avoid what Spivak calls 'the apparent gender-neutralizing of the
world' (Spivak 1996: 230). All nationalisms are gendered, as Anne
McClintock has noted. Typically, 'women are represented as the atavistic
and authentic body of national tradition (inert, backward-looking
and natural) embodying nationalism's conservative principle of con-
tinuity', while men are constructed as the progressive agents of
modernity (McClintock 1997: 359). In an echo of the gendering of
space in colonialism (the feminisation of the territory to be occupied,
possessed or penetrated), nationalist resistance also establishes a gen-
dering of space, so that 'decolonization is waged over the territoriality
of the female, domestic space' (McClintock 1997: 360). In Algeria,
as Nefissa Zerdoumi has noted, 'women became the guardian[s] of
the Algerian-House instituted as a bastion of traditional values against
foreign influences' (cited in MacMaster 2009: 340). Furthermore, the
paradigm of the female warrior defending the community or indeed
the nation – a paradigm often alluded to by Assia Djebar, and occa-
sionally apparent in cinema, as in *La Bombe* (Laradji, 1969) – is in a
sense a reassertion *a contrario* of masculine power and a masculinist
conception of agency, since 'in a world turned upside down by chaos
and defeat, in which men themselves had failed to protect the nation
and [had] become "like women", then it was up to women to assume
the masculine role of the warrior and saviour' (MacMaster 2009:
319). After the war the FLN quickly reimposed the underlying model
of women as keepers of the nation, guardians of the threshold, while
the exceptional status of the female fighter was rapidly relegated to
the past (see Chapter 4). Even in one of the pioneer films of postcolonial

cinema, *La Bataille d'Alger* (Pontecorvo, 1965), a gendering of the struggle is already apparent:

> In privileging the nationalist struggle, *The Battle of Algiers* elides the gender, class, and religious tensions that fissured the revolutionary process, failing to realise that, as Anne McClintock puts it, 'nationalisms are from the outset constituted in gender power' and that 'women who are not empowered to organize during the struggle will not be empowered to organize after the struggle'. (Shohat and Stam 1994: 255)

The illusion of empowerment (masking disempowerment) generated by the Algerian revolution did not only relate to women in the new nation-state. Masculinity was also at stake, with potentially disempowering results derived from the mythologising of male war veterans as either absent martyrs or unapproachable leaders. According to the film-maker Mohamed Chouikh, the shift from independence to alienation, from 1962 to October 1988, can be explained according to an Oedipal model: 'les dirigeants sont devenus les "pères" de la nation [. . .]. Les enfants se sont sentis coupables de n'avoir pas participé à la guerre, ils sont infantilisés par des discours en langue de bois. Ils ont découvert le mensonge du "père" et se sont révoltés' [the leaders became the 'fathers'of the nation. The children, feeling guilty because they were not involved in the war, were infantilised by political rhetoric. They discovered that the 'father' had lied, and so they rebelled] (in Taboulay 1997: 49). Dead or absent fathers are also invoked in Kateb Yacine's novel of origins, *Nedjma* – 'l'ombre des pères, des juges, des guides que nous suivons à la trace' [the shadow of the fathers, the judges, the guides whose trail we follow] (Yacine 1996: 105) – and Djebar's lament for the dead, *Algerian White*: 'Land of the vanished fathers, always absent'; Algeria is a place of 'orphaned sons', of 'sons without fathers, each one forever fearing the resuscitated gaze of the latter should he come back by some misfortune, alive, to weigh on them!' (Djebar 2000: 222). Algerian cinema in some ways represents this 'resuscitated gaze': the father brought back to life as a filmic gaze upon what independent Algeria has become. This is most explicit in *Youcef* (Chouikh, 1993), where the protagonist returns after a symbolic death (exile) to see what he fought and died for, and to be disgusted with the result. In terms of politics, it is also the story of Mohamed Boudiaf, the great hope of the 1990s, who returned from exile to become president, but who was killed (a literal death to follow his symbolic death) before his reforms could be put in place.

The 'resuscitated gaze' of a missing father on the struggles of his family or his orphaned children is also evoked in those films haunted by dead or absent fathers: *Omar Gatlato, La Citadelle, Délice Paloma, Viva Laldjérie*. But crucial to the diversity of Algerian film-making in the last decade or so is the testimony of the female gaze, notably in both fictional and documentary representations of the black decade (Bachir Chouikh, Sahraoui, Djahnine). We may not agree that this is a product of the absence of men, as suggested by Stora: 'dans le conflit d'aujourd'hui, l'Algérie a fait l'expérience d'une société "désertée" en partie par ses hommes (partis en migration, dans les combats et dans les prisons) et prise en main par ses femmes' [in today's conflict, Algeria has expereinced the partial abandonment of society by men (lost to emigration, war, prison) and has been taken in hand by women] (Stora 2001: 104). It is more likely due to the relaxation in the early 1990s of the patriarchal state's control of cinema, and due also to a desire on the part of female directors to testify to the trauma of the *guerre virile*, in particular its impact upon women. But do such historical developments and diverse generations in Algerian cinema map on to taxonomies of the 'phases' of post-colonial film-making?

Phases of cinema

Fernando Solanas and Octavio Gettino's concept of militant third cinema (later elaborated by Teshome Gabriel) is usefully summarised thus:

> For Solanas and Gettino, *first cinema* is a hegemonic commercial cinema [. . .]. Hollywood, or the assimilation of Hollywood style, would fall into this category. *Second cinema* is concerned with issues of decolonization, reflecting a nationalist spirit [. . .] but uses conventional cinematic techniques; it is considered a product of neo-colonialism [. . .]. Third cinema, by contrast, resists the cultural imperialism of Hollywood-style hegemonic consumerism. Produced in the context of a natonal cinema, it is deeply rooted in resistance and decolonization; the whole apparatus of cinema is seen as radical and revolutionary. (Khanna 2008: 106)

Hence we can say that the *cinéma moudjahid* of the late 1960s and early 1970s represents second cinema, while its brilliant precursor *La Bataille d'Alger* – and to an extent *Le Vent des Aurès* (Lakhdar Hamina, 1966) – epitomises third cinema. But Algerian national cinema has for periods seemed frozen in the second phase, neo-colonial, 'trapped inside the fortress' to use Solanas and Gettino's expression.

Certainly this is true of much film-making between *La Bataille d'Alger* and *La Citadelle* (Chouikh, 1988) – that is to say, between Boumediene's coup against Ben Bella and the events of Black October. Two key exceptions that we have considered are *Omar Gatlato* (Allouache, 1976) and *La Nouba des femmes du Mont Chenoua* (Djebar, 1978). In her discussion of *La Nouba des femmes*, Khanna posits a fourth cinema, 'a revolutionary cinema of the cocoon, where the metaphor of the birth of a nation is not repressed into a denial of the feminine' and which thus goes 'beyond the guerrilla cinema where the camera is a weapon' (Khanna 2008: 124). Although Khanna does not apply this concept to *La Nouba des femmes* in a sustained way (making no mention of the uterine setting of the caves for instance), nonetheless she is astute in her assertion that Djebar's film explores 'the experimental relationship between documentary and fiction' and proposes a critique of third cinema 'for its inability to represent the different forms of symbolic violence played out by and on the body of the colonized woman, bringing representation to a crisis' (Khanna 2008: 129). As we have seen in Chapter 4, the gendered symbolic violence confronted by Algerian women is central to Djebar's representation of space and history in *La Nouba des femmes*. Although not immediately productive of a new phase in Algerian cinema as a whole, Djebar's radical film might be said to inform the subsequent transmission of gendered memory in films by men (*Viva Laldjérie*) and women (*Lettre à ma soeur*), and the critique of filmic representation in *Rome plutôt que vous*, as well as providing a pioneering example for women's film-making in Algeria.

Fourth cinema is more usually taken to mean cinema made by indigenous peoples. These communities are often both the originators and the spectators of their own representations (be it in cinema, video, or other media): 'Within "indigenous media", the producers are themselves the receivers, along with neighbouring communities and, occasionally, distant cultural institutions or festivals' (Shohat and Stam 1994: 34). This taxonomy can be applied to Berber cinema in Algeria, particularly in the 1990s when production was dependent on participation and funding from the community and also since, with screenings at Berber film festivals from Tizi-Ouzou to Los Angeles. Berber cinema in Algeria, with its celebration of landscape, custom, ritual and language, certainly complies with what Gabriel calls Third World films' folkloric function, 'a rescue mission' by the 'caretakers of popular discourse' and 'custodians of popular expression' (Gabriel 1989b: 54, 55, 56). Moreover, Berber cinema shares fourth cinema's

'powerful relationships to land, myth and ritual' (Faye Ginsburg, cited in Shohat and Stam 1994: 35). But is Berber cinema always a fourth cinema when it is placed alongside a state-sponsored cinema also made by indigenous peoples (that is to say, Arabic Algerian cinema)? Or when it is co-financed by Western European money (as is the case with *La Maison jaune*)? And is the term 'Third World cinema' useful when applied to Algerian film form? Gabriel sees Third World cinema as characterised by an attention to space rather than Western cinema's fixation on time (Gabriel 1989a: 44). Hence the recurrence of long takes, wide angles, slow-paced editing, repetition in the narrative, and so on. While these elements are clearly present in Berber cinema – especially *Machaho* (Hadjadj, 1996) and *La Maison jaune* – as well as the films of Mohamed Chouikh (for example *L'Arche du désert*, 1993), and the work of Tariq Teguia, it is worth recalling the manipulation of time and the importance of history in films as diverse as *La Nouba des femmes du Mont Chenoua* and *Délice Paloma* (Mokneche, 2007), to name but two. Besides, the emphasis on space rather than time in theories of Algerian culture is problematic in that it dehistoricises the Algerian experience. This is most noticeable in Bourdieu's work on Berber society, which posits a cyclical rather than linear understanding of time, and thus removes Kabyles from history: 'Historical change for the idealized Kabyle peasant, presents itself as thus always already subsumed within the circular logic of time' (Silverstein 2009: 170). That circular logic is evident in the folk narrative of *Machaho*, but is also presented as a dead end in the film's conclusion. Cyclical time is also challenged by the evocation of socio-historical change in fiction films like *Chronique des années de braise* (Lakhdar Hamina, 1974), *Le Soleil assassiné*, *La Colline oubliée* (Bouguermouh, 1996) and *Rachida*, and in documentaries such as *Lettre à ma soeur* and *La Chine est encore loin* (Bensmaïl, 2008). It is unhelpful and inaccurate therefore to define Algerian cinema as conforming to any single scheme of representation. Rather, there is a multiplicity of Algerian cinemas, whose relationships with each other (and with Western cinema) are in flux.

Algerian national cinemas

As Fanny Colonna notes of social science after Bourdieu, the existence of 'inequalities and power relations' should not obscure the role played by 'the multitude of other things that make up everyday life: invention, belief, love, friendship, self-mockery, humour' (Colonna 2009: 89).

Certainly after *Chronique des années de braise*, which tells the story of what Bourdieu would call the 'de-peasanted peasant', modern Algerian cinema – from *Omar Gatlato* in 1976 to *Lettre à ma soeur* in 2008 – has allowed us to understand what Colonna terms 'the varied and, above all, *different* critical resources that people have brought to bear on conditions of domination and injustice' (Colonna 2009: 89, italics in original). Despite the nationalist ideology aimed at erasing difference in the independent post-colonial Algeria, the nation remains a site of multiple audiences, including those resistant to official histories and determined to make their own. The *centre* beyond which these *margins* seek to speak is not the West (as in Gabriel's taxonomy), but the post-colonial, neo-colonial state itself, as dramatised in *Youcef* and analysed in Khanna (2008). Algerian cinema is then a plural cinema that at its best, as I hope to have shown, fulfils the call by Homi Bhabha for 'national, anti-nationalist histories of the "people"' (Bhabha 1989: 131).

References

Anon., *Regards sur le cinéma algérien 2010* [festival programme].

Abu-Haidar, Farida, 'Arabisation in Algeria', *International Journal of Francophone Studies*, 3:3 (2000), pp. 151–63.

Anderson, Benedict, *Imagined Communities: Reflections on the Origin and Spread of Nationalism* (London: Verso, 1983).

Armes, Roy, *Postcolonial Images: Studies in North African Film* (Bloomington: Indiana University Press, 2005).

Bhabha, Homi, 'The commitment to theory', in Jim Pines and Paul Willemen (eds), *Questions of Third Cinema* (London: BFI Publishing, 1989), pp. 111–32.

Bourdieu, Pierre, 'Dévoiler et divulguer le refoulé', in Joseph Jurt (ed.), *Algérie – France – Islam* (Paris: L'Harmattan, 1997), pp. 21–7.

Carroll, David, 'The aesthetics of nationalism and limits of culture', in Salim Kemal and Ivan Gaskell (eds), *Politics and Aesthetics in the Arts* (Cambridge: Cambridge University Press, 2000), pp. 112–39.

Caruth, Cathy, 'Literature and the enchantment of memory: Duras, Resnais, *Hiroshima mon amour*', in Lisa Saltzman and Eric Rosenberg (eds), *Trauma and Visuality in Modernity* (Hanover, NH, and London: Dover College Press, 2006), pp. 189-221.

Chabani, Nacima, 'Salim Aggar (Documentariste): "Il faut ouvrir les salles de cinéma pour financer le cinéma algérien"', *El Watan*, 24 September 2008, unpaginated, at www.elwatan.com/Salim-Aggar-Documentariste-Il-faut, accessed 21 October 2008.

Chatterjee, Partha, *Nationalist Thought and the Colonial World: A Derivative Discourse* (Tokyo: Zed Books, 1986).

Chikhaoui, Tahar, 'Algérie bon augure', *Cahiers du cinéma*, 645 (May 2009), p. 86.

Colonna, Fanny, 'The phantom of dispossession: from *The Uprooting* to *The Weight of the World*', in Jane Goodman and Paul Silverstein (eds), *Bourdieu in Algeria: Colonial Politics, Ethnographic Practices, Theoretical Developments* (Lincoln, NE: University of Nebraska Press, 2009), pp. 63–93.

Djebar, Assia, *Algerian White* (translated by David Kelley and Marjolijn de Jager (New York and London: Seven Stories, 2000).

Djebar, Assia, *So Vast the Prison* (translated by Betsy Wing) (New York and London: Seven Stories Press, 2001).

Evans, Martin and John Phillips, *Algeria: Anger of the Dispossessed* (New Haven and London: Yale University Press, 2007).

Frodon, Jean-Michel, 'Entretien avec Tariq Téguia: "Exploser vers l'intérieur"', *Cahiers du cinéma*, 644 (April 2009), pp. 12–15.

Gabriel, Teshome, 'Towards a critical theory of Third World films', in Jim Pines and Paul Willemen (eds), *Questions of Third Cinema* (London: BFI Publishing, 1989a), pp. 30–52.

Gabriel, Teshome, 'Third cinema as guardian of popular memory: towards a third aesthetics', in Jim Pines and Paul Willemen (eds), *Questions of Third Cinema* (London: BFI Publishing, 1989b), pp. 53–64.

Gilsenen, Michael, *Recognizing Islam: Religion and Society in the Modern Middle East* (London and New York: I.B. Tauris, 1992).

Khanna, Ranjana, *Algeria Cuts: Women and Representation from 1830 to the Present* (Stanford, CA: Stanford University Press, 2008).

McClintock, Anne, '"No longer in a future heaven": gender, race and nationalism', in Anne McClintock, Aamir Mufti and Ella Shohat (eds), *Dangerous Liaisons: Gender, Nation and Postcolonial Perspectives* (Minneapolis: University of Minnesota Press, 1997), pp. 89–112.

MacMaster, Neil, *Burning the Veil: The Algerian War and the 'Emancipation' of Muslim women, 1954–62* (Manchester: Manchester University Press, 2009).

Murphy, David and Patrick Williams, *Postcolonial African Cinema: Ten Directors* (Manchester: Manchester University Press, 2007).

Sansal, Boaulem, *Poste restante: Alger. Lettre de colère et d'espoir à mes compatriotes* (Paris: Gallimard, 2006).

Shafik, Viola, *Arab Cinema: History and Cultural Identity* (revised edition, Cairo and New York: The American University in Cairo Press, 2007).

Shohat, Ella and Robert Stam, *Unthinking Eurocentrism: Multiculturalism and the Media* (London and New York: Routledge, 1994).

Silverstein, Paul A., 'Of rooting and uprooting: Kabyle *habitus*, domesticity, and structural nostalgia', in Jane E. Goodman and Paul A. Silverstein (eds), *Bourdieu in Algeria: Colonial Politics, Ethnographic Practices, Theoretical Developments* (Lincoln, NE: University of Nebraska Press, 2009), pp. 164–98.

Spivak, Gayatri, 'Subaltern studies: deconstructing historiography', in Donna Landry and Gerald MacLean (eds), *The Spivak Reader* (New York and London: Routledge, 1996), pp. 203–35.

Stora, Benjamin, *La Guerre invisible: Algérie, années 90* (Paris: Presses de Sciences Po, 2001).

Taboulay, Camille, *Le Cinéma métaphorique de Mohamed Chouikh* (Paris: K Films Editions, 1997).

Tesson, Charles, 'Boujemaa Karèche' [interview], *Cahiers du cinéma*, Spécial Algérie (February 2003), pp. 36–41.

Yacine, Kateb, *Nedjma* (Paris: Editions du Seuil/Points, 1996).

Zahzah, Abdenour, '*Roma Wella N'Touma* de Tariq Teguia: un film sensitif', *El Watan*, 26 July 2007, at www.djazairess.com, unpaginated, accessed 2 July 2010.

Filmography

Algérie, la vie quand même (Djamila Sahraoui, 1998), 52 mins.
Al-Manara / El Manara (Belkacem Hadjadj, 2004), 90 mins.
L'Arche du désert (Mohamed Chouikh, 1997), 90 mins.
Arezki l'indigène (Djamel Bendeddouche, 2008), 90 mins.
Bab El-Oued City / Bab al-wad al-humah (Merzak Allouache, 1994), 93 mins.
Barakat! (Djamila Sahraoui, 2006), 95 mins.
Barberousse (Hadj Rahim, 1982), 100 mins.
Barberousse, mes soeurs (Hassan Bouabdallah, 1985), 62 mins.
La Bataille d'Alger / La battaglia di Algeri / The Battle of Algiers (Gillo Pontecorvo, 1965), 121 mins.
La Bombe (Rabah Laradji, 1969), 40 mins.
Bled Number One / Back Home (Rabah Ameur-Zaïmeche, 2006), 100 mins.
Le Charbonnier / Al-fahâm / The Charcoal Maker (Mohamed Bouamari, 1972), 97 mins.
La Chine est encore loin (Malek Bensmaïl, 2008), 120 mins.
Chronique des années de braise / Waqâ sanwât al-jamr / Chronicle of the Years of Fire (Mohamed Lakhdar Hamina, 1974), 177 mins.
La Citadelle / Al-qal'a (Mohamed Chouikh, 1988), 96 mins.
Le Clandestin / Taxi Mekhfi (Benamar Bakhti, 1991), 103 mins.
La Colline oubliée (Abderrahmane Bouguermouh, 1996), 90 mins.
Combien je vous aime / How Much I Love You (Azzedine Meddour, 1985), 105 mins.
Délice Paloma (Nadir Mokneche, 2007), 134 mins.
L'Evasion de Hassan Terro (Mustapha Badie, 1974), 115 mins.
Le Grand Jeu (Malek Bensmaïl, 2005), 90 mins.
Le Harem de Madame Osmane / The Harem of Madame Osmane (Nadir Mokneche, 2000), 100 mins.
Harragas (Merzak Allouache, 2009), 95 mins.
Hassan Niya / Hasan niya (Ghaouti Bendeddouche, 1988), 90 mins.
Hassan Taxi / Hasan taxi (Mohamed Slim Riad, 1982), 110 mins.

Hassan Terro / Hasan Tiru (Mohamed Lakhdar Hamina, 1968), 90 mins.
Histoires de la révolution / Stories of the Revolution (Ahmed Bedjaoui, Rabah Laradji, Sid Ali Mazif, 1969), 100 mins.
Les Hors-la-loi / Al-kharijoun an-alkanoun / The Outlaws (Tewfik Fares, 1969), 107 mins.
Hors-la-loi / Outside the Law (Rachid Bouchareb, 2010), 138 mins.
Indigènes / Days of Glory (Rachid Bouchareb, 2006), 120 mins.
Inland / Gabbla (Tariq Teguia, 2008), 140 mins.
La Légende de Tiklat (Azzedine Meddour, 1991), 90 mins.
Lettre à ma soeur / Letter to My Sister (Habiba Djahnine, 2008), 68 mins.
Machaho / Machano (Belkacem Hadjadj, 1996), 90 mins.
La Maison jaune / The Yellow House (Amor Hakkar, 2007), 84 mins.
Mascarades / Masquerades (Lyès Salem, 2008), 94 mins.
Mimezrane, la fille aux tresses / Mimezrane (Ali Mouzaoi, 2008), 101 mins.
La Montagne de Baya / Djebel Baya (Azzedine Meddour, 1997), 116 mins.
La Nouba des femmes du Mont Chenoua / Noubat nissâ jabal chnouwwa (Assia Djebar, 1978), 115 mins.
Omar Gatlato / Umar gatlatu (Merzak Allouache, 1976), 90 mins.
L'Opium et le bâton / Al-afyun wal'asa (Ahmed Rachedi, 1969), 135 mins.
Patrouille à l'est / Dawriyyah nahwa al-sharq (Amar Laskri, 1972), 115 mins.
Rachida (Yamina Bachir Chouikh, 2002), 100 mins.
Le Rescapé (Okacha Touita, 1986), 90 mins.
Rome plutôt que vous / Roma wella n'touma (Tariq Teguia, 2006), 111 mins.
Les Sacrifiés (Okacha Touita, 1982), 100 mins.
Si Mohand U M'hand, l'insoumis (Liazid Khoja and Rachid Benallal, 2004), 100 mins.
Le Soleil assassiné / The Assassinated Sun (Abdelkrim Bahloul, 2003), 85 mins.
Sous les pieds des femmes (Rachida Krim, 1997), 85 mins.
Tahia ya didou / Tahia ya dîdû / Viva Didou! (Mohamed Zinet, 1971), 76 mins.
Timgad / Timgad, la vie au cœur des Aurès (Amor Hakkar, 2000), 50 mins.
Vent de sable / Rih al'rimâl (Mohamed Lakhdar Hamina, 1982), 103 mins.
Le Vent des Aurès / Rih al-awras / The Winds of the Aures (Mohamed Lakhdar Hamina, 1966), 95 mins.
Viva Laldjérie / Viva Algeria (Nadir Mokneche, 2004), 113 mins.
Visa de la mort (Samir Dellal, 2008), 60 mins.
La Voie / The Way (Mohamed Slim Riad, 1968), 105 mins.
Youcef: la légende du septième dormant, / Youcef kesat dekra sabera (Mohamed Chouikh, 1993), 105 mins.
La Zerda ou les chants de l'oubli (Assia Djebar, 1980), 60 mins.

Index